PACIFIC
MODERN

First published in the United States of America in 2006 by
Rizzoli International Publications, Inc. 300 Park Avenue South, New York, NY 10010
© 2006 Rizzoli Publishing © 2006 Raul A. Barreneche
Reprinted 2012
All rights reserved. No part of this publication may be reproduced, stored in a retrieval system, or transmitted in any form
or by any means, electronic, mechanical, photocopying, recording, or otherwise, without prior consent of the publishers.
ISBN: 978-0-8478-2765-7 Library of Congress Catalog Control Number: 2005937600
Designed by Claudia Brandenburg, Language Arts; Universe editor: Ron Broadhurst; Copy editor: Julie Di Filippo
Printed in China

Pacific
Overtures

The western shores of the Pacific Ocean frame one of the most diverse and dynamic regions in the world. The vast arc sweeping from the South Pacific to Southeast Asia boasts booming populations and growing economies that rival the powerhouses of China and Japan. There are large, thriving cities—Kuala Lumpur, Auckland, Bangkok, Sydney, Singapore, Melbourne, Jakarta—and stunning untouched landscapes, from the stark emptiness of the Australian outback and the snow-capped peaks of New Zealand's aptly named Remarkables range to Indonesia's jagged volcanic islands and Thailand's dense tropical jungles. Each of these places has distinct architectural traditions that evolved from unique geographic, cultural, and historical circumstances, including colonial imports from England, Spain, and Holland of sometimes dubious appropriateness to their new climate. But contemporary modern houses in these disparate lands do have common threads. They share an openness and simpatico spirit with the tenets of modernism—fluid, informal spaces, porous boundaries between indoors and outdoors, and freedom from the burden of too much history—while still remaining true to the particulars of place.

Seeing the table of contents of this book without a single image may seem like many things: overreaching, ambitious, naïve in its broad geographic sweep. What does a mini-malist glass shed gazing out on the bright blue waters of New Zealand's Bay of Islands share with an inward-looking brick-clad house in Manila? What could a sleek family com-pound in suburban Singapore have in common with a funky retreat in Australia's pastoral Kangaroo Valley that was built from salvaged industrial drums? They are a diverse bunch to be sure, separated by thousands of miles and a number of languages, religions, and cultures. To see images of these houses as a group, however, is to grasp the power of modern architecture to interpret and adapt to a seemingly infinite number of settings.

The very title *Pacific Modern* may be taking liberties with geography, as houses in Southeast Asian nations like Thailand and Singapore are grouped alongside those in places with actual Pacific coastlines: Australia, New Zealand, the Philippines. The World Bank, the United Nations, and multinational corporations see this part of the world area inclusively. They group Asia and the Pacific into a cohesive whole, conscious of the possi-bilities of commerce and culture in the region. The twenty-one member nations of the Asia-Pacific Economic Cooperation (APEC) take things a step further: In the name of pur-suing common trade and economic goals, countries on both sides of the Pacific Ocean—including Canada, the United States, Mexico, Peru, and Chile—have joined forces to liberalize trade and ease investment in a region of 2.5 billion consumers. (For the record, the houses featured in this book are all located in APEC countries.) Distant outposts of the old British Empire like Sydney and Melbourne used to have stronger cultural and commer-cial ties to London, nearly 11,000 miles away, than with its neighbors in Asia. Those days are long gone. Now, transactions in business, architecture, and the visual and culinary arts among Pacific Rim countries are an everyday occurrence.

Several projects featured in this book reflect the region's increased cultural ties. Singapore in particular is a melting pot: a former British colony with large populations of ethnic

Chinese, Malays, and Indians living together in a tidy, prosperous business-driven city-state off the coast of Malaysia. A family compound on the compact island-nation, designed by the local architecture firm Bedmar & Shi (pages 110–23), embodies the multinational composition of Singapore, and indeed the larger region. The owners of the three-house compound are an Indonesian family of Chinese origin who shuttle between Singapore and Jakarta, where they run a petrochemical shipping business. One of the homes is occupied by the couple's grown daughter, who is married to an Italian. One of the design firm's partners, Ernesto Bedmar, was born in Argentina, educated in the United States, and has been practicing in Singapore for two decades. The house itself combines sleek, polished modern architecture with touches of Southeast Asian materiality and breezy, indoor-outdoor spaces suited to the tropical climate.

The Hughes/Kinugawa House in Auckland, designed by local architect Andrew Lister (pages 82–87), also embodies the region's increasingly intertwined business and cultural environment. The clients are a film producer from New Zealand and an actress from Japan. The house infuses hard-edged modernism with a strong Japanese sensibility. The rooms, including the bathroom (which accommodates traditional eastern bathing rituals) and the master bedroom (which boasts an oversized platform bed covered with tatami mats and a ceiling sheathed in bamboo), are laid out according to the Japanese take on Feng Shui principles. And the lush garden includes plants native to both New Zealand and Japan. The Hughes/Kinugawa House may sound like the architectural equivalent of fusion food, but it is the exception among the projects illustrated on these pages. These houses are less about exotic, multicultural cross-pollinations of materials and building techniques than expressions of modern living in a particular part of the world.

The man who introduced Australia and indeed much of the Pacific region to Bauhaus modernism straight from its European roots was Harry Seidler. The Viennese-born architect joined his parents in Sydney in 1948 after having studied with Walter Gropius and Marcel Breuer at Harvard and Josef Albers at Black Mountain College in North Carolina, and working in Breuer's New York office and briefly with Oscar Niemeyer in Rio de Janeiro. That same year he completed a house for his mother, Rose, in Turramurra, outside Sydney. The Rose Seidler House, a pristine glass-enclosed cube partly lifted above the ground on slender columns, with a long ramp leading to an open-air courtyard with an abstract mural designed by Seidler, was without precedent when it was built. Now owned by the New South Wales government's Historic Houses Trust, it remains one of the most iconic modern houses in all of Australia—on par with Frank Lloyd Wright's Fallingwater or Mies van der Rohe's Farnsworth House in America. Seidler went on to design a number of daring, influential houses that adapted International Style modernism to the Australian climate and sensibility: the Rose House (1950), the Meller House (1950), and his own house in the Killara area of Sydney (1968). The house (opposite) frames broad views of the surrounding nature preserve and a rushing creek at the bottom of the hillside site with its angular concrete structure and walls of rough-textured stone. Seidler and his wife, Penelope, still call home this compelling example of bold modernism tempered to the openness and mild climate of its Australian context.

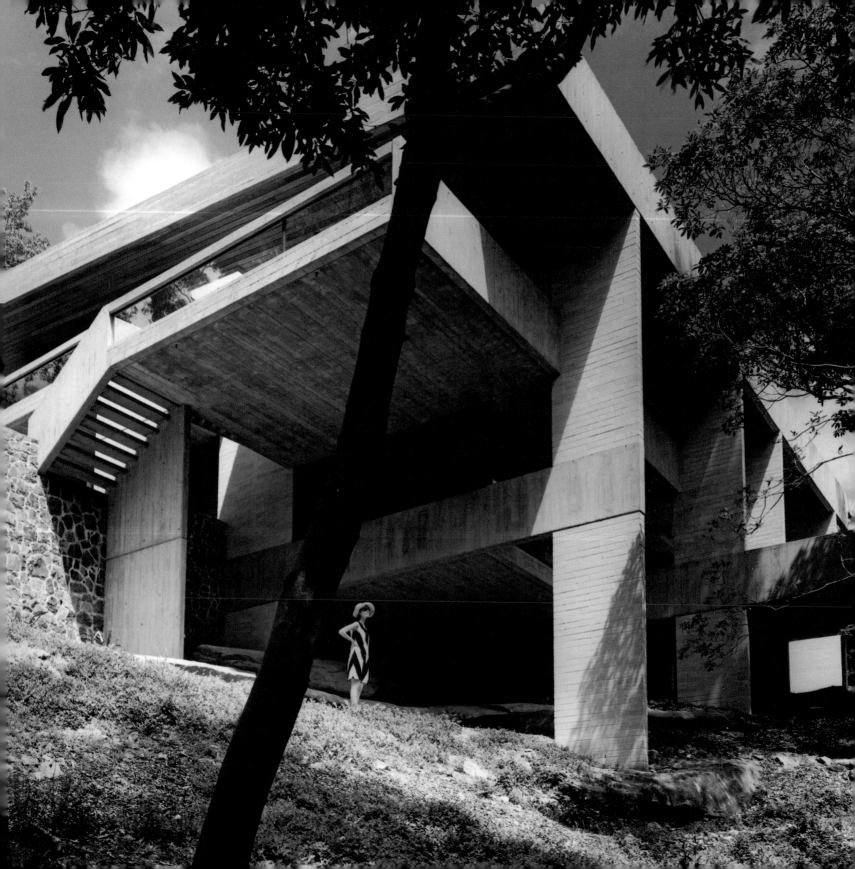

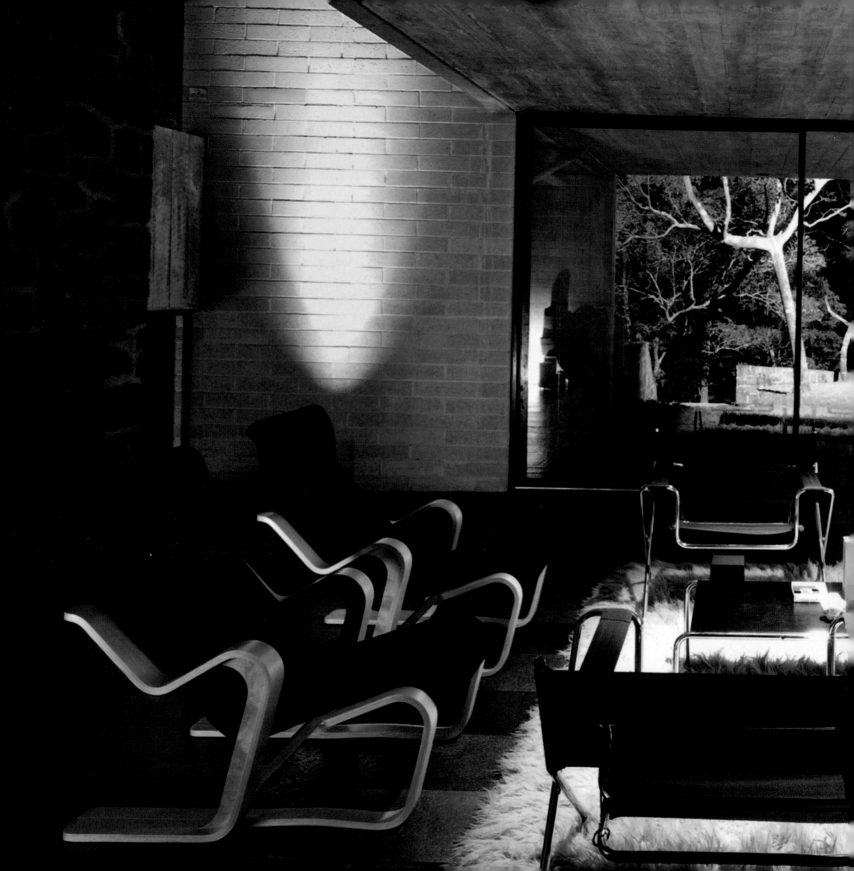

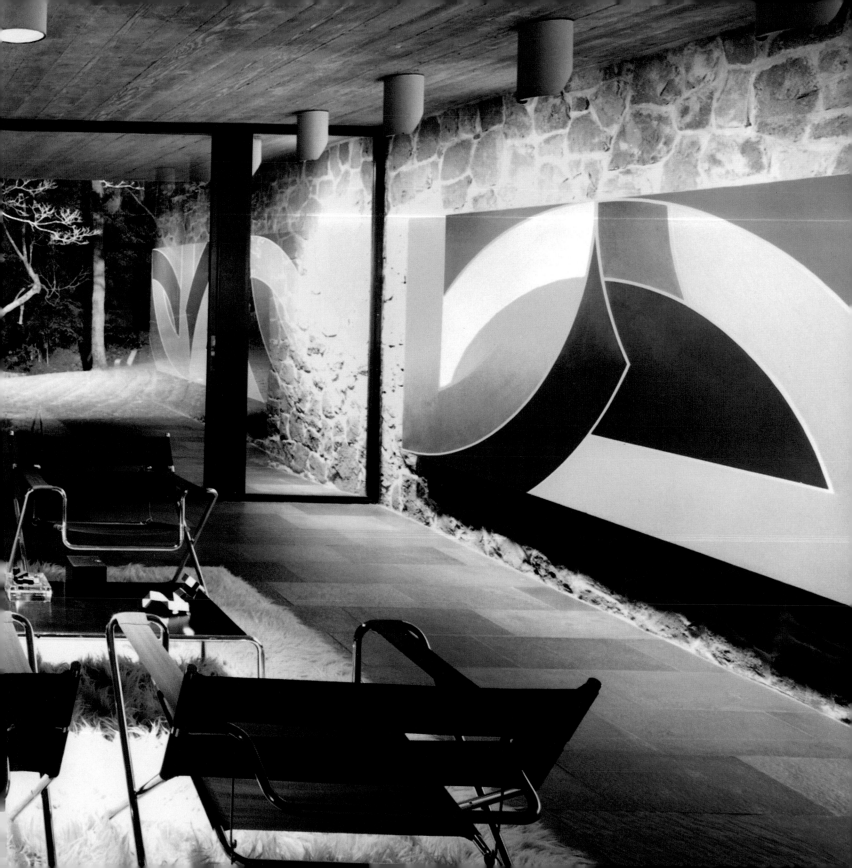

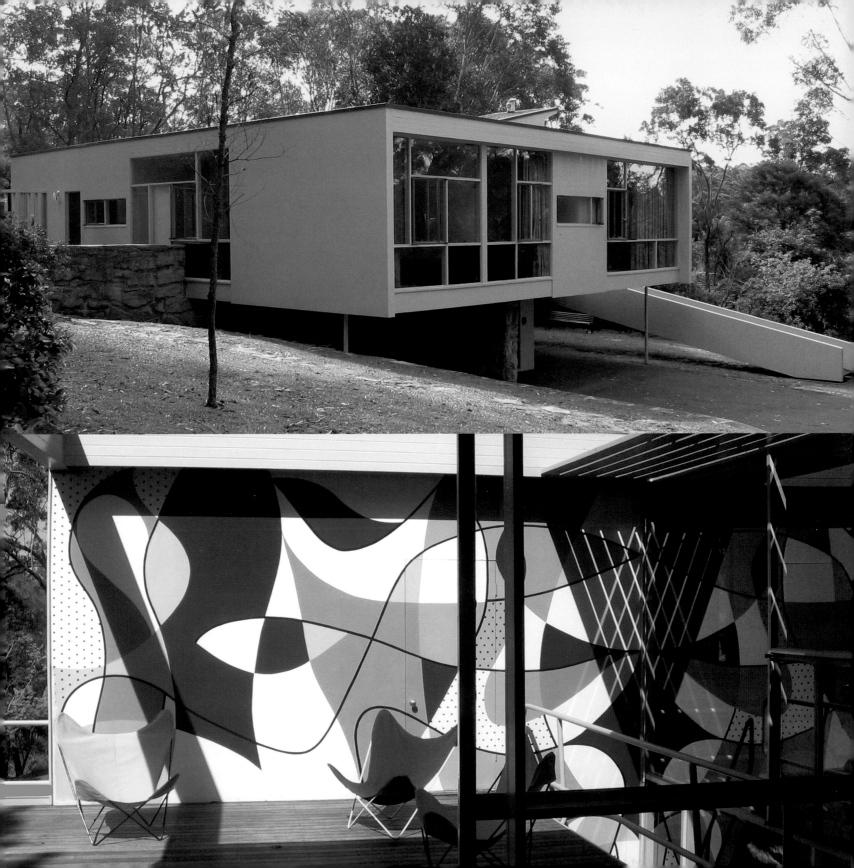

Rose Seidler House,
Wahroonga, Australia.
Harry Seidler, architect, 1950.

The majority of contemporary projects in the book are freestanding houses in bucolic landscapes, whether the scenic coast of northern New Zealand's Bay of Islands or the absolute isolation of the Australian bush. Some are decidedly big-budget, high-end productions; others were built on more modest budgets. But none is truly extravagant. In fact, several are architects' own homes, which are usually cost-conscious projects driven by innovation rather than deep pockets. I have made an effort to include small homes in denser urban and suburban settings, including the brick-clad Pablito Calma House in a residential enclave of Manila (pages 88–93), designed by Lor Calma Design Associates, and Thai architect Duangrit Bunnag's V42 House (pages 154–61) in the urban bustle and congestion of Bangkok, as well as adaptations of established urban-housing types and even complete renovations of existing houses. For instance, Forum Architects' Fulton Road House on the outskirts of congested Singapore (pages 68–73) improves upon the standard terrace house common in so many cities. The architects opened up the interior of the long, narrow floor plan to get light into the typically dark center, with sliding doors at both ends of the house and an interior garden that connect the interior to the outdoors, which seems commonsensical in a warm tropical climate like Singapore's. In Sydney, a city filled with charming Victorian housing stock that similarly ignores the pleasant climate and bright sunlight, local designers Burley Katon Halliday added a crisp, polished new wing onto a nineteenth-century Georgian sandstone cottage on the outskirts of Sydney (pages 54–61). The addition, which includes a walled-in private garden, transformed a dark, cramped Victorian house into an elegant, light-filled loft. On the Western Pacific Rim, as in other areas where rapidly growing and urbanizing populations are putting a squeeze on housing, adapting existing architecture to fit evolving modern lifestyles (and simply to accommodate more urban dwellers) is one of the most timely design challenges. Seeing how the architects of these houses have balanced tradition and innovation is especially inspiring.

Among the projects featured in this book, there is an admitted imbalance of houses in Australia, New Zealand, and Singapore compared to those from other nations. That is not because of any cultural bias on my part but because those countries are blessed with thriving architectural cultures and sophisticated building industries that translate into an abundance of high-caliber modern houses. Kerstin Thompson, a Melbourne architect and one of a growing number of female designers making important contributions in this part of the world, speaks of Australians' "big house dream." By that she means an aspiration among her countrymen, as entails the American Dream, to own a freestanding house surrounded by acres of land. There is no great tradition of dense social housing as there is in land-pressed Europe or crowded parts of Asia. Instead, Australia, a country with roughly the same land mass as the United States but less than ten percent of America's population, embraces a "great outdoors" mentality in part because of the great open spaces that stretch across the continent-sized country.

For Elizabeth Farrelly, the architecture critic of the *Sydney Morning Herald*, there is a downside to this culture of building big stand-alone houses on large plots of land: Australians'

"obsession with nature" has led them to neglect urban culture. Farrelly finds it an "Australian dilemma—call it conflicted, call it hypocritical—that glues our lives to the tarmac while our hearts beat for the bush [I]t is to virgin nature that we sing our lovesick songs. Which may simply show that our rurophilic Anglo heritage is alive and prevaricating."[1]

In my own travels Down Under I found private houses a much stronger barometer of the state of contemporary architecture in Australia than buildings in the public realm. John Wardle's Vineyard House on the Mornington Peninsula in Victoria (pages 38–45), Dawson Brown's Mackerel Beach House in the idyllic waterfront hamlet of Mackerel Beach (pages 178-87); and Alexander Michael's own retreat in the pastoral isolation of the Kangaroo Valley (pages 196–203) present a much rosier picture of Australia's design talent than the generic glass towers crowding the waterfronts of Brisbane, Melbourne, and Sydney. True to form, two houses by Australia's only Pritzker Prize–winning architect, Glenn Murcutt, embrace the landscape with a lightness of touch that draws on the Aboriginals' philosophy of building delicately and respectfully on the earth: the Bowral House (pages 22–29) and Fletcher-Page House (pages 170–77). For Antonio Citterio, the prolific Italian architect and furniture designer, Murcutt's architecture goes beyond its relationship to the landscape and the environment. It "epitomizes Australia's *spirito libero*—free mind. It's a natural quality of life without conventional architecture and without exaggeration Australians focus on the real qualities and values in their life—family, relationships, food, the natural. I like these people who do not seem under stress—unlike, for example, New Yorkers."[2]

Citterio would find New Zealanders committed to an equally relaxed lifestyle very much connected to the outdoors. Kiwis take their environment very seriously. Indeed, arriving in New Zealand, the visitor is struck by the sternness of the quarantine policy, which is designed to protect the unique and fragile flora and fauna of these islands in splendid antipodean isolation from pests and plagues carried into the country by unsuspecting travelers. Agriculture is big business in New Zealand, so the quarantine police mean business. Fines for bringing undeclared food into the country are hefty, and even a seemingly innocent snack can be met with a swift penalty, as a famous American actress learned when she was fined for not declaring an apple and an orange forgotten in her handbag after a long flight to Auckland.

The architectural upshot of making New Zealand's natural environment "the cleanest and greenest on earth," as the country's Ministry of Agriculture and Forestry promises, is a deep-seated sensitivity to designing houses that forge strong ties to the landscape. Even the most spectacular, sophisticated homes seem to touch the earth lightly, as Murcutt would put it, and make the outdoors a central element of their designs. Take, for example, the project on the cover of this book: the Coromandel Beach House, a weekend house on the Coromandel Peninsula designed by Auckland architect Ken Crosson for his own family (pages 46–53). Set in a clearing of native tea trees on a grassy ridge overlooking the sea, Crosson's house is a visually simple wooden box with giant flaps on either side that fold

Herbst Bach, Great Barrier Island, New Zealand. Lance Herbst Architects.

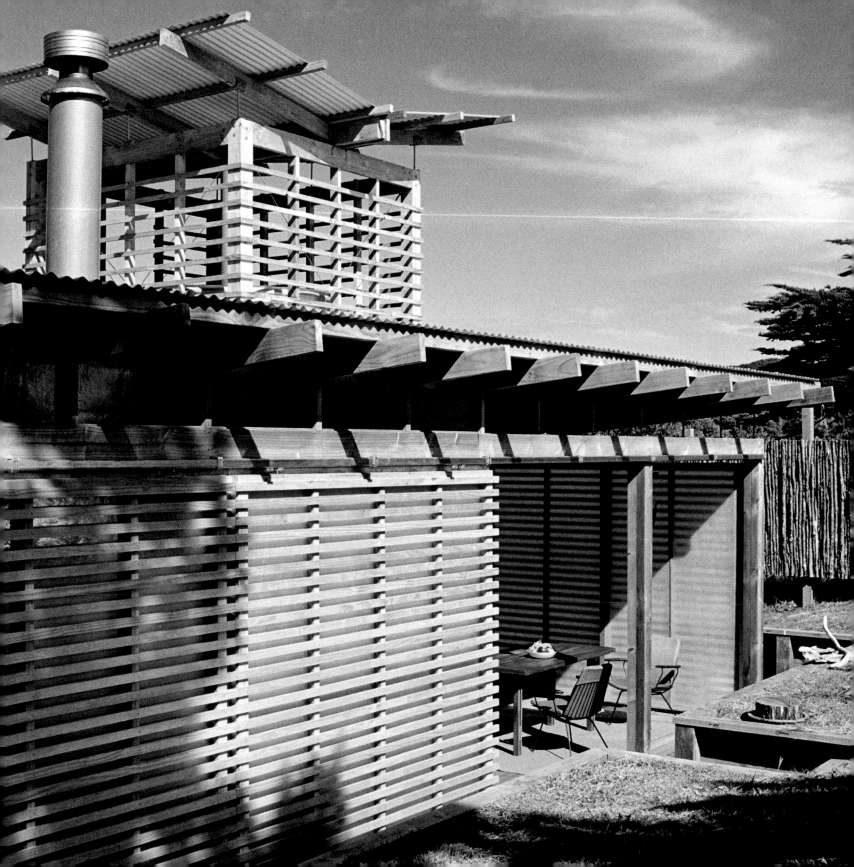

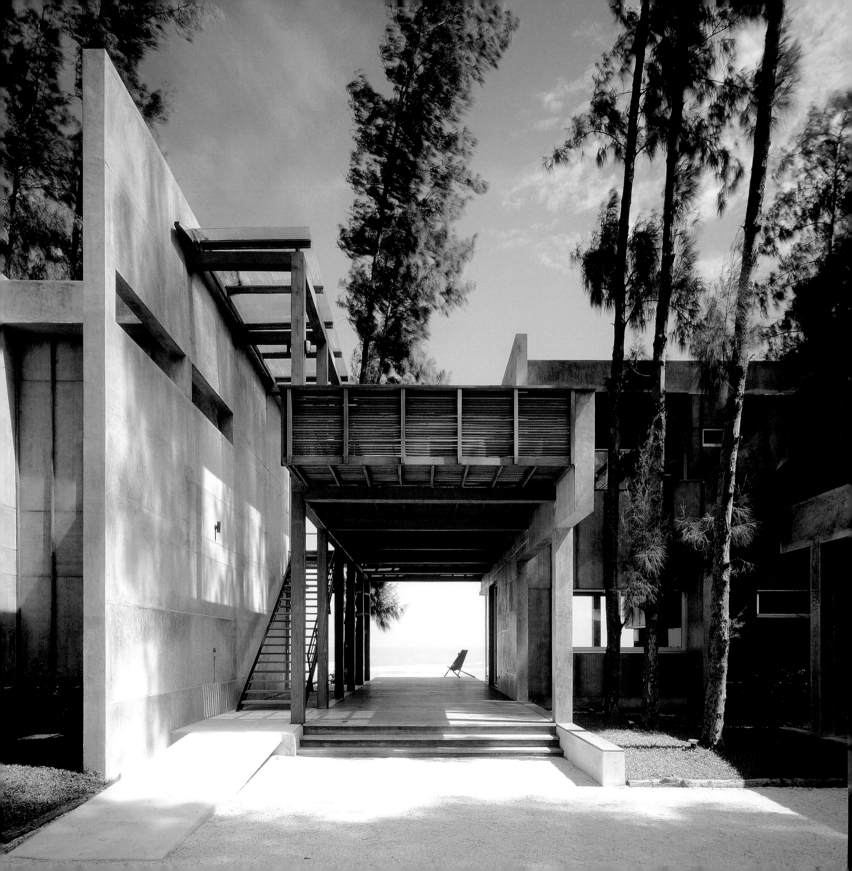

down, like drawbridges, to reveal sliding glass doors. When these slide open, nature flows unimpeded through the heart of the house. Two projects by young hotshot Auckland architects Fearon Hay put a more polished spin on houses that open themselves completely to the outdoors. Both their Shark Alley House on Great Barrier Island (pages 132–39) and the Bay of Islands House in Rawhiti (pages 30–37) feel like almost imperceptible pavilions.

These houses continue the great New Zealand tradition of the "bach" (short for "bachelor"), a term that arose in the early twentieth century to refer to simple, rustic cottages or cabins used by young men (presumably bachelors) out in the country for a weekend hike or hunt. Usually modest and sometimes made of inexpensive or even recycled materials, baches came to symbolize New Zealanders' practicality and informality when it came to taking a holiday. Now New Zealanders use the term "bach" to refer to any weekend or holiday home, few of which are as rustic or ad hoc as their early predecessors. Although they evolved over time into more sophisticated dwellings, baches never lost the informality and ease of living that were central to their conception. More polished baches such as Crosson's or the architect Lance Herbst's own retreat on Great Barrier Island (page 15) still have a certain simplicity despite their architectural finesse. The Auckland architect André Hodgskin is taking the concept of the bach a step further by making it more affordable. He designed the "bach kit," a prefabricated holiday home that can be built in roughly nine weeks. A bach kit prototype on Waiheke Island outside Auckland (following pages) showed prospective homebuyers the breezy sophistication of Hodgskin's contemporary take on the classic Kiwi retreat.

The houses in Pacific Modern share a kindred modern spirit despite the great geographic distances they cover and the variety of cultural and architectural traditions they interpret. In general, these houses are sophisticated but relaxed, polished but resolutely unfussy. They capture the boundless sense of openness and optimism that extends up and down the western shores of the great Pacific Ocean.

1 *Sydney Morning Herald*, January 31, 2005.
2 *Vogue Living Australia*, January/February 2005.

left
P-Cube House, Naresuan Beach, Thailand. Spacetime Architects.
following pages
Bach Kit prefab prototype, Waiheke Island, New Zealand. André Hodgskin, Architects.

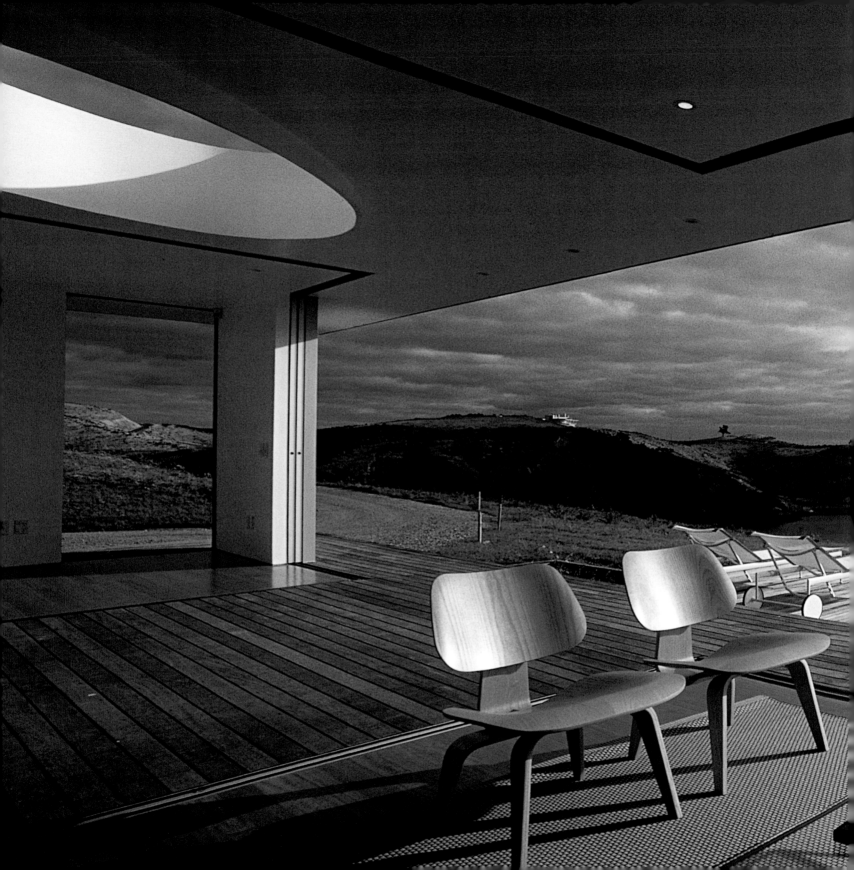

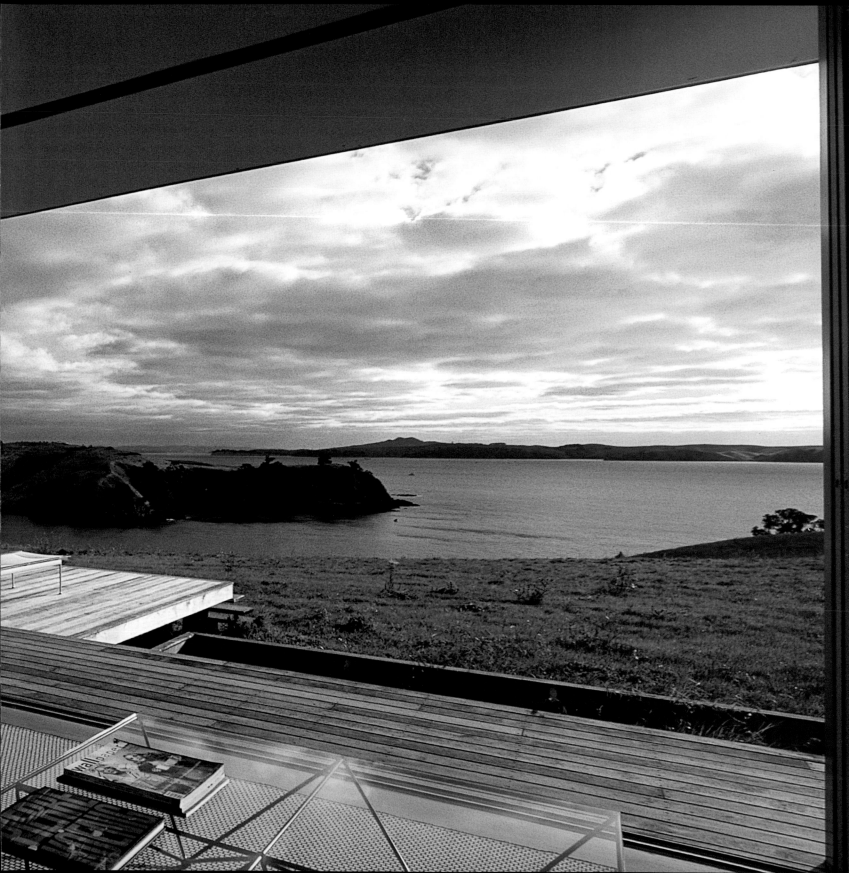

Projects

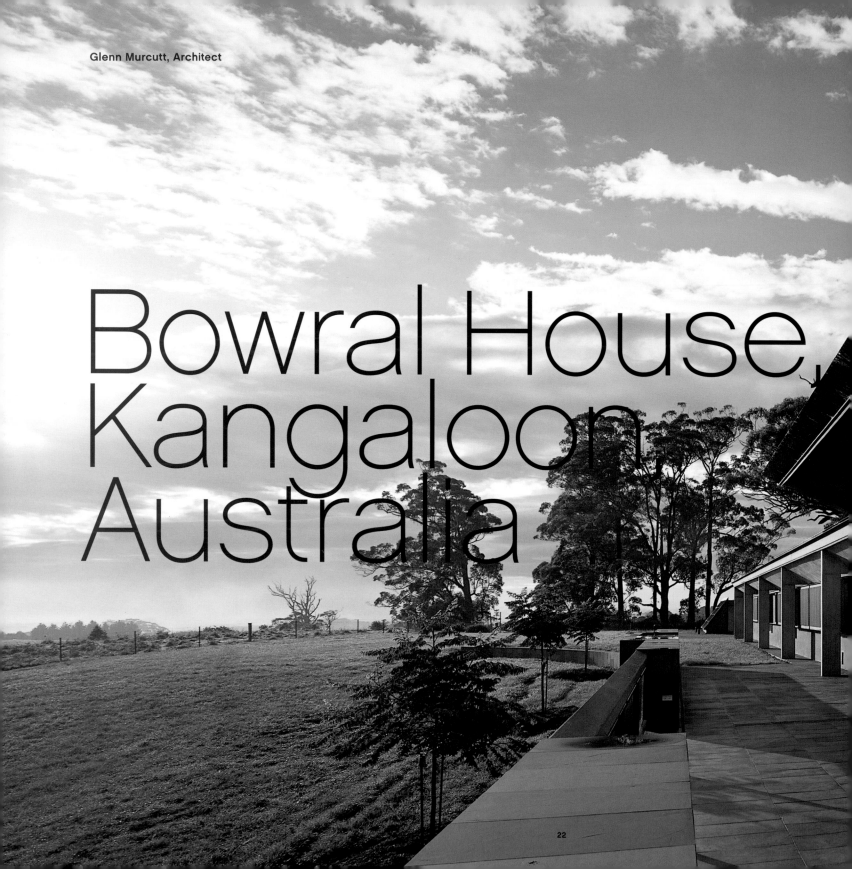

Glenn Murcutt, Architect

Bowral House, Kangaloon Australia

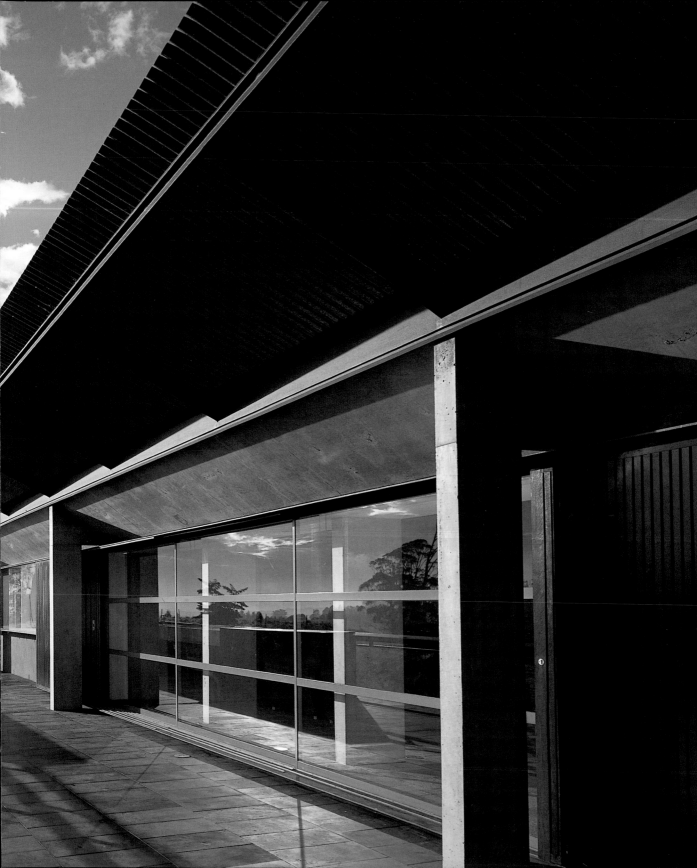

Glenn Murcutt, Australia's only Pritzker laureate, creates masterful modernist buildings whose sublime beauty is all the more compelling because it comes from a sensitive reading of landscape, environmental conditions, and traditional building types. Heeding the philosophy of Australia's native Aboriginals, Murcutt's buildings "touch this earth lightly," yet they are very much integrated into their surroundings. In Kangaloon, in the Southern Highlands of New South Wales, the architect designed a house whose distinctive gabled shed profile strikes a harmonious chord with its rural landscape and, at a practical level, deflects the cold southern winds as they blow across the site.

The single-story house sits on a grassy, gently rolling hillside. The plan is quite simple: a long, narrow bar with a vaulted hallway on the south flank, extending the full length of the house. One enters past the garage and along a walkway shielded from the wind by a curving wall of corrugated steel. Inside the glazed front door the flattened curve of the exterior windbreak continues along the entire length of the house with the hallway's solid white wall, which is washed in daylight through north-facing clerestory windows.

All of the rooms—three bedrooms with two shared baths, an open kitchen-dining-living area, and additional bedrooms with two full baths—open onto the sculptural, light-filled hallway to the south. Windows face the bright northern exposure. Tapered blade-shaped concrete piers between each room support an angled roof with funnel-shaped scuppers that collect rainwater at either end. The living spaces also open onto an elevated stone-covered terrace, shaded by a roof overhang, with steps leading down to the hillside. Slatted timber screens mounted on the exterior of the house on tracks along the top and bottom slide closed to shade windows in each room.

Inside, the crisp gabled roof that gives the house its distinct profile creates lofty rooms with the vague feeling of a barn or agricultural shed. Murcutt's crisp detailing renders them polished and sophisticated spaces, like a countrified loft. The architect placed ventilation grilles along the joints between the angled ceiling planes, highlighting the particular geometry. On the exterior, the house's quality of both the familiar and traditional—barnlike but pristine and modern—captures Murcutt's distinctive sensibility.

There's a great logic and economy to Murcutt's plan, with its functional bathroom and kitchen cores dividing spaces along the narrow length of the boxy house. And although the house's distinctive features, including its sharp gabled profile and its sweeping angular roofs and walls, seem sculptural, they also derive from a clear logic about the house's relationship to its environment. The house is solid and closed where it needs to be (on the colder, windier south side) and open and permeable where it's best suited (on the warmer, sunny north side). As with most of Murcutt's buildings, there's a sense that the house indeed touches the earth lightly but makes a strong impression—and strong architecture.

previous spread
The living spaces open on to a sunny north-facing terrace through sliding glass doors shaded by retractable wood screens.
following spread
A curving wall of corrugated steel provides shelter from the wind as it edges the walkway to the front door (right). The curved profile, which extends through the house as a long hallway, echoes the gabled roof that gives the house its distinctive modern-yet-traditional profile.
pages 28–29
Inside, the gabled roof crowns a lofty open kitchen and dining room toward the center of the bar-shaped house.

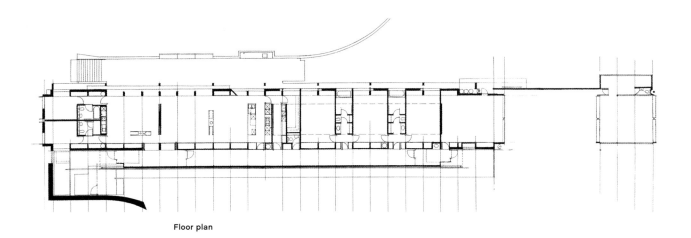

Floor plan

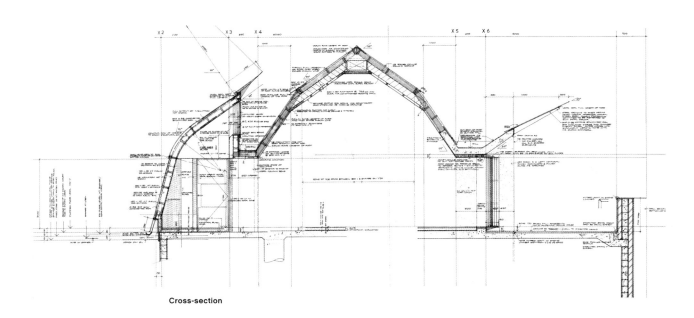

Cross-section

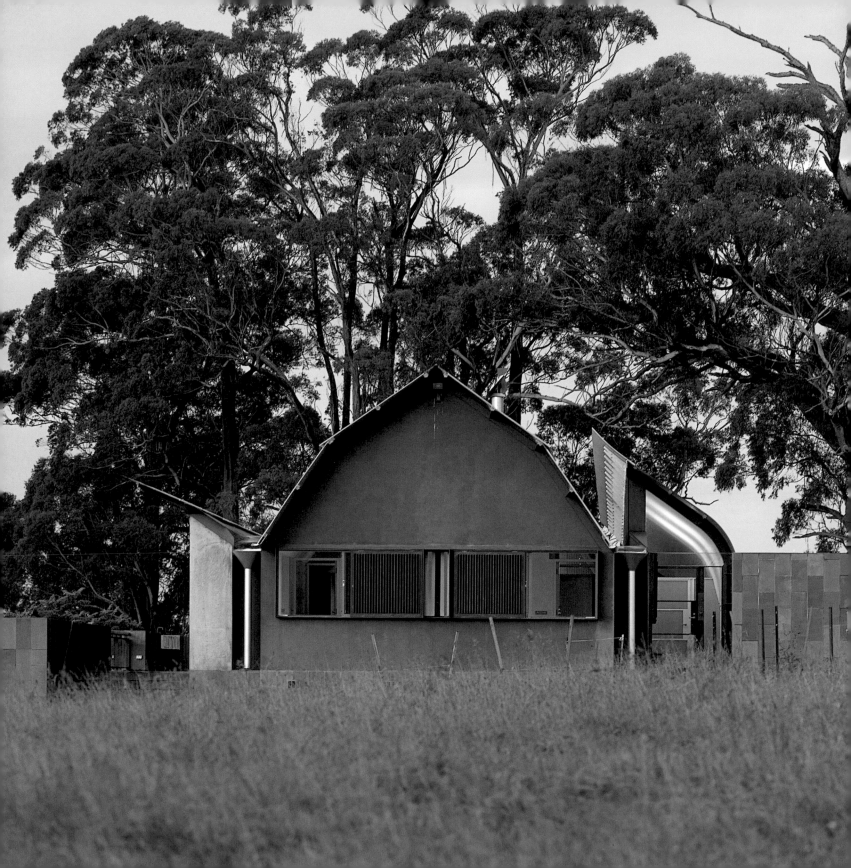

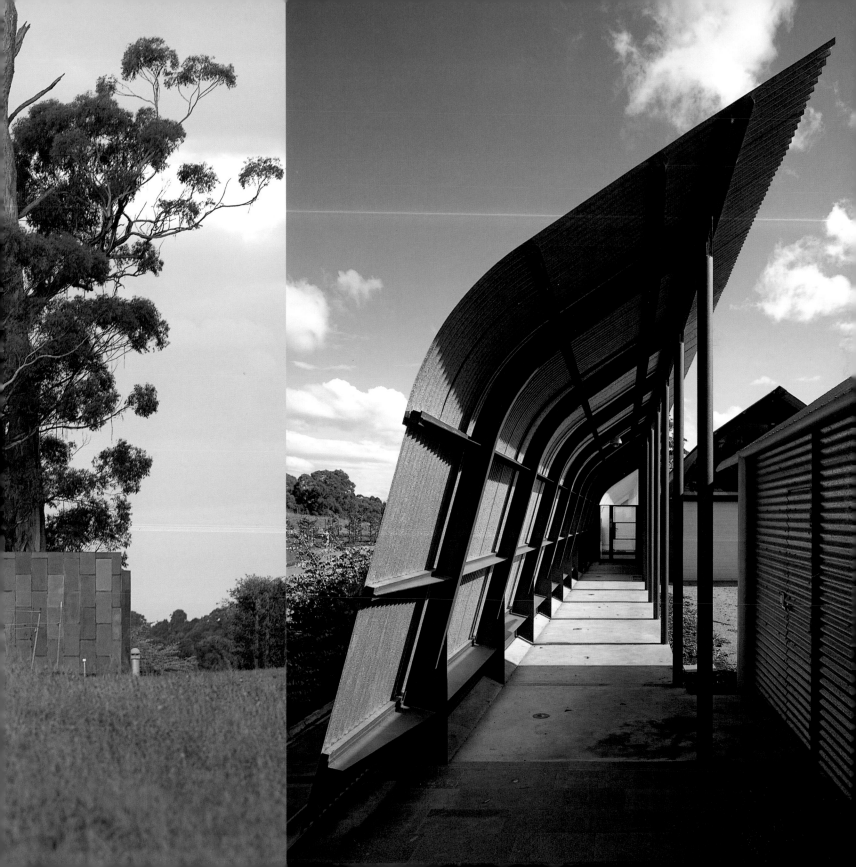

Bay of Islands House, Rawhiti, New Zealand

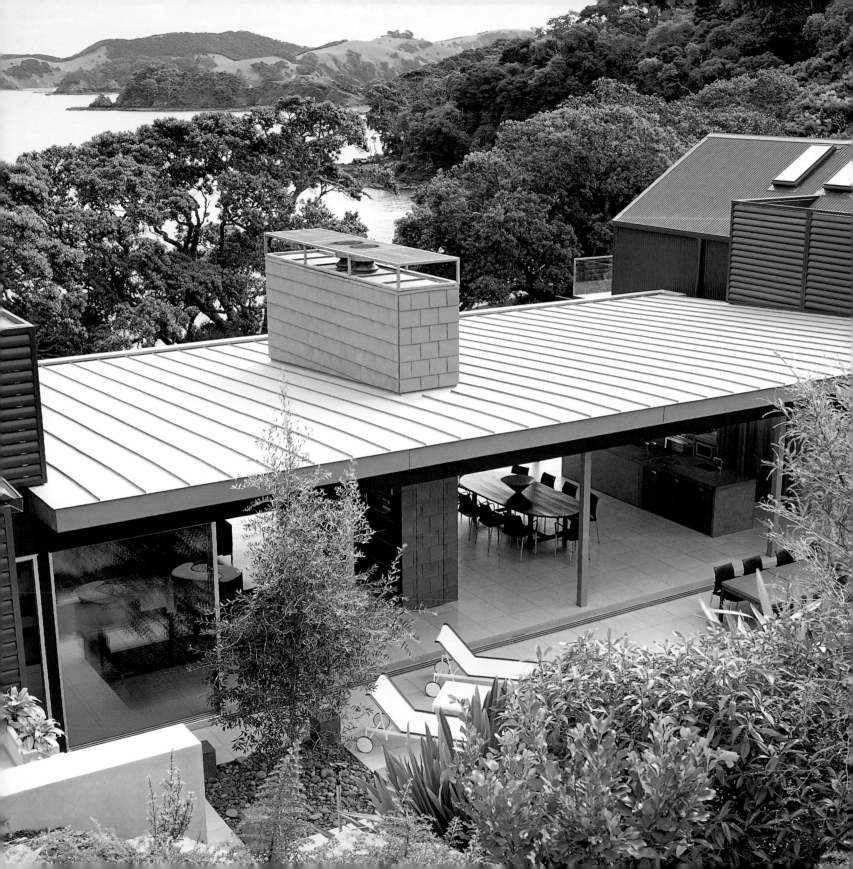

As its name suggests, the Bay of Islands off New Zealand's Northland Peninsula is a crystalline blue body of water dotted with more than a hundred lushly forested islands. These mountainous islets, ringed with white sandy coves and clear blue water, are a temperate version of the Caribbean and its tiny jewel-like islands. Overlooking the bay is the scenic Rawhiti Peninsula, where Auckland architects Jeff Fearon and Tim Hay turned a pair of existing gabled sheds into bookends to a sleek modernist pleasure pavilion that's the heart of an easygoing modernist house by the sea.

Fearon and Hay's clients, a large family, purchased the beachfront property with two existing boat sheds spaced 65 feet apart on a site sloping down to the water. They wanted to expand the existing structures to accommodate five bedrooms, each with its own bath, as well as an informal bunk room, open-plan living areas, storage for bulky boating and diving equipment, and plenty of outdoor space. Fearon and Hay reused the original buildings. They renovated the gabled structures into bedrooms and connected them with a new glass pavilion containing the living and entertaining spaces.

The architects re-skinned the gabled sheds in corrugated aluminum, with metal louvers shading large expanses of glass overlooking the water. They placed the loftlike living, dining, and kitchen spaces in the long, narrow bar connecting them, which frames an outdoor courtyard bound by a landscaped retaining wall along the hillside. A broad terrace, partially shaded by the deep overhang of the flat roof and covered in the same terrazzo pavers that cover the interior, overlooks a simple lawn and the sea to the west.

As in their Shark Alley House on another panoramic waterfront (pages 132–39), Fearon and Hay treated the long pavilion as a giant verandah that can open itself completely to the elements. They sheathed the living wing with large aluminum-framed, commercial-grade glass doors that span floor-to-ceiling; when they slide open, the external walls dissolve to bring the outdoors inside. In the Rawhiti house, the effect is even more dramatic because of the towering scale of the rooms within the sleek Miesian structure, a flat concrete roof resting atop slender zinc-finished steel columns.

The long, narrow bar is not broken down into properly defined rooms, but towering walls floating within the flat ceiling spaces suggest clear divisions. A thick zinc-clad wall containing the fireplace separates the living room from the dining area. A tall counter marks the boundary between the open dining area and the kitchen, whose storage and appliances are sheltered within walls of native New Zealand Tawa wood. (Fearon and Hay used the same flooring on the upper levels of the renovated sleeping wings.) All of the interior spaces open onto both the terrace and the internal courtyard, where open-air entertaining could be moved if bad weather forces the glass doors to be closed. With their signature restraint and sense of minimalist cool, Fearon and Hay created an elegant house that distills waterfront living to the bare essentials.

previous page
The living spaces create a permeable buffer between a sheltered courtyard and open views of the scenic Bay of Islands.
following spread
Sliding doors retract to open the loftlike living and dining areas, housed in a sleek glass pavilion bookended by reconfigured gabled sheds containing bedrooms, to terraces on both sides of the long, narrow addition.
pages 36–37
A stone fireplace separates the open kitchen and dining area from the living room. Both spaces open onto a paved terrace overlooking the bay.

Upper-floor plan

Ground-floor plan

Longitudinal section

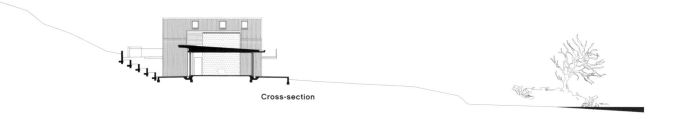

Cross-section

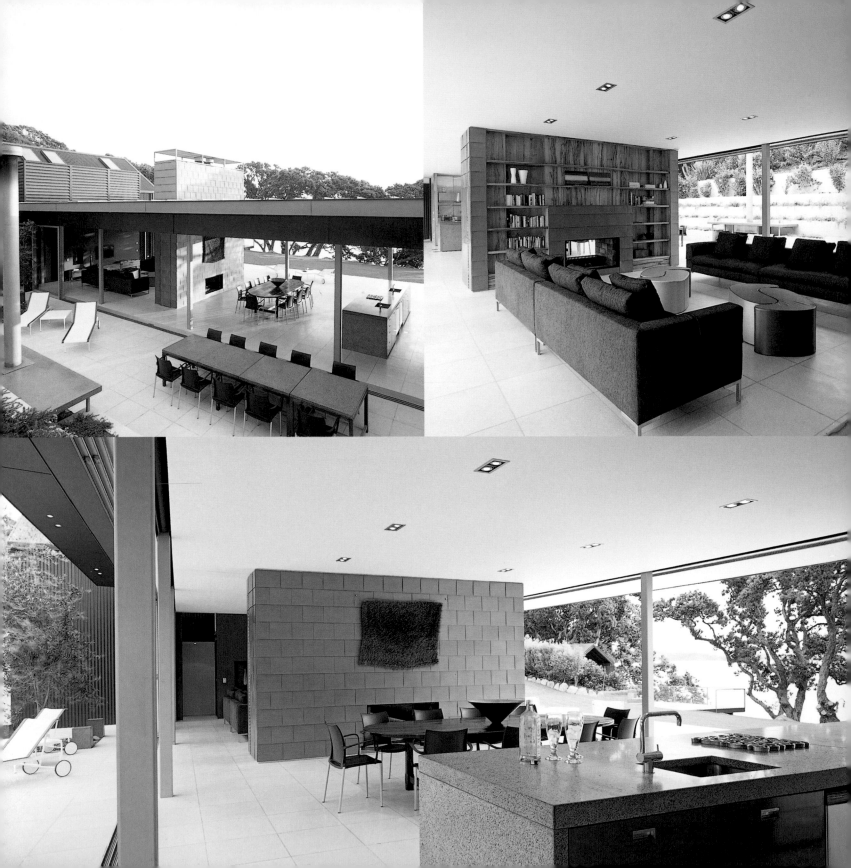

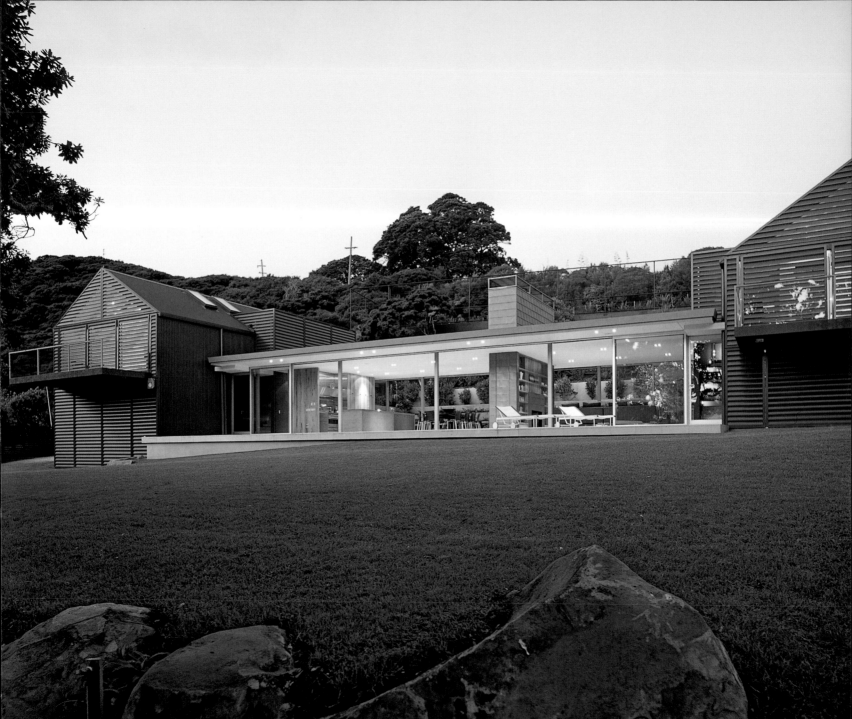

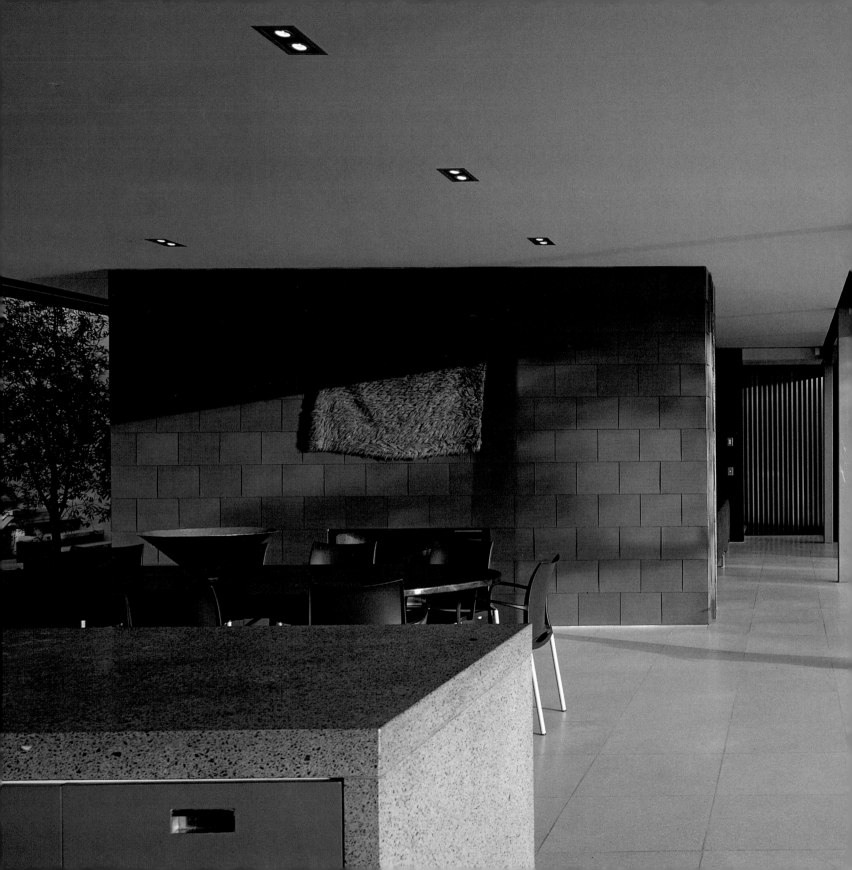

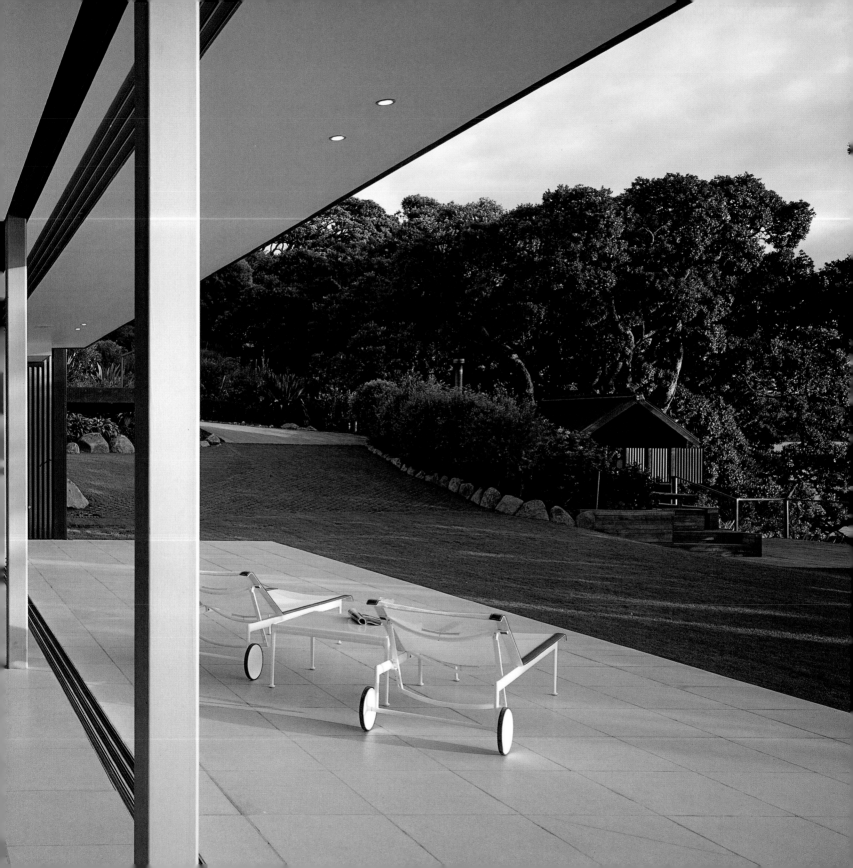

Vineyard House, Mornington Peninsula, Australia

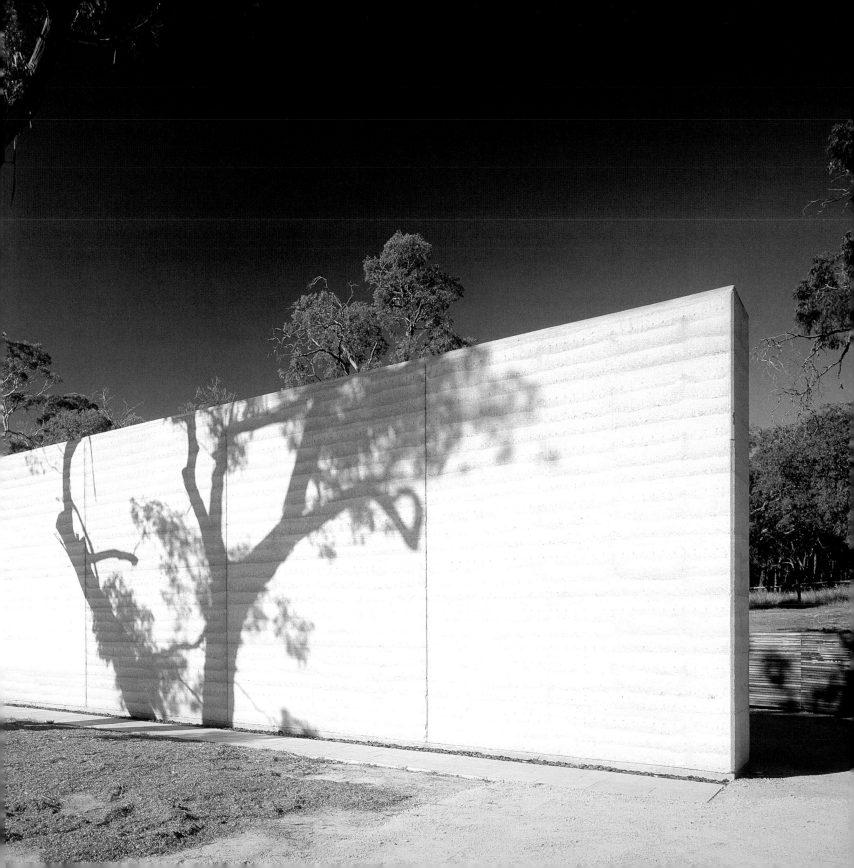

The Mornington Peninsula, not far from Melbourne's urban bustle, curves out toward the Bass Strait with a lush green arc of laid-back communities along the wild expanses of beachfront and working vineyards and wineries. The region's climate resembles that of Burgundy, so familiar French varietals such as chardonnay and pinot noir grapes thrive. On farmland adjoining a 65-acre vineyard, Melbourne architect John Wardle designed a homestead that puts a refined modern spin on the rural vernacular buildings of this largely unspoiled swath of Australia.

Wardle's design borrows a page from viticulture techniques, translating the visual of a new vine grafted onto an old root stock into architecture. On a large scale, Wardle organized the house into two branching volumes: the "root stock" containing the main living spaces and the "cultivar," or new transplant, which contains the bedroom wing in a curving volume grafted onto the back side of the house. As if to reinforce the analogy, Wardle terminated the bedroom wing with an angled wall of floor-to-ceiling glass, resembling a stem expertly clipped with a sharp knife. The public spaces align with the orderly, repetitive lines of the vines in the distance, while the bedroom wing curves back to the less orderly landscape of gum and stringy bark trees.

Wardle repeated the vine-cutting analogy in a row of ironwood posts composing a pergola that defines an open verandah along the entry facade. He notched the upper parts of the posts, made of rough-sawn, untreated wood that has faded to a silvery gray, with angular cuts and joined them into bases of polished and preserved wood that have retained their reddish glow. The pergola also lines up with the rows of vine plantings.

Wardle gave the house a solid but clean-lined quality with massive walls of rammed earth that contrast with huge expanses of glass, especially along the towering, lofty living-dining room. Here, huge sliding glass doors open onto the consummately Australian verandah and views of the rolling green hills and the vineyards' repetitive lines. An angled roof rising up to the wall of windows further draws the views out from the house. Throughout the house great open expanses of glass, sometimes shaded from troublesome sun exposures by screen walls of rough timbers, open rooms to the landscape. The large angled wall of the master bedroom, for instance, poetically frames a robust, weathered eucalyptus tree.

Although exceedingly crisp and modern, the house exudes warmth. Its palette combines polished industrial elements (painted bent steel and plywood) that contrast with warm natural materials: the golden rammed-earth walls, walls and ceilings of tawny Tasmanian sassafras wood, cabinetry made of distressed Victorian ash, honed granite from local quarries, and green slate from India. In the wall containing the highly sculptural fireplace, Wardle combined rammed earth, brick, steel, and stone into a materially dense composition. These elements echo the rich colors of the Mornington landscape, while Wardle's architecture defines a modern take on the venerable old farmhouse.

previous spread
A weathered tree casts a shadow on a wall of rammed earth enclosing the garage and guest bedrooms. A pergola of ironwood posts framing a sweeping verandah aligns with rows of vines on the property.
right and far right
A slatted timber screen next to the front door partially shades a glass wall in the dining room.
following pages
A slatted wood bench in a window nook (left page) seems to pierce the glass and extend outside the house. An angled glass wall in the bedroom overlooks the Mornington Peninsula landscape.

pages 44–45
The lofty living-dining room, overlooking the vineyard beyond an outdoor verandah, exudes warmth with tawny walls and ceilings of Tasmanian sassafras wood, built-in cabinets of distressed ash, local granite, and green slate from India.

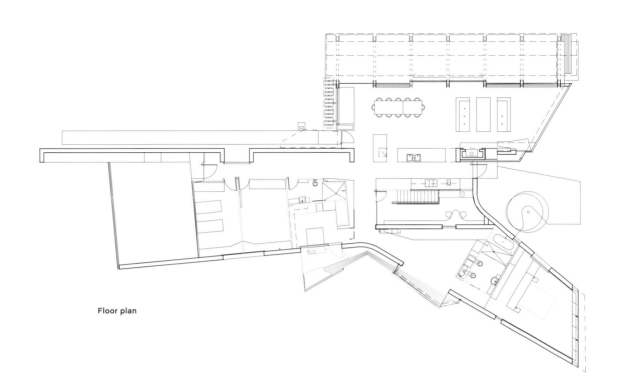

Floor plan

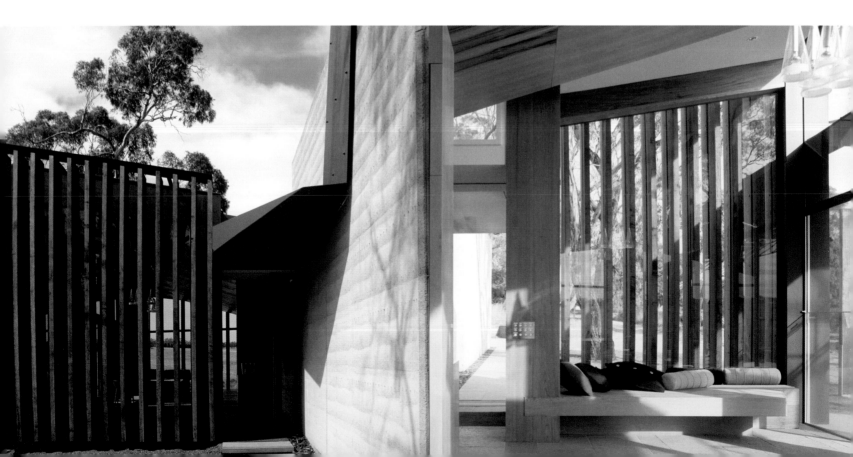

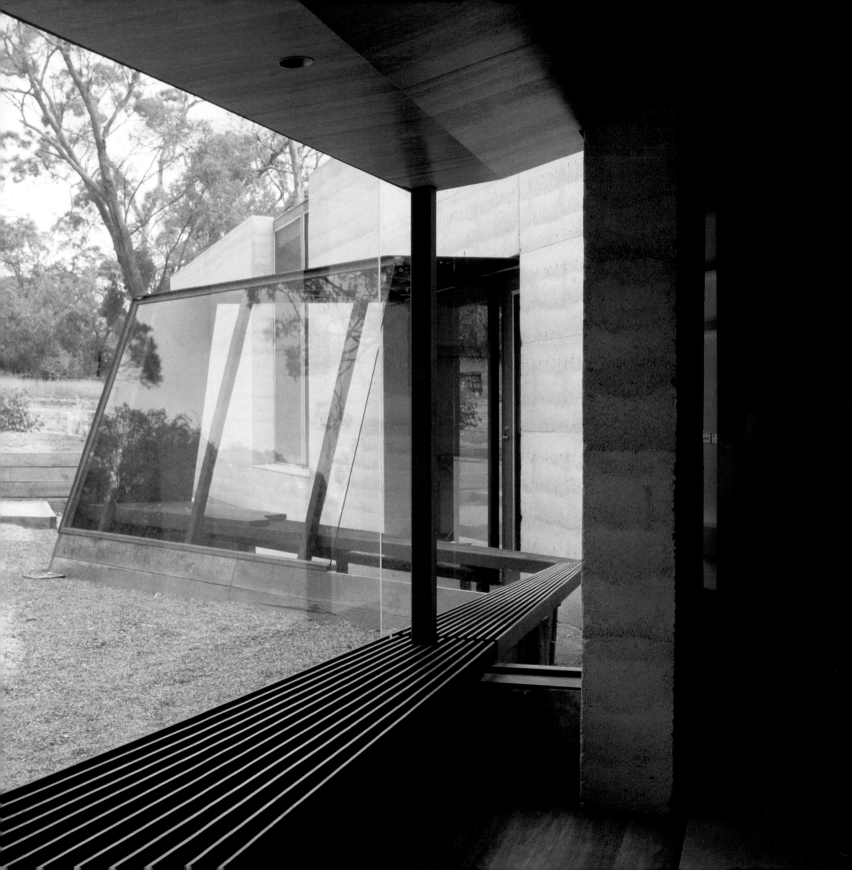

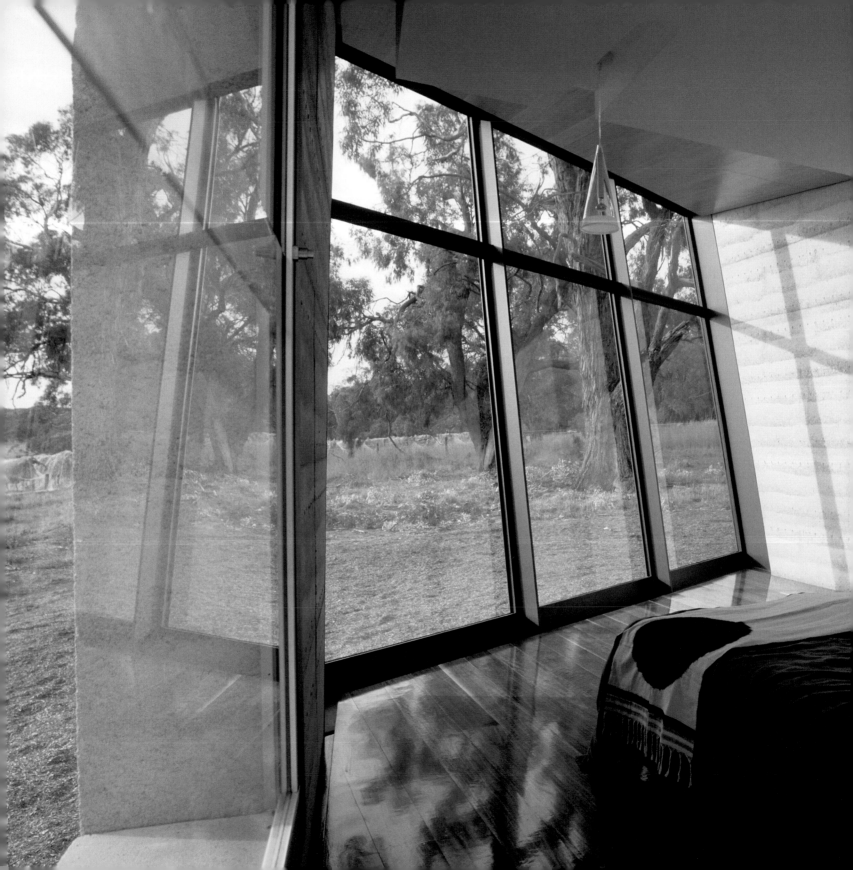

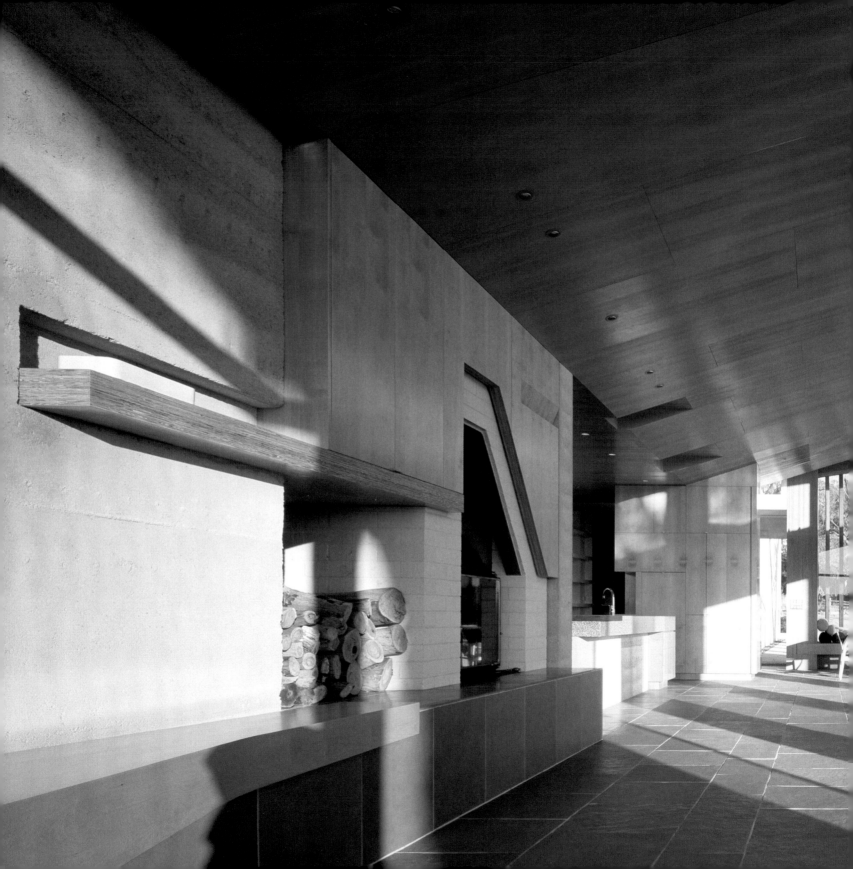

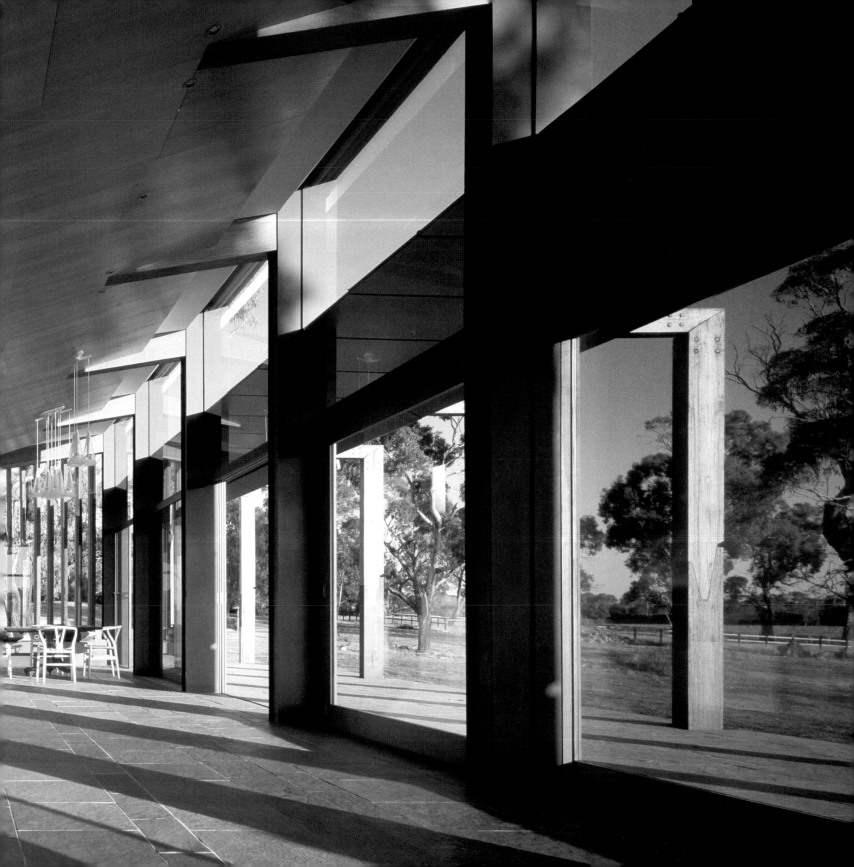

Coromandel Beach House, Coromandel Peninsula, New Zealand

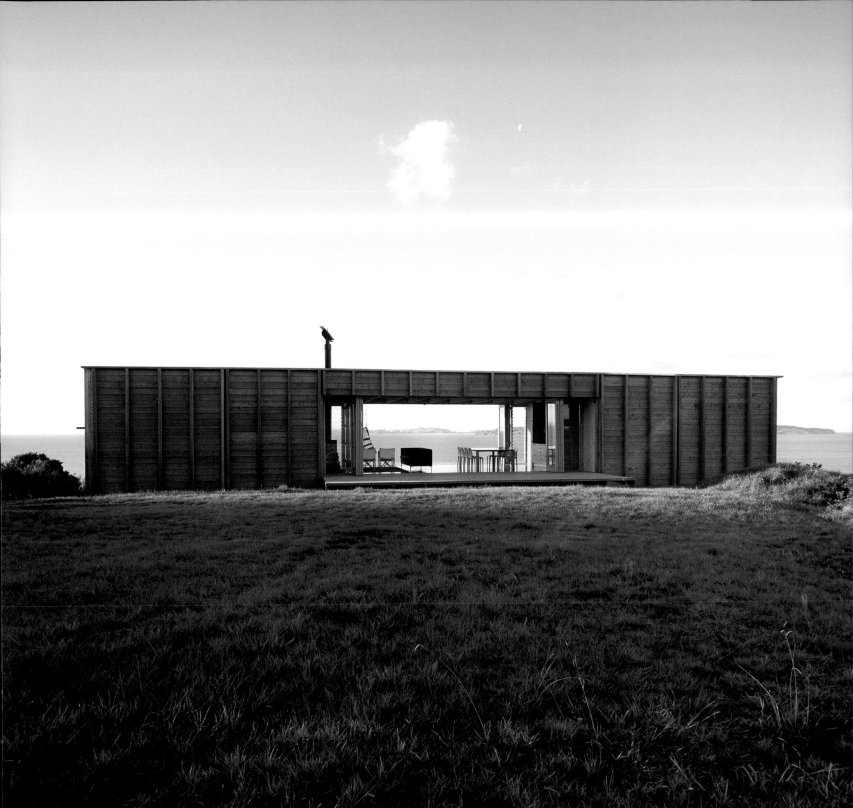

Maintaining a weekend beach house always raises the question of how to keep it safely shuttered during the week when no one is home. Auckland architect Ken Crosson solved the problem simply and dramatically. The weekend house he built for his family on the Coromandel Peninsula, across the Hauraki Gulf from Auckland, stays completely shuttered, like a long wooden box or a suitcase, as the architect suggests, while the family is back in the city. When they return, Crosson cranks an electric winch to lower two huge sections on opposite sides of the facade. The timber sections fold down, like drawbridges, to reveal another layer of folding glass doors—and a breathtaking ocean view through the middle of the house. (The unfolded facade panels become wooden decks on either side of the loftlike living-dining room.) The New Zealand Institute of Architects recognized Crosson's ingenious, clean-lined house naming the project the country's best residential design in 2004.

Crosson's house sits squarely on a grassy ridge, in a clearing of native manuka, or tea trees. The architect, principal of Crosson Clarke Architects (now Crosson Clarke Carnachan Architects), wanted to create a simple, rustic retreat that put his family back in touch with the quintessential New Zealand landscape. So he kept the materials simple and unfussy. On the outside he clad the long rectangular box with horizontal boards of cypress spanning between solid eucalyptus battens. Inside he left pine beams and rafters exposed and clad the walls, floors, and kitchen cabinetry in warm pine plywood. Although slightly rustic, the carefully detailed plywood surfaces give the interior the feeling of a giant piece of furniture. The exterior has already started to fade an even shade of silvery gray and will continue to weather as sun and salt air bleach the cypress cladding; inside, the polished plywood interior will retain its tawny glow.

The heart of the house is the lofty living-dining room and open kitchen, framed like a giant proscenium arch by the monumental facade flaps. The metaphor is apt, given the dramatic vista of the seaside cliffs and the deep blue sea framed by these massive doors. Even when the weather cools and the family needs to warm up by the fireplace, wood-framed glass doors maintain the view.

The entry-side facades of the bedroom and bathroom wings on opposite ends of the central living space are clad in solid timber, but on the oceanfront side they open up to the view with rolling glass doors. (Solid wood shutters close down over the glazed expanses when the family heads home to Auckland.) Crosson made the bathrooms, which can be accessed directly from the outdoors, very beach-friendly with removable slatted-wood floor panels over steel trays in the shower area, so water and sand are easily drained. In warm weather bathtubs on casters can be rolled out onto the deck for an alfresco soak; in any season, expanses of louvered-glass windows make every shower feel like an open-air shower. These simple details add up to a spectacular but low-maintenance beach house that's remarkable for its dramatic views as well as its practicality.

previous page
Architect Ken Crosson's rustic weekend house perches on a cliff overlooking New Zealand's Hauraki Gulf. When the family returns to Auckland, large sections of the wood-batten facade fold up, like a drawbridge, to shutter the house.
right
When the family is in residence, the center section of the wooden box folds down to reveal retractable glass doors that open up the living areas to the view.

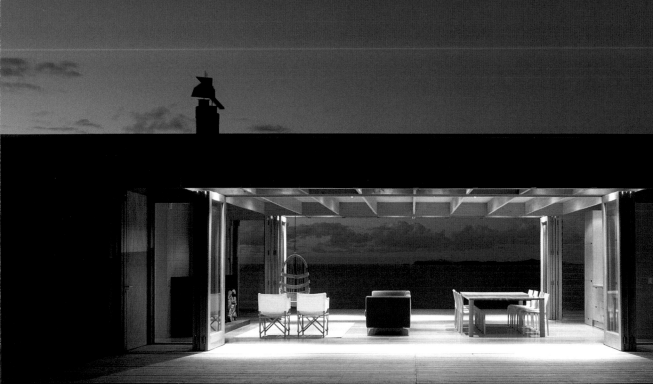

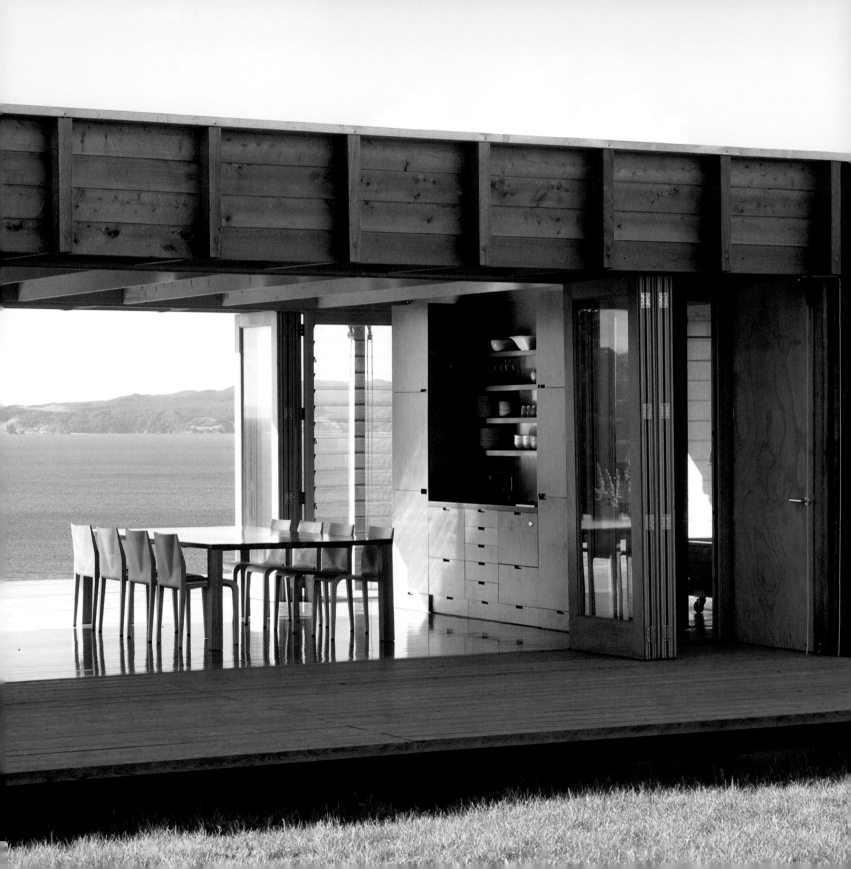

Site plan

left
The retractable exterior, built of cypress slats and solid eucalyptus battens, folds down to create decks on either side of the lofty living-dining room (see cross-section, below right). Wood-framed glass doors retract to create a dramatically scaled opening.

following spread
The interior of the simple, loftlike house features exposed pine beams and pine plywood in the living-dining room (left) and bathroom (right).

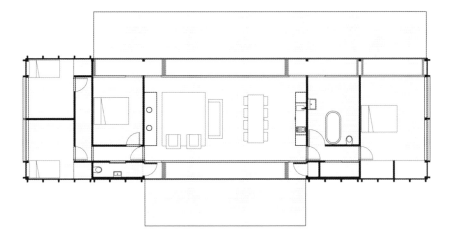

Floor plan

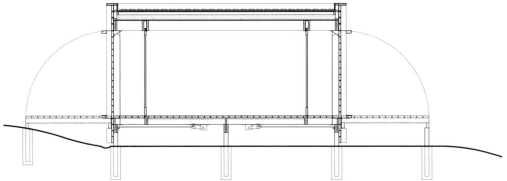

Cross-section

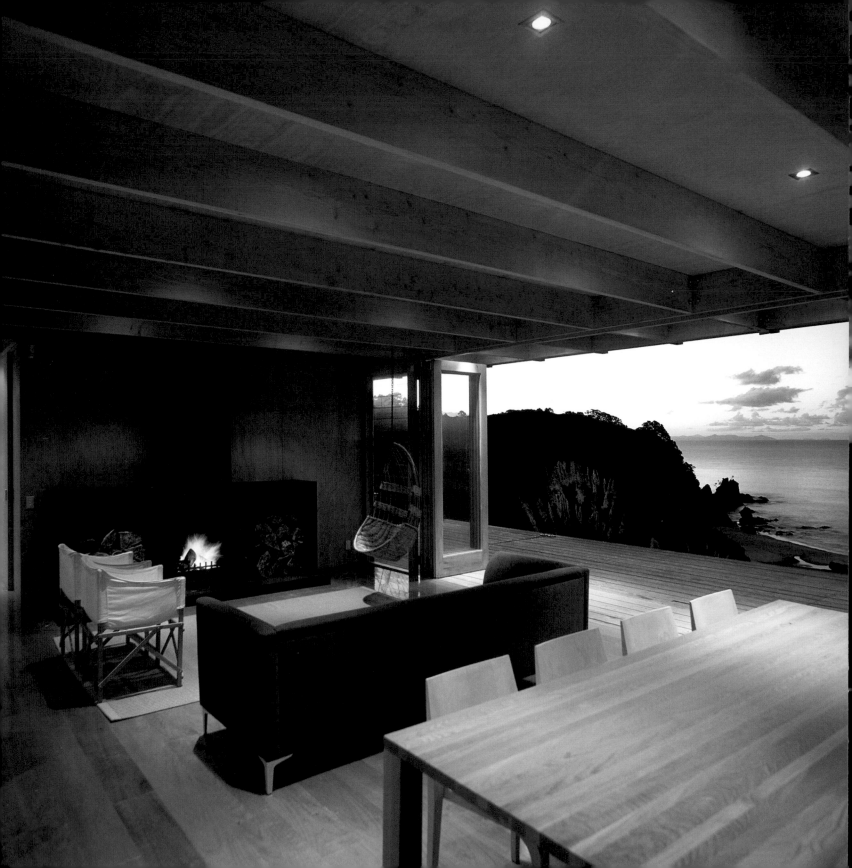

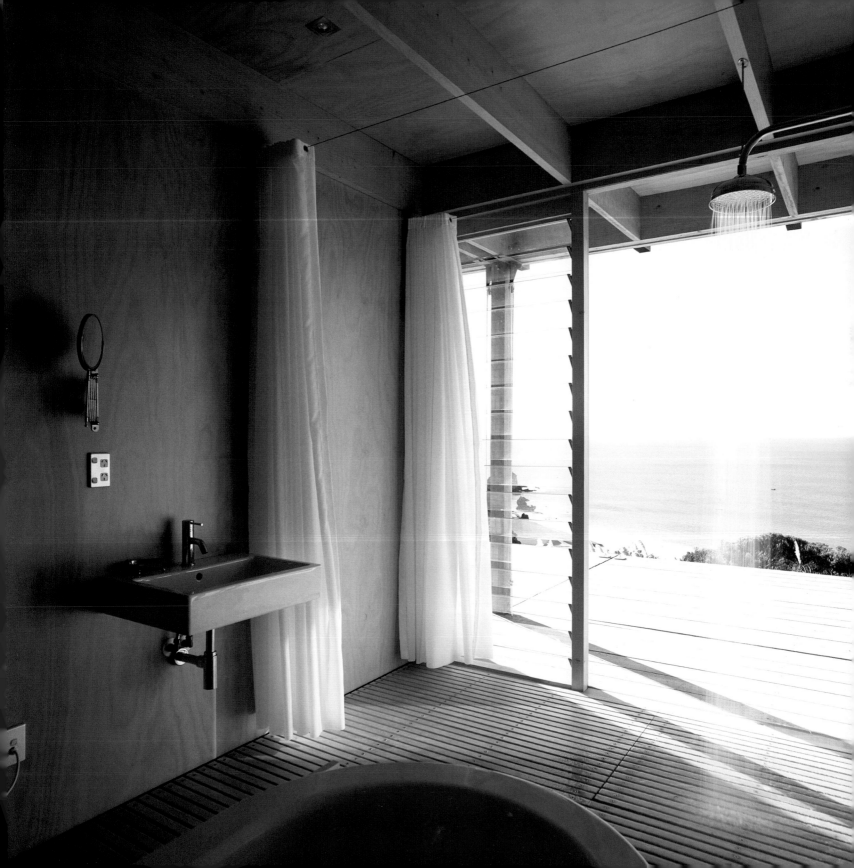

Bartlett/ Pennington House, Sydney, Australia

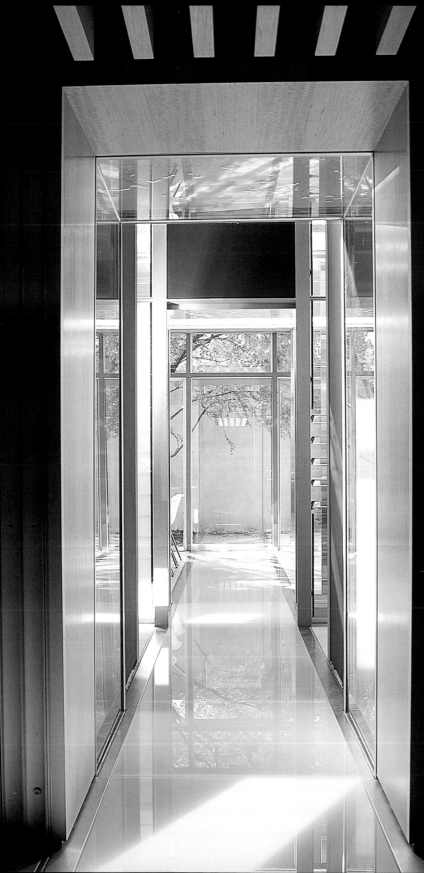

Besides its unparalleled waterfront setting, with seemingly endless coves and inlets culminating in the postcard panorama of the opera house and Harbor Bridge, one of Sydney's greatest urban assets is its charming Victorian fabric. From the terraced housing of Paddington and Potts Point to the grander houses of Woolhara and beyond, the city's streets exude the nineteenth-century architectural charm of London by way of San Francisco and New Orleans. But these nineteenth-century treasures can seem completely wrong for Sydney's mild, sunny climate and lush semitropical vegetation: dark, cramped houses completely detached from outdoor life.

Architect Iain Halliday of the in-demand Sydney firm Burley Katon Halliday remedied the short-comings of one such nineteenth-century house, a Georgian worker's cottage in one of the city's well-off suburbs. Halliday demolished the entire back of the house, a composite of rooms added onto the original gabled sandstone structure through the years, keeping a pair of formal rooms symmetrically arranged on either side of an axial hall at the front of the house.

Halliday capitalized on the inherent coziness of these spaces behind the thick stone walls: One became the bedroom, the other a private study. Picking up on the warm tones of the sandstone exterior, the designer covered the floors, walls, and ceilings with silver ash and added sliding wood doors along the central hall that resemble Japanese shoji screens. He also added new wood-framed glass doors opposite the original street-front windows, with wooden screens that can be drawn from wall pockets for privacy.

Behind the sumptuous private quarters, Halliday created an entirely new—decidedly more hard-nosed modernist—realm. He squeezed two additional pavilions into the tight 30-by-50-foot lot, one containing the kitchen and bathroom and the other, living and dining spaces. The structures are separated by a narrow moat that winds around the kitchen block. At the very back of the site a private garden, screened off from neighbors by tall concrete walls, faces north to catch the Southern Hemisphere's brightest sun.

The materials of each mini-structure also highlight their distinct character: The walls of the 16-foot-tall kitchen that face the original stone house are clad in stainless steel; the side facing the living-dining area, a transparent box wrapped in large sliding glass doors, is clad floor-to-ceiling in glass louvers. This lofty, elegant living and dining room opens onto the walled-in garden to create an indoor-outdoor room, or a sophisticated urban version of the great Australian verandah.

While the narrow moat is meant to distinguish the three mini-pavilions woven together to create this sensuous urban house, a carpet of light unifies them. At times a "carpet," at others a bridge, this strip of glass extends the entire length of the site. The house takes on a dramatic play of light and shadow at night, when the floor is uplit and reflections on the various transparent and reflective surfaces confuse and confound the boundaries between inside and out.

Halliday packed a lot, functionally and experientially, into a tight urban site. He kept the best features of a traditional Australian dwelling and improved on it simply by lightening up and opening up to Sydney's inviting climate and brilliant light.

previous spread
The solid stone exterior of the Georgian cottage (left) contrasts with the sleek, luminous corridor (right) linking the renovated structure and a new addition at the rear.
following spread
The architects turned the once-cramped cottage into an office (left) and bedroom (right), both lined in warm wood. The glass hallway between the two rooms leads to a new pavilion with living spaces.
pages 60–61
The kitchen (left) occupies a new pavilion between the original stone house and a new glass-enclosed structure containing an open living-dining area (right) with a garden accessed by floor-to-ceiling sliding glass doors.

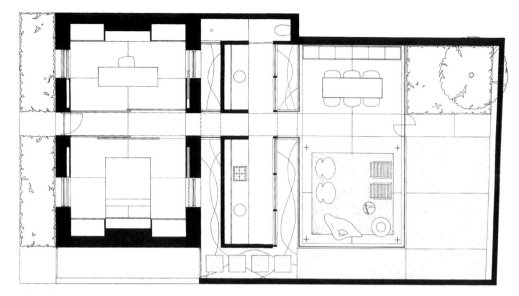

Floor plan

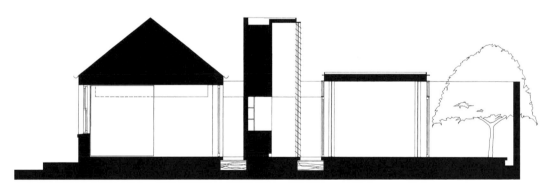

Longitudinal section

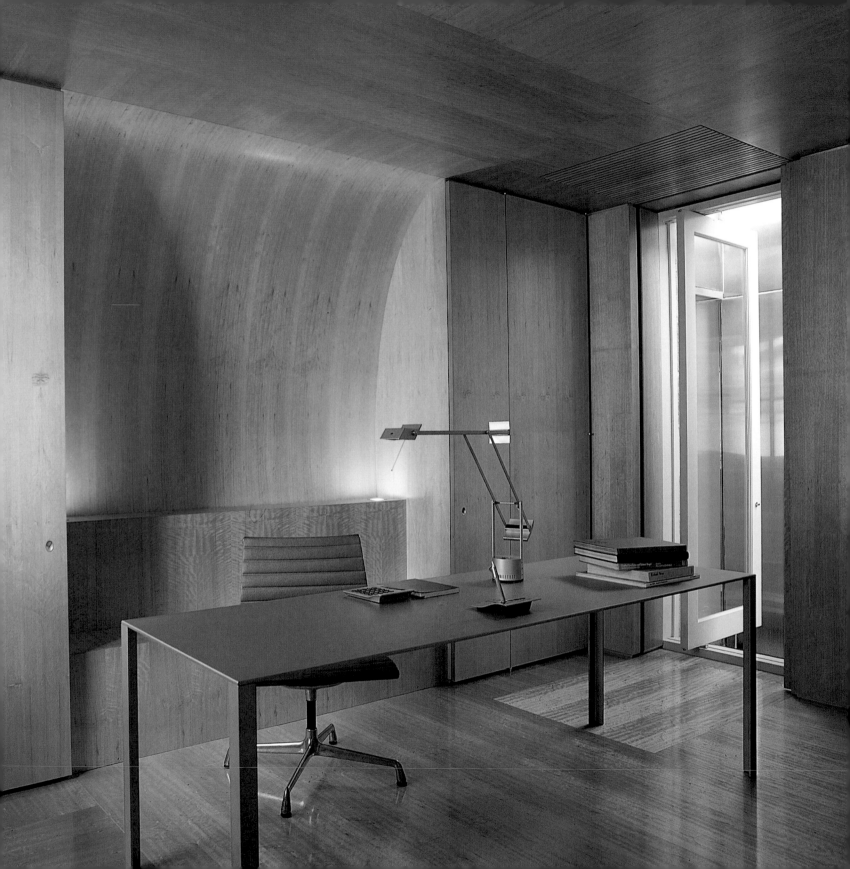

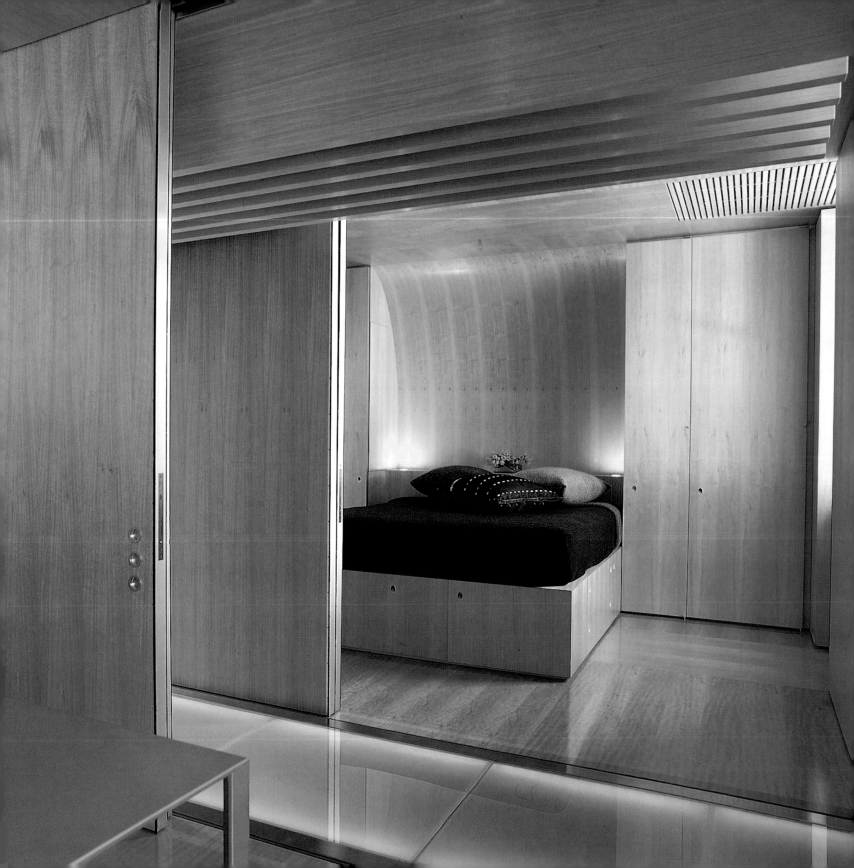

Hobson Bay House,

Auckland, New Zealand

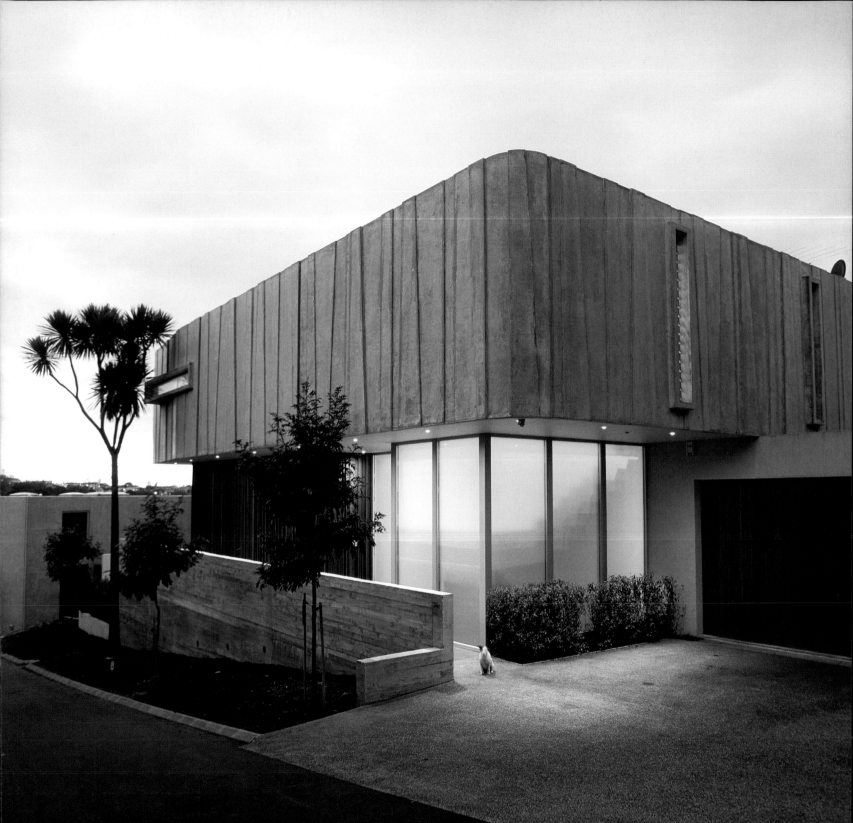

This compact house overlooking Hobson Bay, one of the dozens of picturesque inlets that ring Auckland, the boat-plied City of Sails, captures the best of two worlds. Along its suburban street front, the house appears opaque and private. But behind the sculptural wood, glass, and concrete facade, the house dissolves into an open, casual realm inspired by the Case Study houses that embodied the bright, optimistic modern spirit of mid-century southern California.

Auckland architects Nicholas Stevens and Gary Lawson designed the house to embrace panoramic views of the sailboat-filled bay, hillside neighborhoods, and Auckland skyline, dominated by the quirky needle-topped Sky Tower—but kept these a secret to the occupants of the house. The image passersby take away is of a highly detailed piece of sculpture. On the ground floor a wall of randomly sized, rough-sawn cedar battens creates the effect of a timber curtain drawn over a glass plinth. (The corner nearest the driveway and carport, veiled in translucent glass, conceals a sculptural wood staircase inside.) As if defying gravity, the pleated concrete box enclosing the second floor seems to float above the wooden scrim. A single window, a long horizontal slit, projects from the unevenly textured concrete box. The skin is actually composed of fiberglass-reinforced concrete sprayed onto wood panels and attached, like a curtain wall, to the house's steel structural frame.

Moving away from the street, both floors begin to dissolve visually: The pleated wood of the ground level starts to draw back, like theatrical curtains, to reveal floor-to-ceiling sliding glass doors. Upstairs more frequent vertical slit windows give way to glass facades. The biggest surprise comes in an open-air deck, where the architects cut back the corners of the facade to create an outdoor room defined by a corner column and a rhomboid cutout in the ceiling. From this perch, the owners enjoy views of the lush green islands that dot the Hauraki Gulf beyond Auckland, including volcanic Rangitoto Island. The overhead cutout makes the South Pacific sky the true ceiling of this outdoor room.

The plan of the house is simple and compact. The curving cypress exterior curves in to create an interior wall in the entry hall, filled with light from translucent glass panels surrounding the front door and adjoining staircase, as well as narrow skylights over the stairs. Behind the pleated wood wall is a bathroom serving three bedrooms. The main living spaces and master suite are located upstairs: An open kitchen overlooks a living-dining room that opens onto the outdoor deck through sliding glass doors. A library off to one side also accesses the terrace. The large expanses of glass surrounding these public rooms—sliding doors, walls of glass louvers—fill them with natural light, made more brilliant by its reflection off the bay.

The interior palette is simple and spare: whitewashed walls, black terrazzo and polished wood floors, hefty cantilevered wood stair treads. The real excitement comes from the light, the panoramic views of city, sky, and bay, and from the sense of openness and informality that makes this city house feel like a laid-back getaway.

previous page
From the street, the house seems to defy gravity: The pleated concrete-covered upper level, which contains the living spaces, sits atop the cedar and translucent glass enclosing the ground floor, where bedrooms are located.
following spread
A wall of rough-sawn cedar battens along the wall of the entry foyer (left) resembles a wooden curtain. The cantilevered stair leads to upstairs living spaces, including a library that opens onto an outdoor deck (right) overlooking the Auckland skyline.

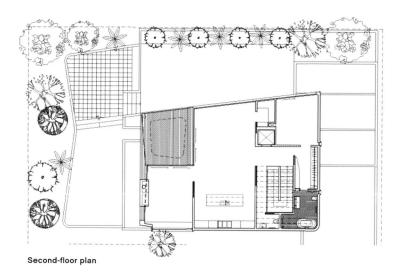

Second-floor plan

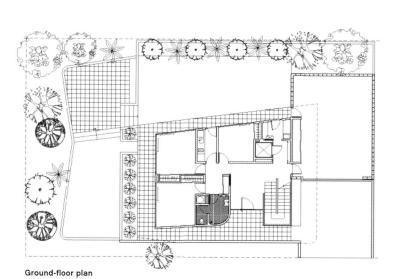

Ground-floor plan

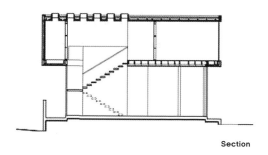

Section

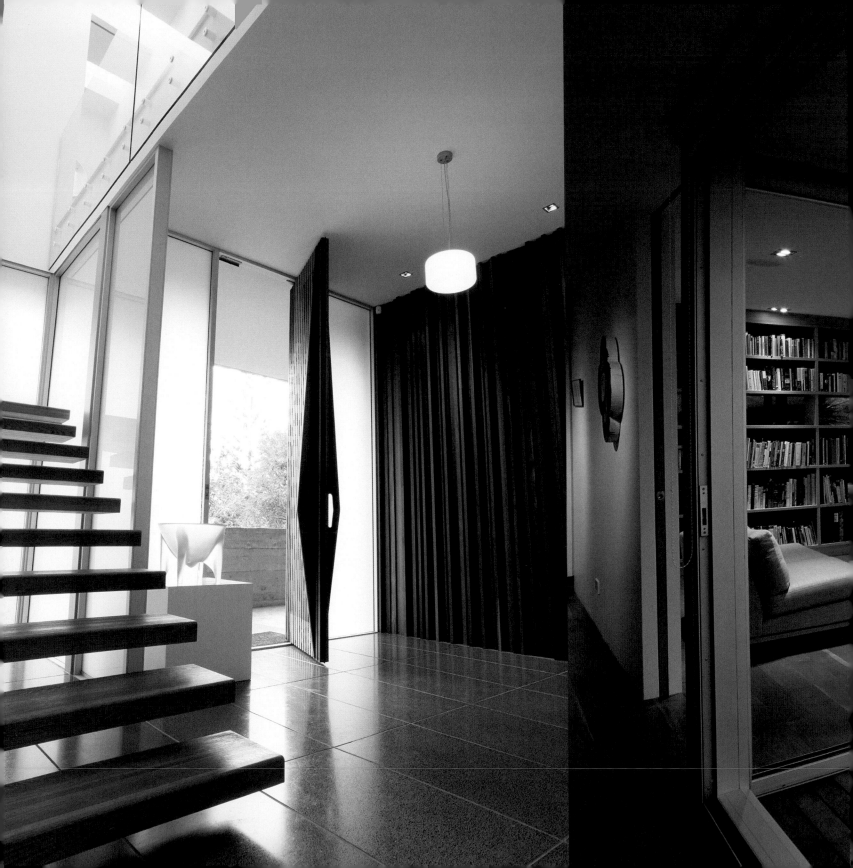

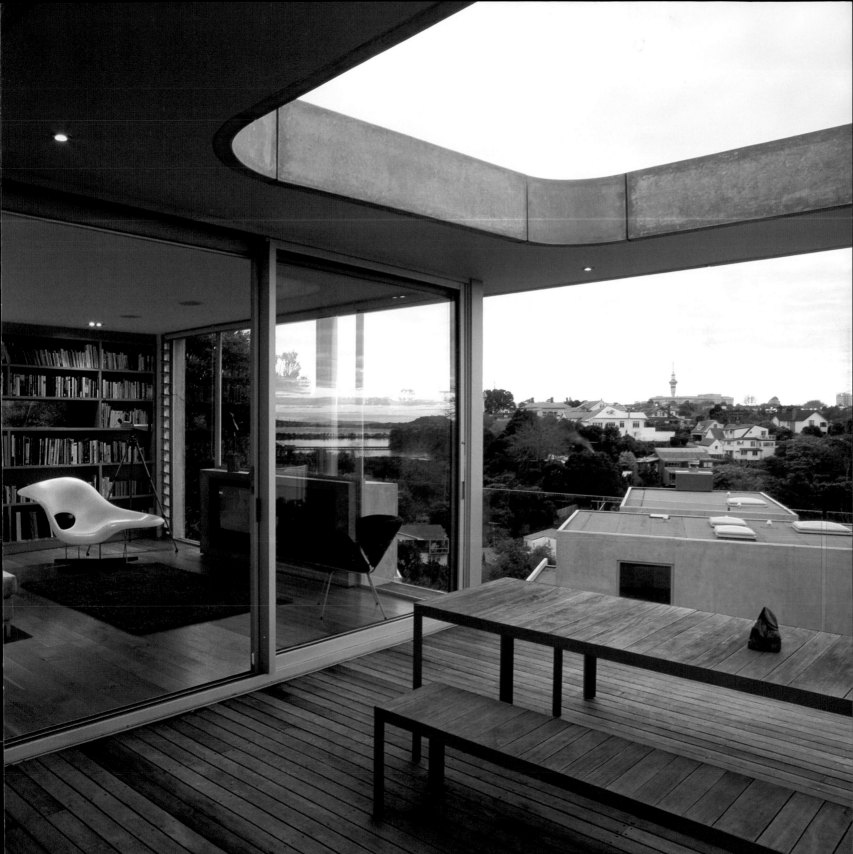

Fulton Road House, Singapore

On the outskirts of central Singapore, near Bishan Park and the island's large nature reserve, Forum Architects designed a pared-down modern take on the traditional terrace house found in many cities around the globe. Their version of the terrace house solves some of the shortcomings of this particular building type: ground-floor views limited to carports at the front of the house and small yards in the back; small, inflexible rooms; and dark rooms, especially at the center of the long, narrow floor plates.

The car park is still located at the front of this house, along with a small reflecting pond off a small wooden deck extending from the living room. The architects aligned the living room with the dining room at the center of the house, a study at the back, and an open-air patio; beyond the patio is a small garden. Purely functional spaces (the kitchen, a staircase up to the bedrooms) are tucked to one side, allowing an unimpeded visual flow through the main living areas, from the front pool to the rear garden. Upstairs the master suite occupies the front half of the house. At the rear, two bedrooms overlooking the garden and a family room toward the center of the floor plate pinwheel around a shared bathroom. The exact configuration of these three spaces can be changed, adding unexpected flexibility to a tiny, narrow floor plan.

The architects made the entire house feel larger than it really is (the long, rectangular structure is 25.5 meters long and 6.75 meters wide, or roughly 84 feet by 22 feet) by making flexible, movable boundaries between inside and out. In the living room, for instance, sliding doors made of a tight wooden grid can be drawn to make a small wood deck part of the living room. The walled-in pool area also becomes part of the interior, echoing the traditional Japanese concept of borrowed landscapes. Informal, inexpensive roll-up bamboo shades mounted to the outer edge of the wooden deck also confound expectations of indoor and outdoor space.

The open-air patio on the rear of the house also extends its interior toward the backyard. The architects used the same gridded wood doors and bamboo shades to create a permeable, layered enclosure. Skylights above the stairwell and the second-floor bathroom also help make the long, narrow building feel larger by letting natural light flow into the core, which is often dark in terrace houses.

Forum Architects' design is simple, even modest. There are no fancy finishes, no attention-grabbing architectural tricks, no especially large rooms. But their thoughtful interpretation improves the shortcomings of a housing type that's common to so many places. They also made it more appropriate to Singapore's tropical climate by adding open-air living spaces and improving ventilation from front to back. As cities such as Singapore, one of the world's most densely populated, continue to grow, improving on existing urban housing types will continue to be an important design challenge.

previous page
Rolling bamboo shades and a slatted screen enclosing a terrace off a second-floor bedroom give the entry facade of this terrace house a breezy, informal quality.
following spread
Wooden accordion doors with a grid of small square openings open up the living room to a small garden with a reflecting pool at the front of the house.

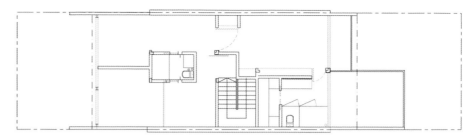

Second-floor plan

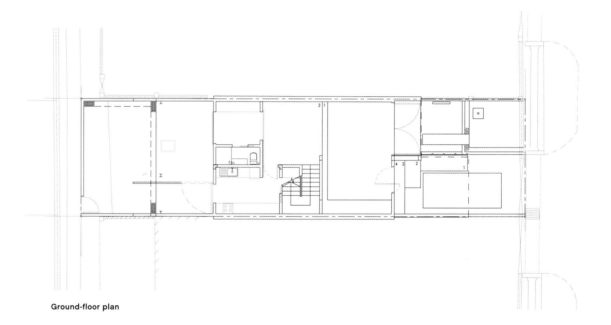

Ground-floor plan

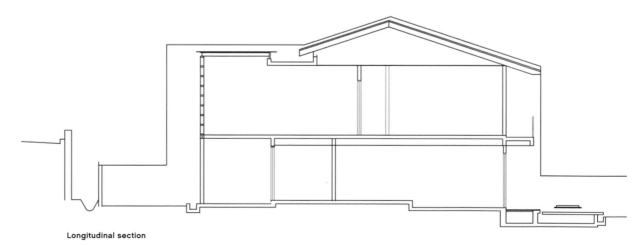

Longitudinal section

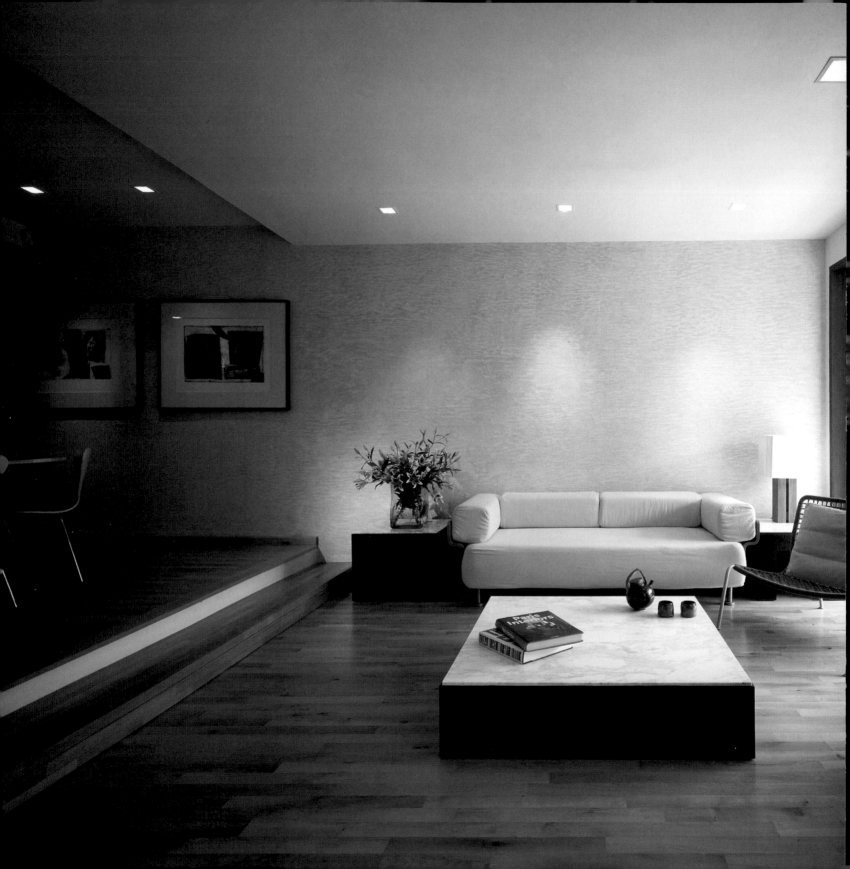

Spry House, Point Piper, Australia

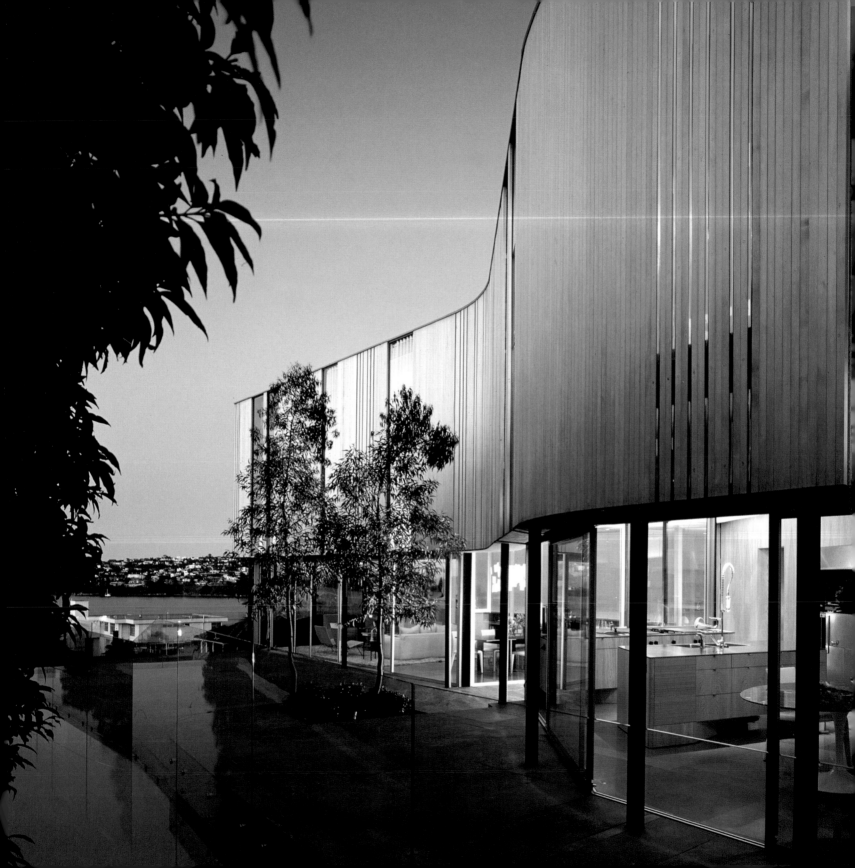

Sydney is blessed with a seemingly endless supply of drop-dead gorgeous views. With its inlets and promontories overlooking the city's sprawling harbor, there's a spectacular vista from nearly every corner of the city. For Camilla Block, partner of Sydney-based Durbach Block Architects, views can be "a real drag." If just a single column interrupts the panorama that clients paid top dollar to enjoy, they feel cheated, she says.

Two of the firm's clients, the owners of the Spry House, certainly chose their property for its million-dollar views. From a steep hilltop in the city's Point Piper area, they could gaze out at a view of Sydney Harbor, with Shark Island at its center. Perhaps surprisingly, the architects found the view troubling: It was so spectacular that it threatened to overwhelm the architecture. So rather than fronting the house to the water and opening every room to the full-on view, Block and partner Neil Durbach proposed orienting the house perpendicular to the hillside, coquettishly framing off-center views instead of a full-frontal panorama. The clients agreed with the architects' strategy, so the house was built with this counterintuitive but highly dramatic approach to the view.

Durbach and Block buried the lowest level of the curving three-story house into the hillside, creating the illusion of a smaller, lighter structure floating above the hill. (The architects were also keen to create a house that was luxurious but compact and efficient.) The pool and an outdoor staircase are carved out of the plinth; large trees planted on its surface reinforce the appearance of the ground floor as a continuation of the topography, rather than architecture built upon it. A curving outline of slender columns and sliding glass doors that open onto a shady terrace defines one face of the second-floor living space. The other side is defined by an angled wall crowned by a skylight that brings a wash of natural light into every level of the house. The uppermost story contains a master suite and guest bedroom.

The house dances gently around the site with a graceful profile resembling the scalloped profiles of a classic glass vase by Alvar Aalto. Above the transparent base of the living spaces, a curving skin of thin vertical battens of yellow cedar with slender (4/5 to 1 inch) windows cut into its surface shield the owners from neighbors to the north. Inside, these skinny windows refract shafts of green light through the interior. The sinuous plan opens up subtly shifting, layered views of interiors and views of the water beyond; the house's strategic use of glass fills the interior with a soft, almost Nordic quality of light.

Despite its unusual appearance and opposition from neighbors displeased with the house's unorthodox form Durbach Block's design passed a conservative local council with flying colors. (It didn't break a single code or restriction.) It also won one of Australia's top architectural honors, the Robin Boyd Award for residential architecture. Its approach to such a privileged setting may be unexpected, but the result is pure delight.

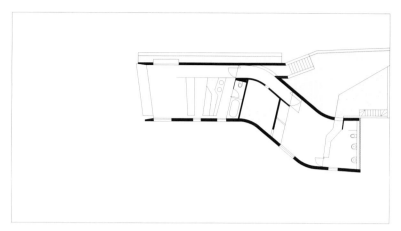

Top-floor plan

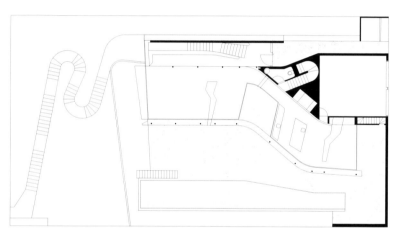

Entry-level plan

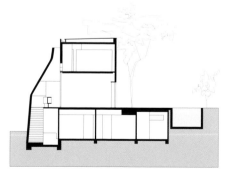

Section

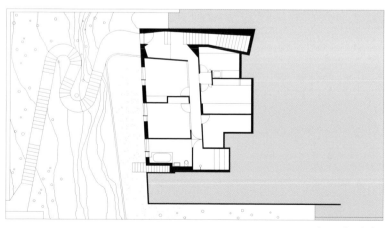

Lower-level plan

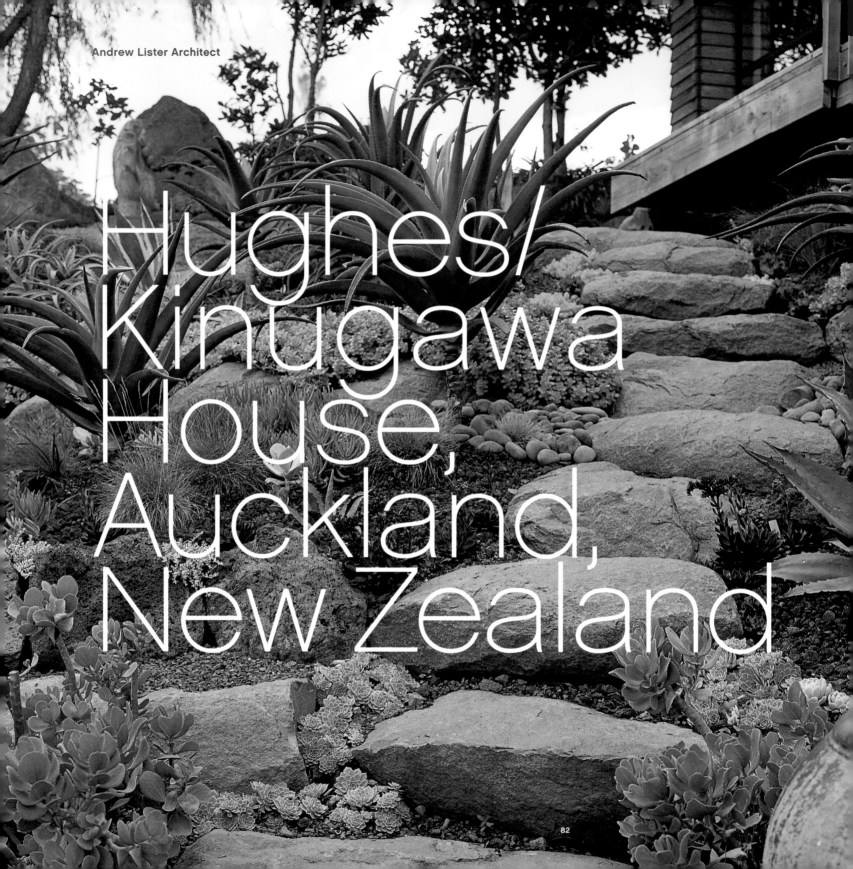

Hughes/ Kinugawa House, Auckland, New Zealand

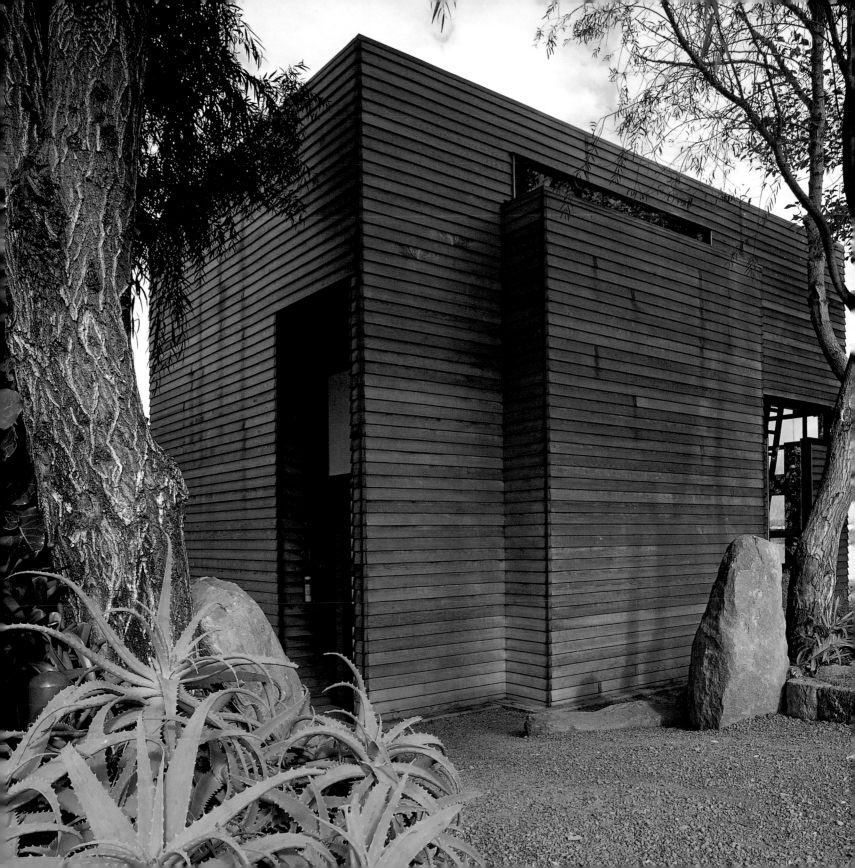

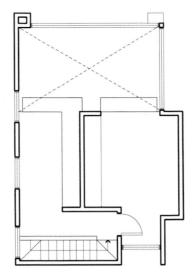

Second-floor plan

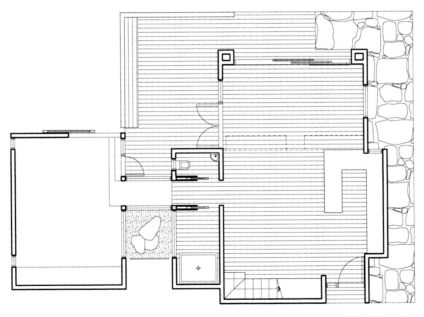

In the master bedroom an oversize platform bed covered in tatami mats and a bamboo-covered ceiling evoke a strong Japanese aesthetic.

Ground-floor plan

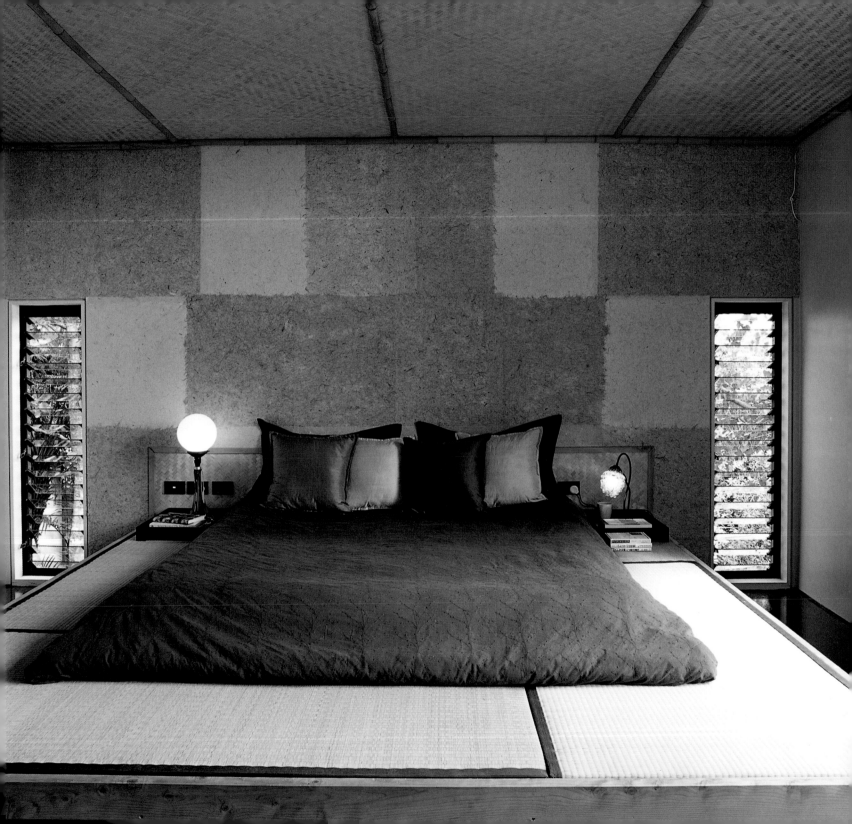

Pablito Calma House, Manila, Philippines

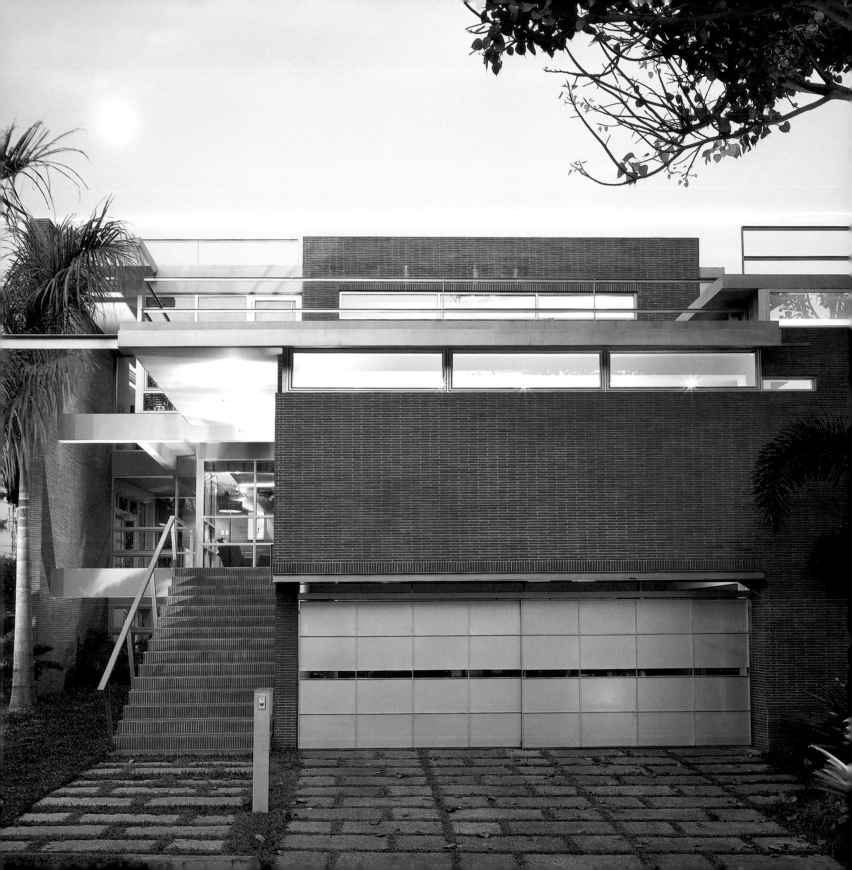

In Manila, as in many big cities where crime is a concern, it can be difficult to keep houses from feeling like bunkers hidden behind protective street walls. Manila architects Lor Calma Design Associates took an innovative approach in designing the Pablito Calma House in Manila: They made the street wall part of the architecture.

Along its main elevation, the sprawling 8,400-square-foot (782-square-meter) house, located on a corner lot, turns a fairly solid face to the street. Brick walls above the garage are punctuated with only a single slotted horizontal window in the upper reaches of the facade. The strategic placement of what amounts to a long clerestory window creates a sense of security and offers its residents privacy, as well as limiting the glare and heat of the tropical afternoon sun along this west-facing elevation. A brick staircase leads from the driveway and entry walk to a recessed front porch, which is also sheltered from the side street by a wall of red brick. Behind this solid exterior, however, the house opens up with towering walls of glass overlooking the private bamboo-filled courtyard framed by the house's U-shaped plan.

The ground floor contains the garage, servant's quarters, a bedroom, and storage areas. The dining room and master bedroom, kitchen, and a soaring double-height living-dining room are located on the second floor; a third-floor study overlooks the towering living-dining room. Of course, the house is fully air-conditioned, but the architect aligned the windows, including operable panes in the living-dining room's double-height curtain wall, to create cross-breezes that ventilate the house naturally when the tropical heat is not at its peak.

The interior, especially the vast living and dining room, positively glows. Part of the radiance comes from the natural light that fills the space through the large curtain wall along the courtyard, as well as a large skylight above the wood staircase that reaches the top-floor study. But the rich tropical woods that Lor Calma used throughout the house also add to the warm glow of the interior. The living room's dark-red tindalo-wood floors contrast with the pale honey-colored Philippine mahogany panels lining the staircase and the underside of the study (which creates a lowered ceiling away from the window wall) that overlooks the double-height space. The tindalo wood is also used for the treads of the staircase and for shelves in the open study, which are hung from the same painted steel fins that support the cantilevered stair. The staircase is a definite sculptural focus for the spacious room, whose detailing and materials give the space a more intimate human scale and a warm, tactile quality.

For a house concerned with maintaining privacy from the outside, it's remarkably open and inviting inside. And it manages to bring views of nature indoors, keeping its occupants in touch with their surroundings. Openness and security do not have to be mutually exclusive, as Lor Calma's design succinctly proves.

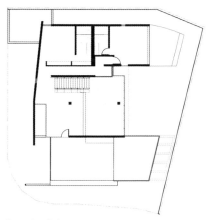

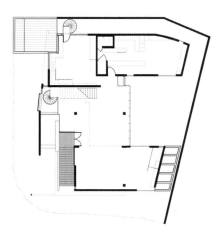

Entry-level plan

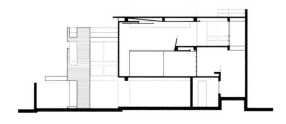

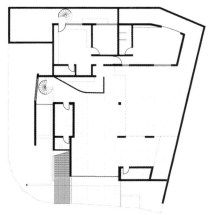

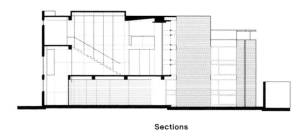

Sections

Ground-floor plan

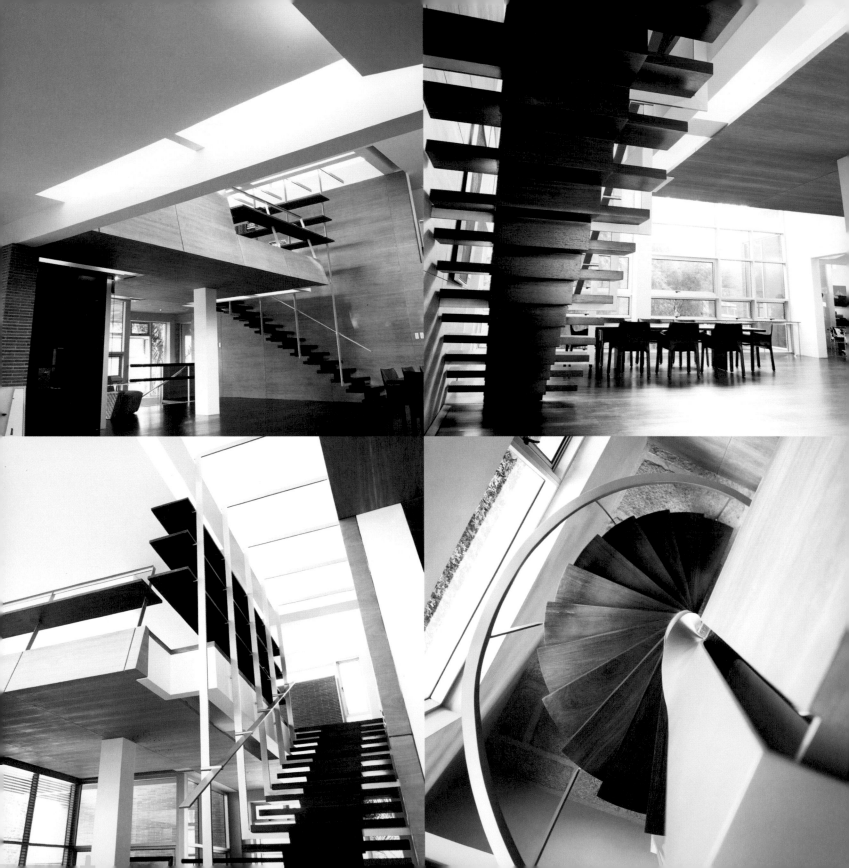

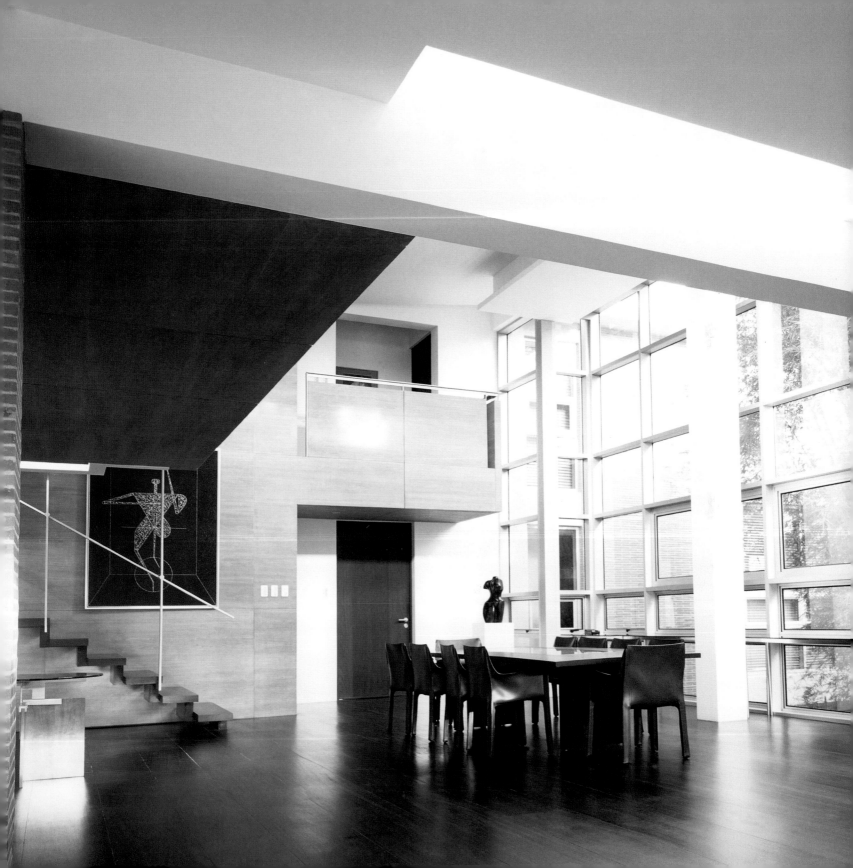

Rose House, Kiama, Australia

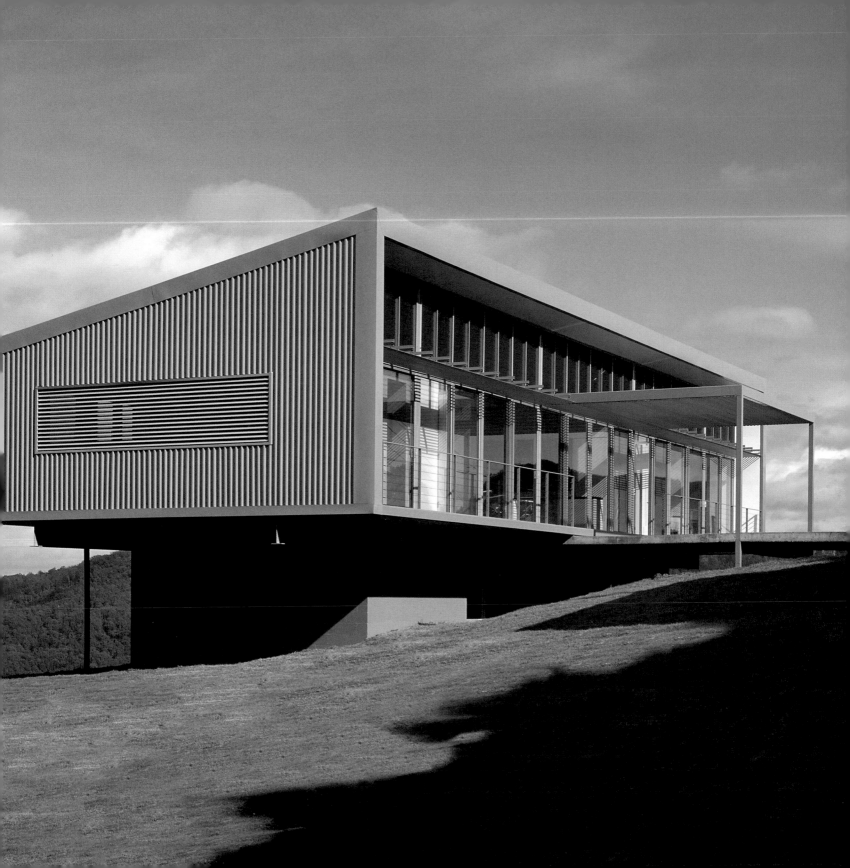

Until parting ways, interior designer Tina Engelen and architect Ian Moore ran one of Sydney's most successful and prolific design practices, Engelen Moore. The duo designed some of the city's most popular restaurants, bars, shops, and design showrooms, as well as houses and apartment blocks that became sought-after commodities by fashionable Sydneysiders. Their crisp, luminous modern style merged Engelen's flair for spare white-washed interiors and Moore's technical precision, honed during his early years in structural engineering (he worked for the legendary London engineering firm Ove Arup & Partners on Norman Foster's Hong Kong and Shanghai Bank building).

Two hours' drive south of Sydney, Engelen Moore designed a year-round home on a spectacular site 164 feet below the summit of Saddleback Mountain. The simple, shedlike house sits on the south slope of the mountainside, with 180-degree views of the heavily forested hillsides of Australian bush country, nearby Pigeon-House Mountain, and the New South Wales coastline and Seven Mile Beach to the east. A ridge runs north-south through the center of the site, which slopes steeply 49 feet downhill.

To get the best views while building on the gentlest part of the slope, the architects centered the house on the ridgeline, toward the top of the site. To minimize the impact of building on the site, Engelen and Moore came up with a lightweight steel structure composed of two Vierendeel trusses running the length of the house and perched atop a pair of reinforced-concrete storage rooms beneath the house—the only points at which the house actually touches the ground. Most of the structure hovers above the hillside, cantilevered 11 feet on either end. As Moore says, "The entire house is a bridge." It also minimized the cost of foundation work.

The plan of the floating house couldn't be simpler: a rectangle divided into three distinct zones by two service cores. The eastern zone contains the parents' private quarters; the western zone is for the children. An open kitchen and living-dining area separate the two bedroom wings. Engelen and Moore pulled the cores of bathrooms and storage away from the edge of the house so they could keep wide-open views of the striking Pacific landscape through walls of sliding glass doors on both the north and south. (The taller north elevation also has a strip of louvered clerestory windows above the sliding doors.) The short ends are clad in sheets of corrugated gray steel, with louvered strip windows framing horizontal views.

Engelen Moore's simple design owes something to sources both local and global, from industrial and agricultural sheds to pared-down urban lofts. But when the walls of glass doors slide open, the house takes on a strong Australian accent: It becomes a giant verandah, the covered porch Australians cherish. With its simple surfaces, the house is less about architecture than about creating a subtle frame from which to enjoy the outdoors—also a particularly Australian trait. When the doors open and a soothing breeze blows clear through the space, it's as if the house is hardly there.

previous spread
From its commanding hilltop perch, the shedlike single-story house opens up to views of hilly bush country.
following spread
Within the minimalist loftlike volume, an open kitchen (left) overlooks the living and dining room (right). Behind the kitchen is a service core and children's bedrooms; the master suite is behind the living room.
pages 100–101
The pavilion-like house seems to float atop a pair of concrete storage rooms buried into the hillside. Its continuous walls of sliding glass doors open up to views of the New South Wales coastline in the distance.

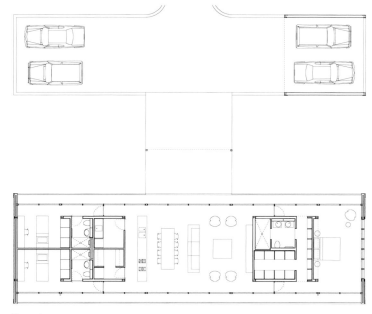

Floor plan

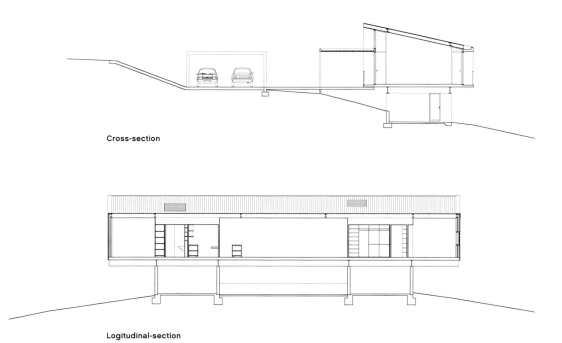

Cross-section

Logitudinal-section

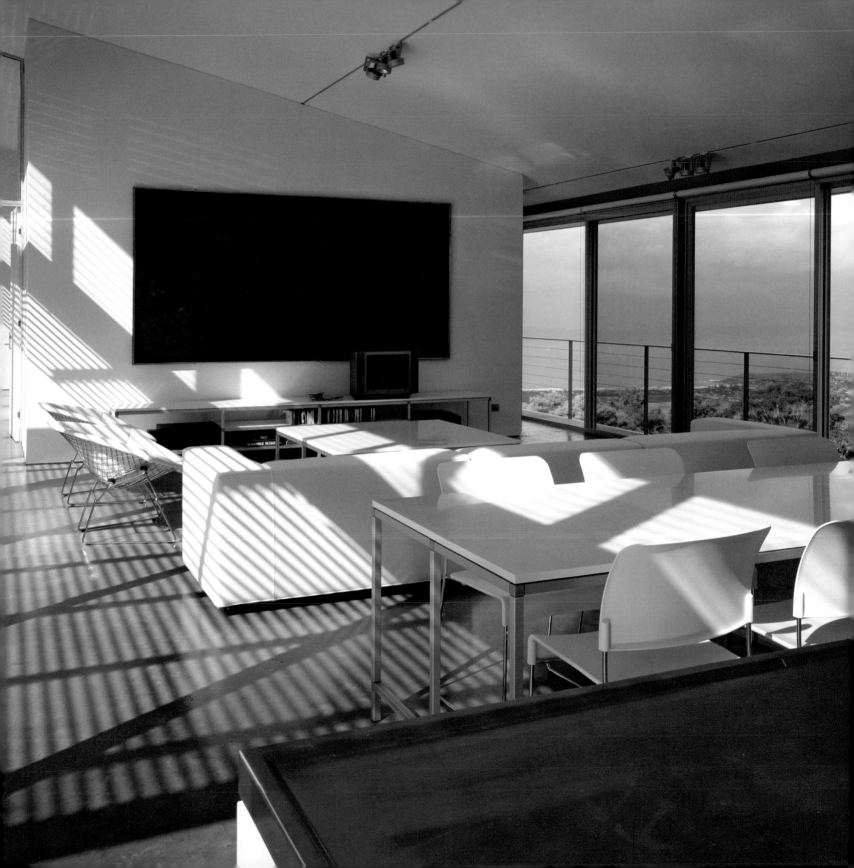

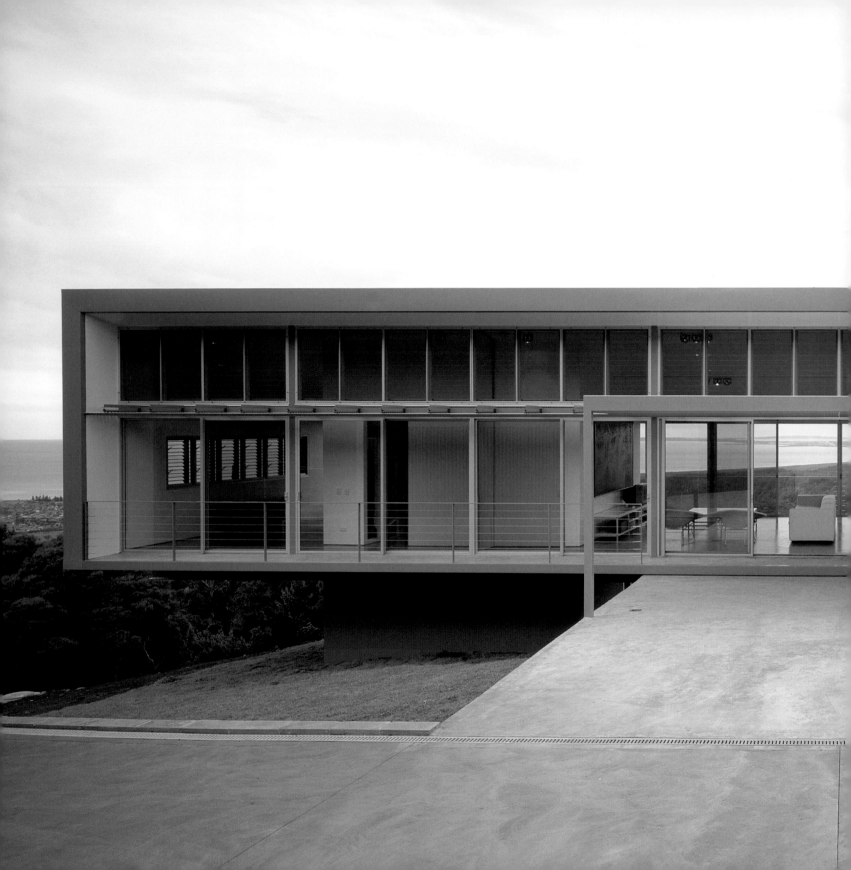

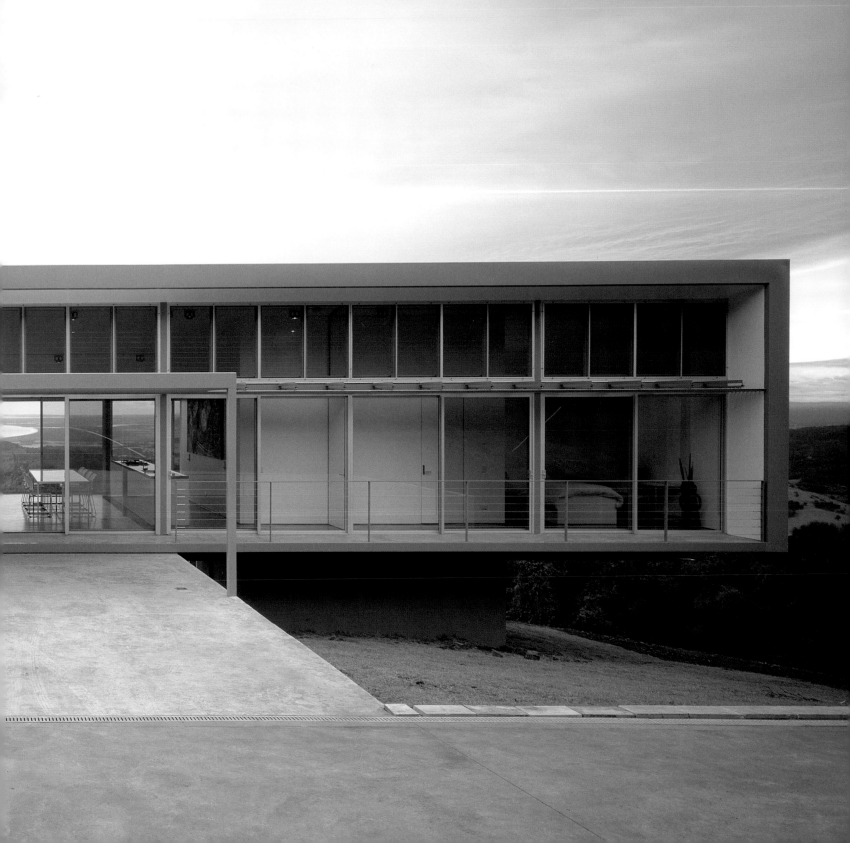

Clifford-Forsyth House, Auckland, New Zealand

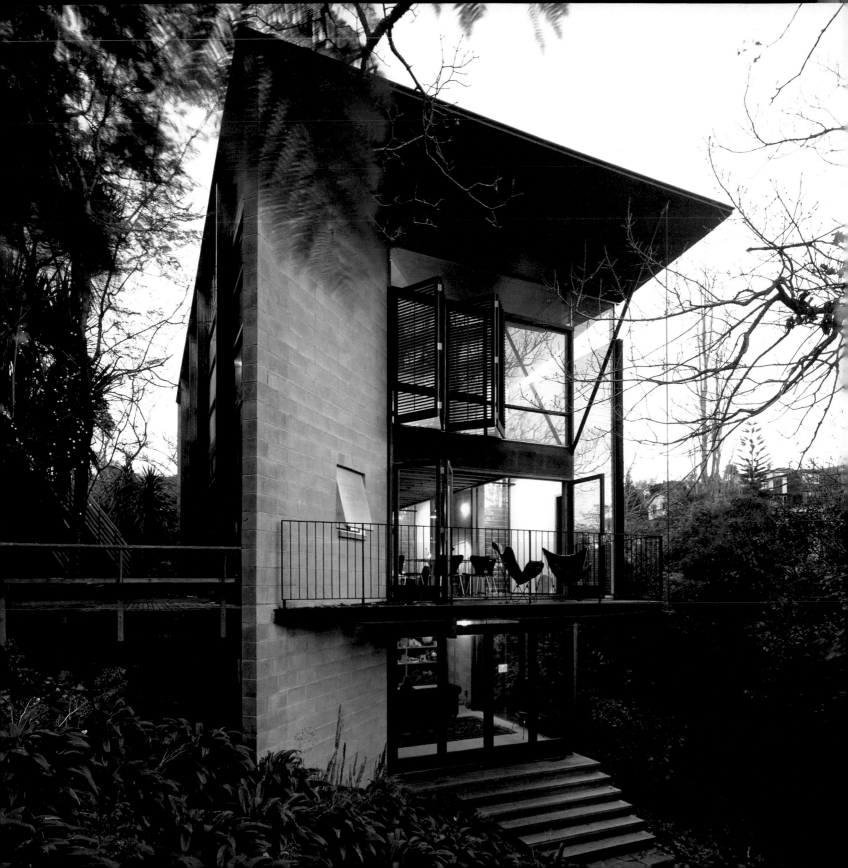

East of downtown Auckland steep slivers of land extend into the Orakei Basin, a tidal water-way connected to Waitemata Harbor and the Hauraki Gulf beyond. On one of these forested hillsides, architect Patrick Clifford, a director of the multi-office collaborative Architectus (the firm has offices in Auckland, New Zealand; Brisbane, Melbourne, and Sydney, Australia; and Shanghai, China) built a house for himself. The architect describes the house as having the spirit of a boathouse or retreat—a vacation house within the city. Indeed, seeing the dense vegetation surrounding Clifford's house, it's hard to imagine it sits almost in the shadow of downtown Auckland's high-rises.

The approach to the three-story house is from a street at the uppermost level; a simple wooden staircase leads down to the entry one level below the street. This middle floor con-tains a lofty living-dining room with terraces cantilevered into the woods at either end, and a kitchen that opens onto a wooden deck at the base of the stairs leading down from street level. Upstairs is a pair of bedrooms: the master suite with a dressing area as its core and a private bath, and a second bedroom on the other side of the dressing-room core. On the lowest level is a family room, guest room, and another full bath. Stairs from the glass-enclosed family room lead down the hillside to the inlet of water.

The exposed hybrid structure—a timber frame with knotty floor joists and columns, and a pair of concrete block retaining walls angling out toward the hillside—gives the house the friendly, informal feeling of a light-filled loft in the woods. But the structure is crisply engi-neered: more like the famous Eames house in Pacific Palisades, California than a repur-posed factory. Clifford varied the degree of enclosure within the wood and concrete frame depending on the need for privacy and shading. Along the entry facade translucent glass panels on the uppermost level screen the sleeping area and bathroom from view. Clear glass panes above and alongside the translucent panels reveal the concrete-block retaining walls and the angled plywood ceiling overhead. Beneath the bedrooms wood-framed glass doors offer full views into the kitchen and living area, partially veiled by slender wood battens along the interior staircase. The changing rhythm of vertical and horizontal frames and clear and translucent skins give the facade the feeling of a play on Japanese shoji screens.

The north and south facades, shaded by deep roof overhangs supported on large steel struts bolted to the house, combine different materials, textures, and degrees of openness. Pivoting wooden louvers shade operable windows in the bedrooms; accordion doors, some solid, others glazed, open the lofty living-dining room to cantilevered terraces. The west facade, which would have born the brunt of harsh afternoon sun, is almost entirely sheathed in warm timber; sliding louvered panels shield a single opening in the dining room. But light still enters these spaces from the north and south, washing the solid walls through vertical ribbons of louvered windows extending the full height of the house.

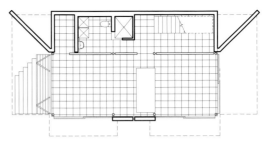

Top-floor plan

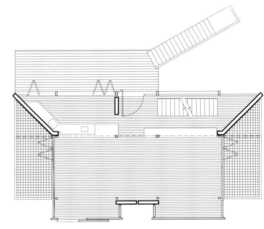

Entry-level plan

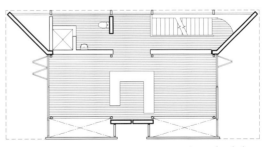

Lower-level plan

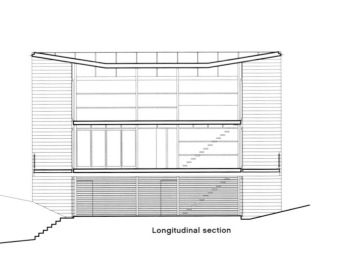

Cross-section

Longitudinal section

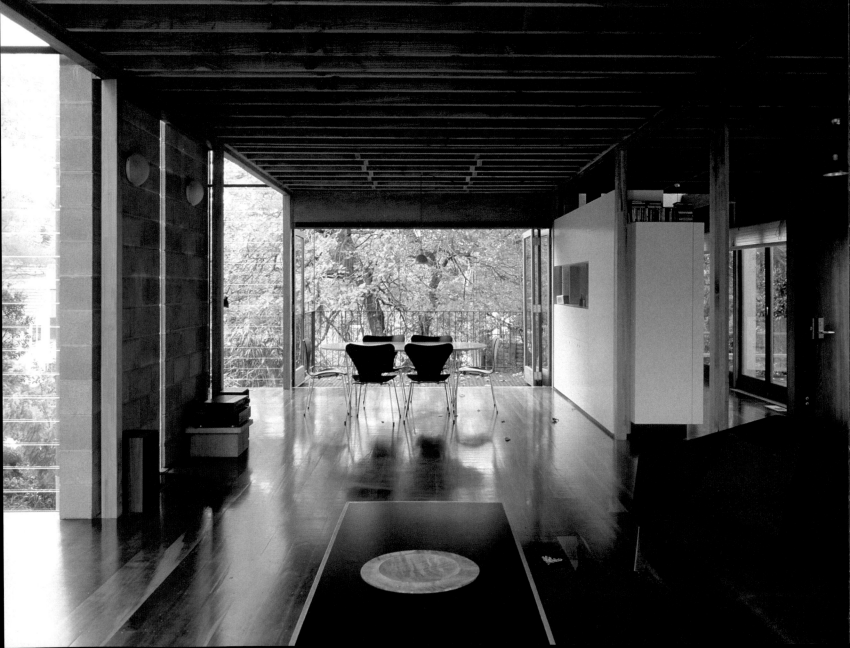

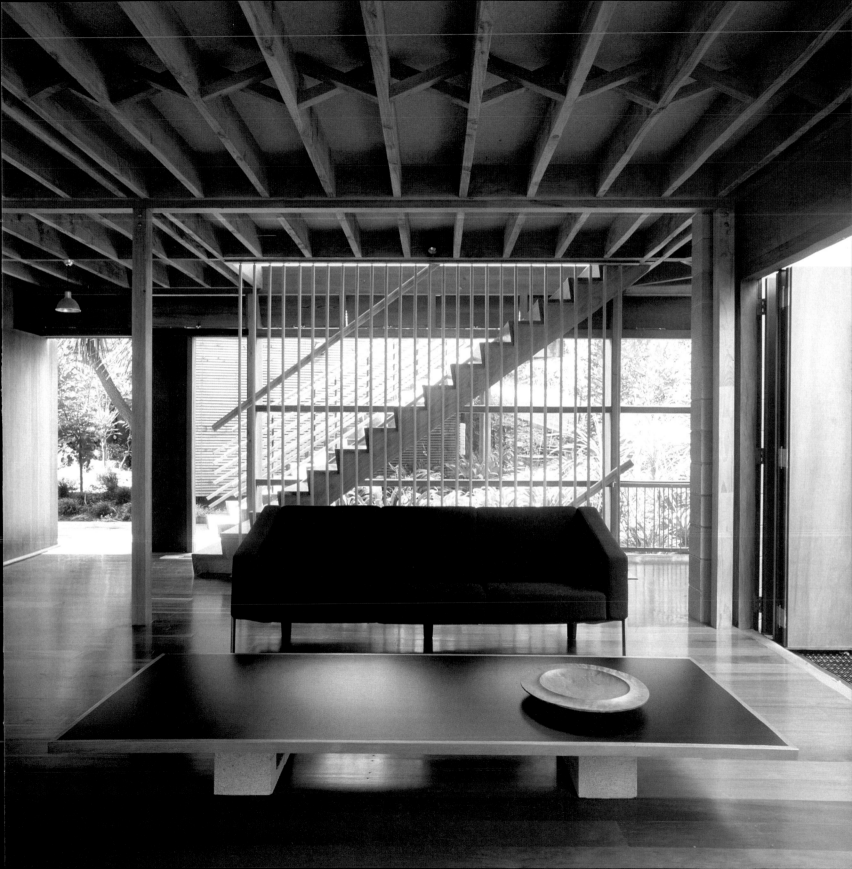

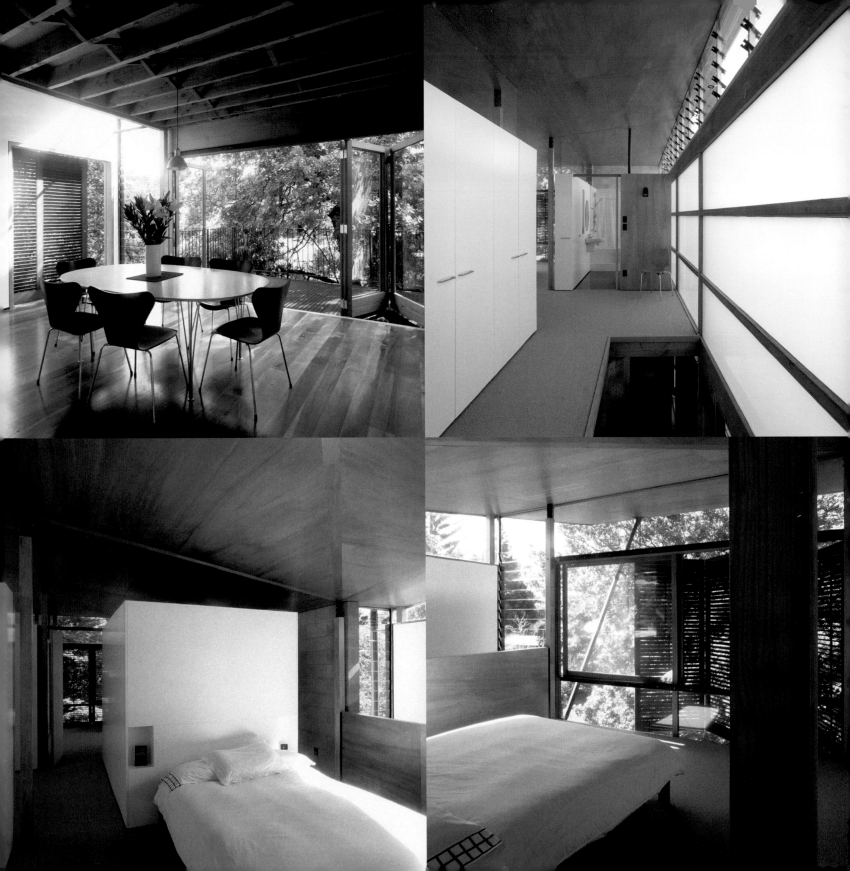

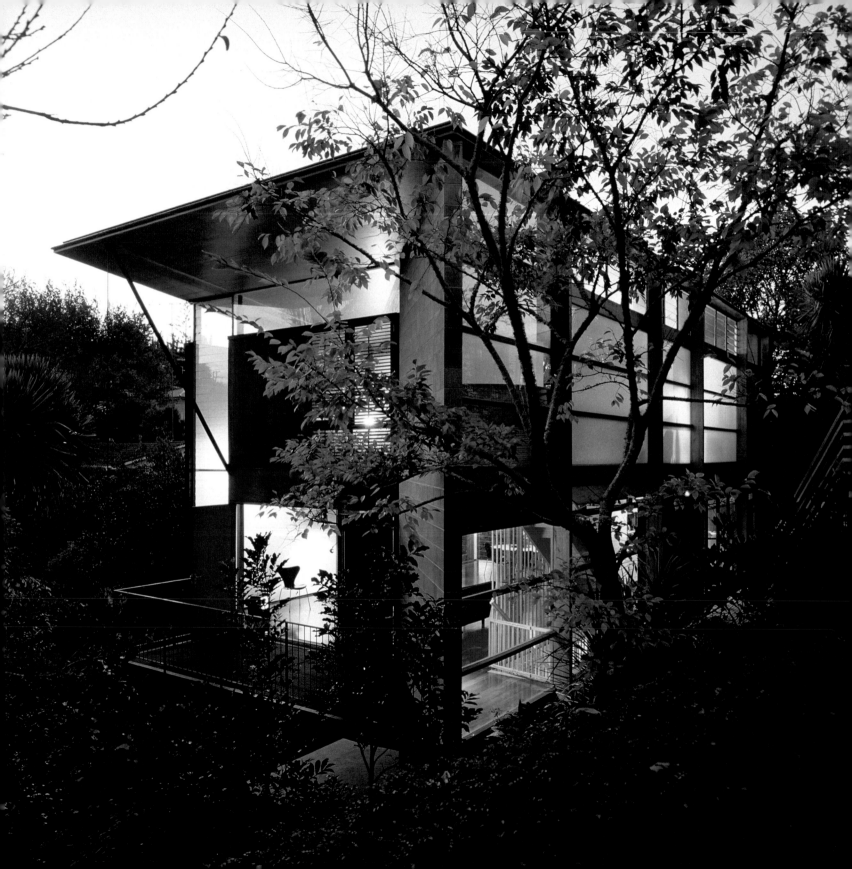

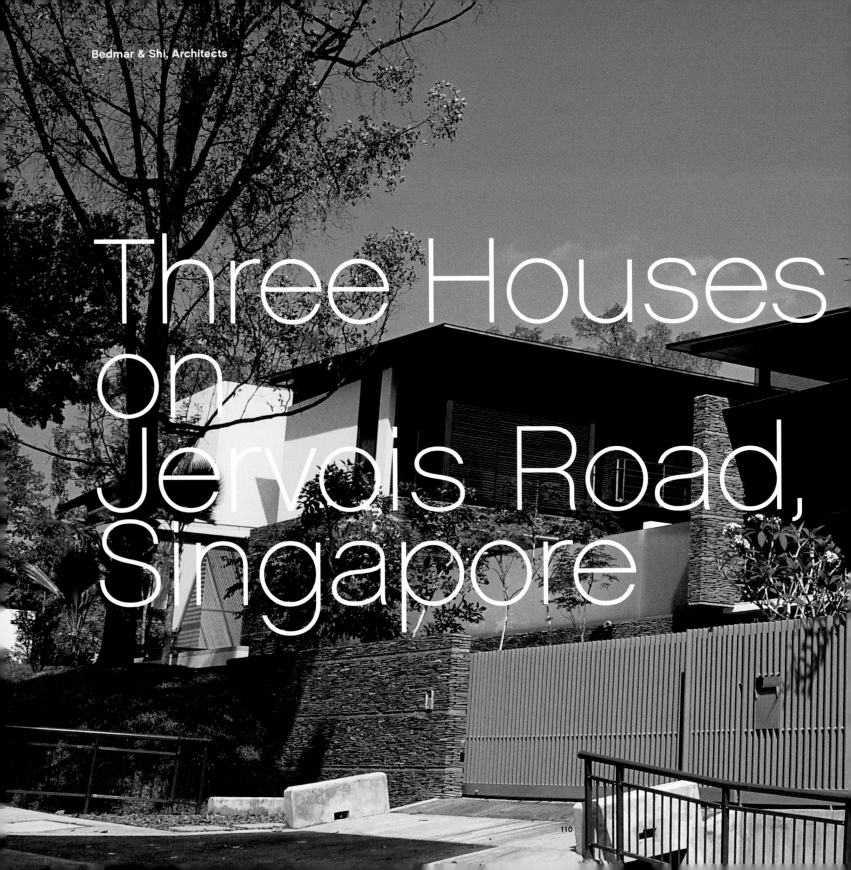

Three Houses on Jervois Road, Singapore

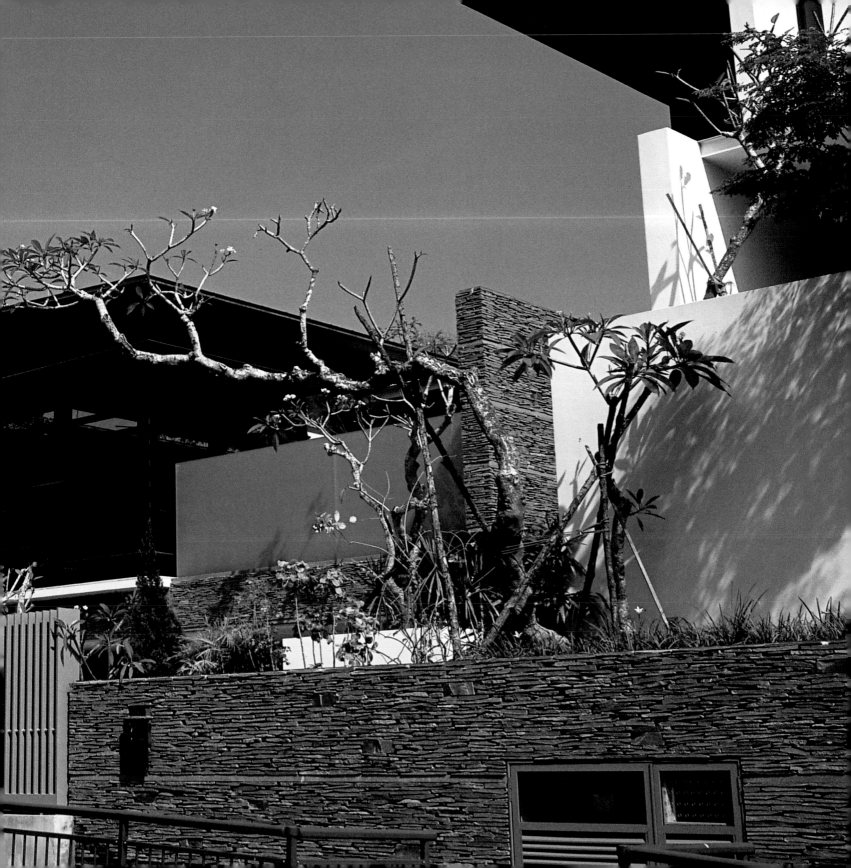

Singapore's roughly 4 million residents make up one of the world's most ethnically diverse yet integrated countries. The former British colony is truly a melting pot. This multigenerational family compound designed by local architects Bedmar & Shi perfectly reflects the cross-cultural mix of the prosperous island-nation. The owners are an Indonesian family of Chinese origin who commute between Jakarta and Singapore; one of the daughters is married to an Italian; one of the architecture firm's partners, Ernesto Bedmar, is an American-educated Argentine who has lived in Singapore for two decades.

The compound is located not far from Singapore's tony Orchard Road shopping district. Bedmar refers to the three individual houses simply as Houses A, B, and C. The parents live in House B; the daughter, her Italian husband, and their two children in House A; and the son with his wife and two children in House C. The parents' house, located at the center of the compound, is the only one without a swimming pool. That way, as Bedmar points out, the elders have the perfect excuse to visit their children and grandchildren for a swim.

House A stands apart from its neighbors. The two wings of the L-shaped structure, shaded by slender wood battens, frame a private courtyard with a lap pool. The wider section of the L houses a dramatic double-height living space beneath a pitched ceiling of exposed wood beams. Angled clerestory windows give the illusion that the roof is lifting off the house. One of the most unique spaces is the open-air dining room just beyond the living room's tall sliding glass doors. Sheltered by a double-height ceiling but open to the elements (there is no outside wall), the breezy dining room has a striking inside-out feeling that makes the most of the tropical climate.

House B is the smallest and most compact of the three. Organized as a long rectangle with an entry hall and, further out, a reflecting pool as its main axis, the house has airy public spaces that overlook a walled-in side garden. A double-height verandah, set back from the richly colored stone walls of the garden facade and shaded in its upper reaches by louvered wood screens, separates the living and dining rooms. Just inside the verandah is a piano room. The long, narrow reflecting pool tucked between the living room and a game room adjoins an outdoor terrace at the rear of the house.

House C is clearly divided into two interconnected structures: an airy living room pavilion and verandah, separated from the main house by a glass-enclosed lobby surrounded on two sides by shallow reflecting pools. Decks and walkways that open onto a dining room, family room, and guest room frame a lap pool at the rear of the property. (The other bedrooms are upstairs.) The house shares the same rich palette of stone, wood louvers, and glass with its neighbors—which are separate and distinct enough to make sure the family stays close, but not too close.

previous spread
Low stone walls, deep roof overhangs, and slatted wooden screens give the compound of three houses, designed for two grown siblings and their parents, a warm, tropical modern feeling. The site plan (right) shows the location of the parents' home (House B) between the houses of their children and grandchildren.

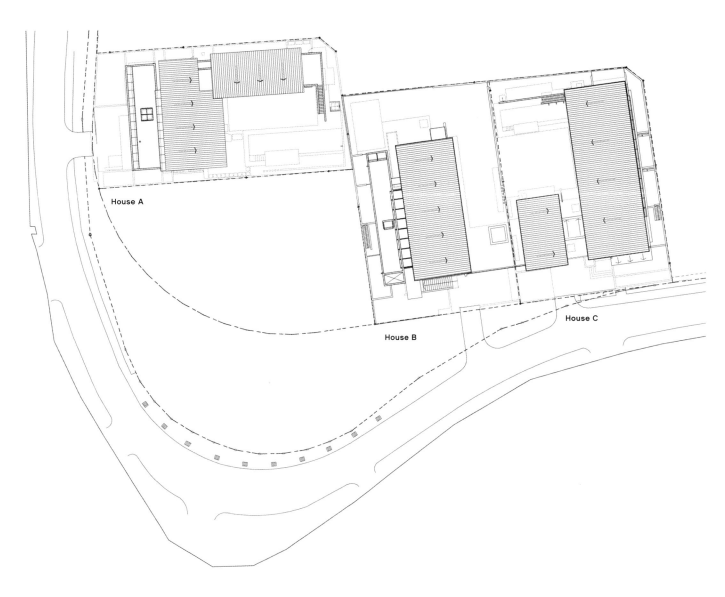

House A

House B

House C

Site plan

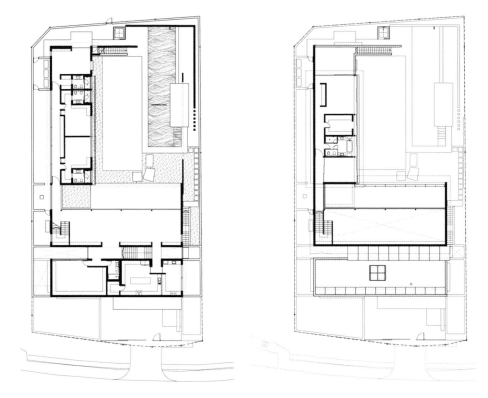

Ground-floor plan, House A Second-floor plan

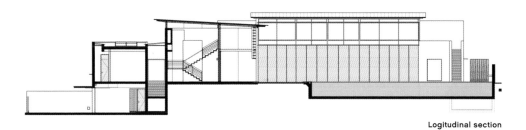

Logitudinal section

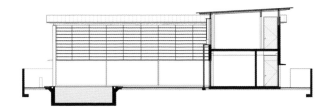

Cross-section

The two wings of
House A frame a private
courtyard with a
swimming pool (right,
top). Beyond the glass-
enclosed double-
height living room is an
open-air living room
(right, bottom).
following spread
Angled clerestories
beneath the sloping
wood ceiling give
the illusion that the
roof is lifting off the
house (left). Glass-
walled spaces wrap
an open-air courtyard
filled with tropical
vegetation (center). A
glass-enclosed bridge
over a staircase
(right) is one of the
home's sophisticated
plays of indoor and
outdoor space.

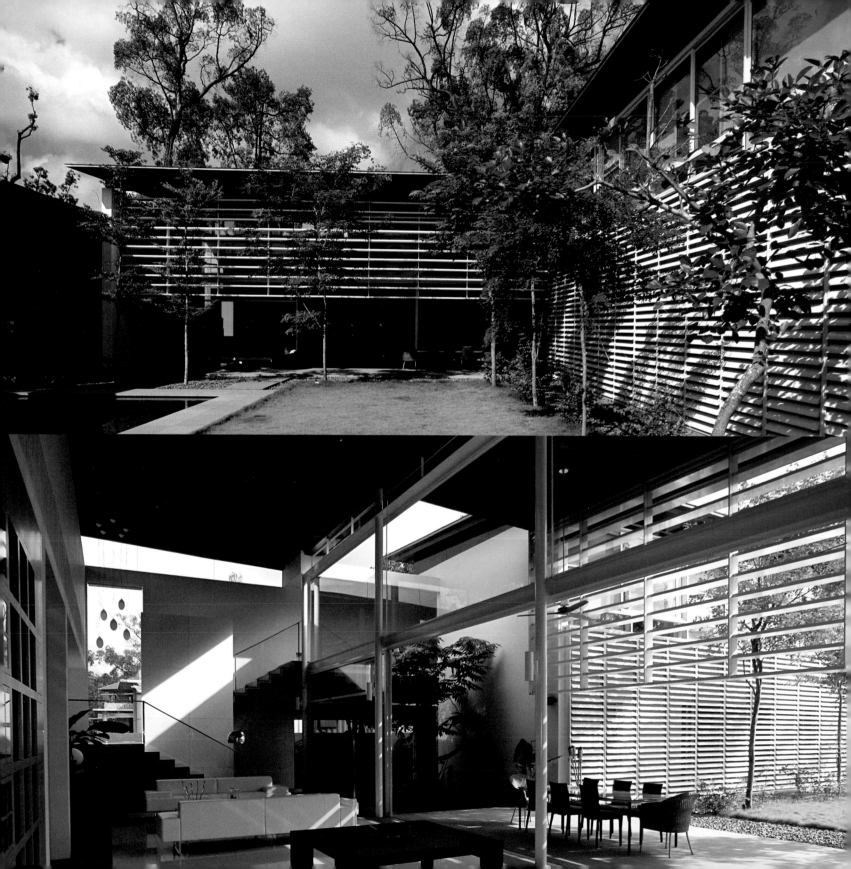

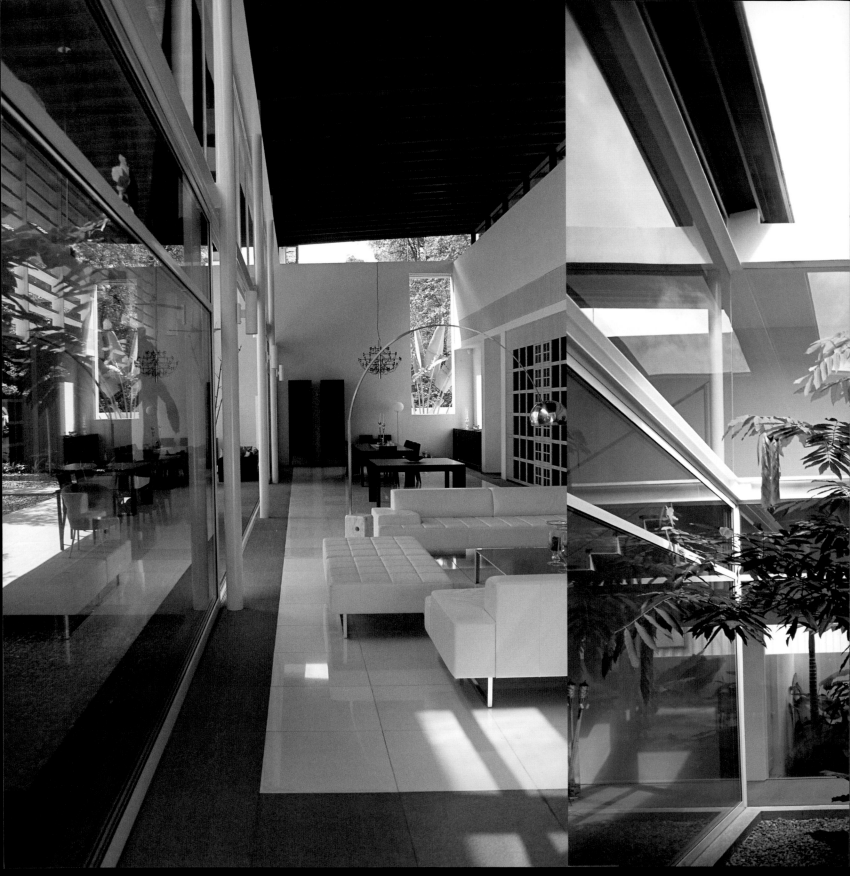

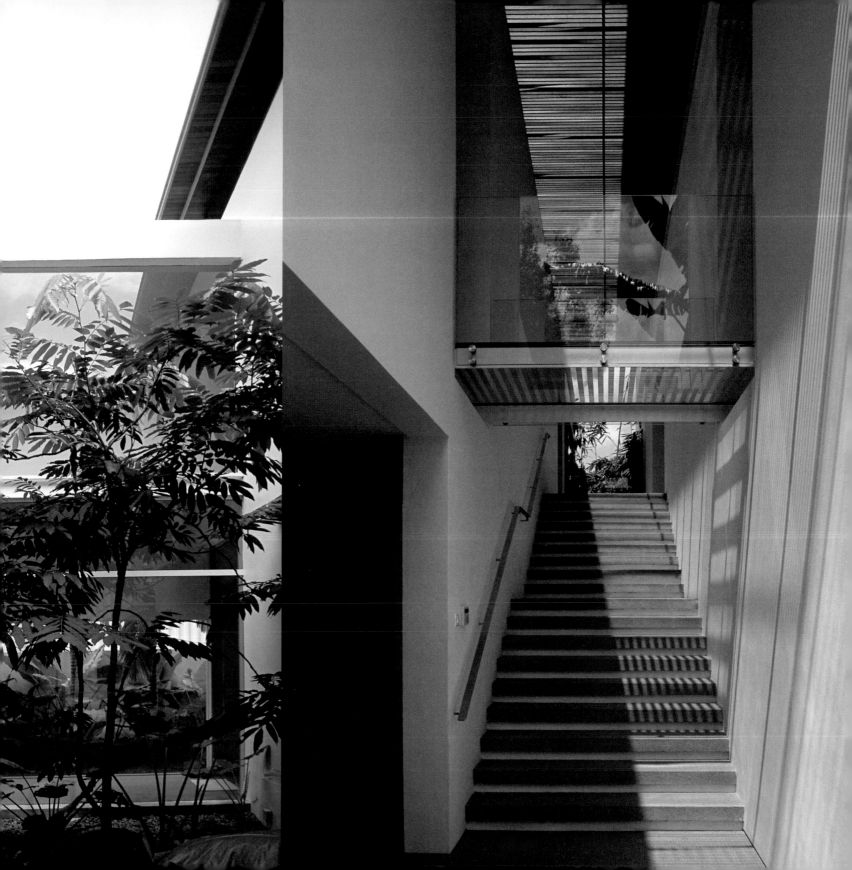

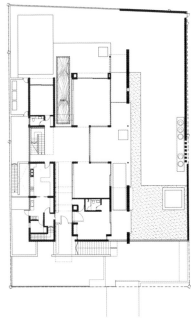

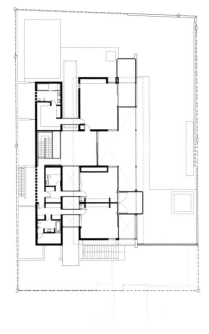

Ground-floor plan, House B Second-floor plan

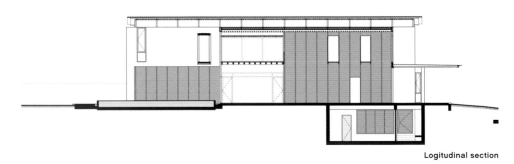

Layered stone walls
distinguish the surface
of House B. The most
distinctive space is
a double-height
verandah, its upper
reaches shaded by
louvered wood screens,
that separates the
ground-floor living and
dining areas.

Logitudinal section

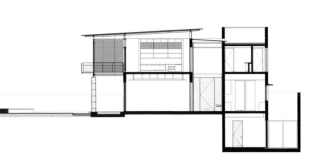

Cross-section

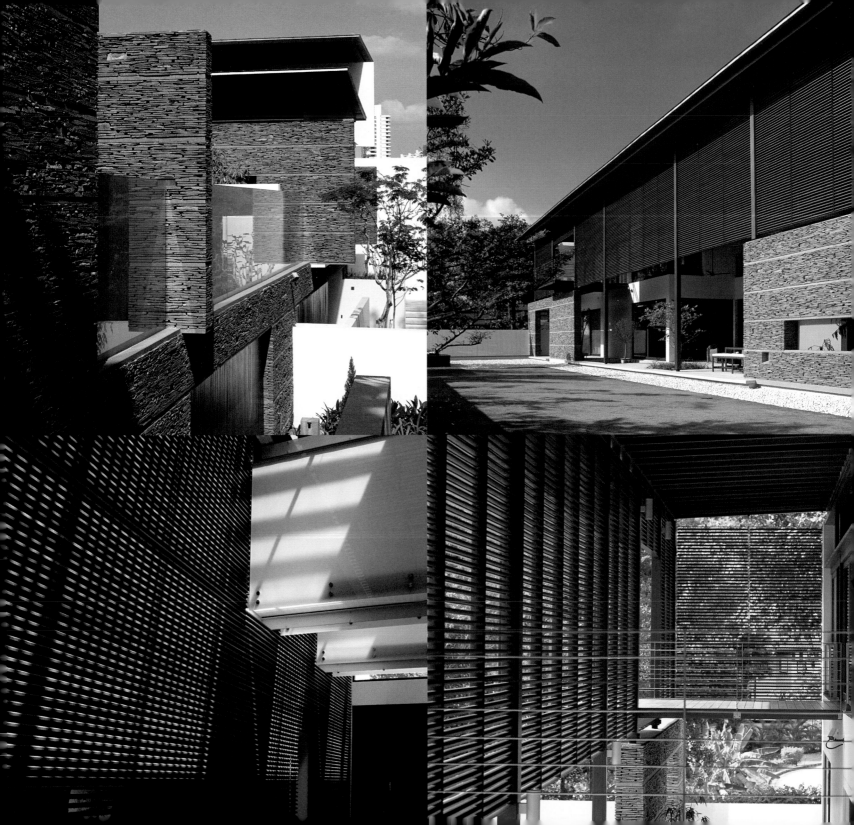

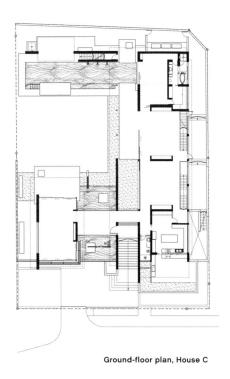

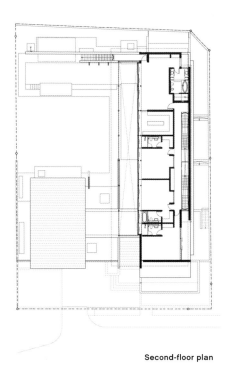

Ground-floor plan, House C

Second-floor plan

House C's crisp volumes and deep roof overhangs continue the architectural vocabulary of its neighbors.
following spread
A glass-enclosed lobby separates the airy, double-height living room pavilion (at right) from the rest of the house. The breezy spaces overlook a pair of reflecting pools.

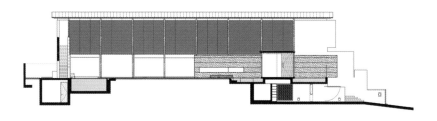

Logitudinal section

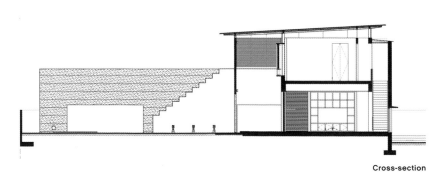

Cross-section

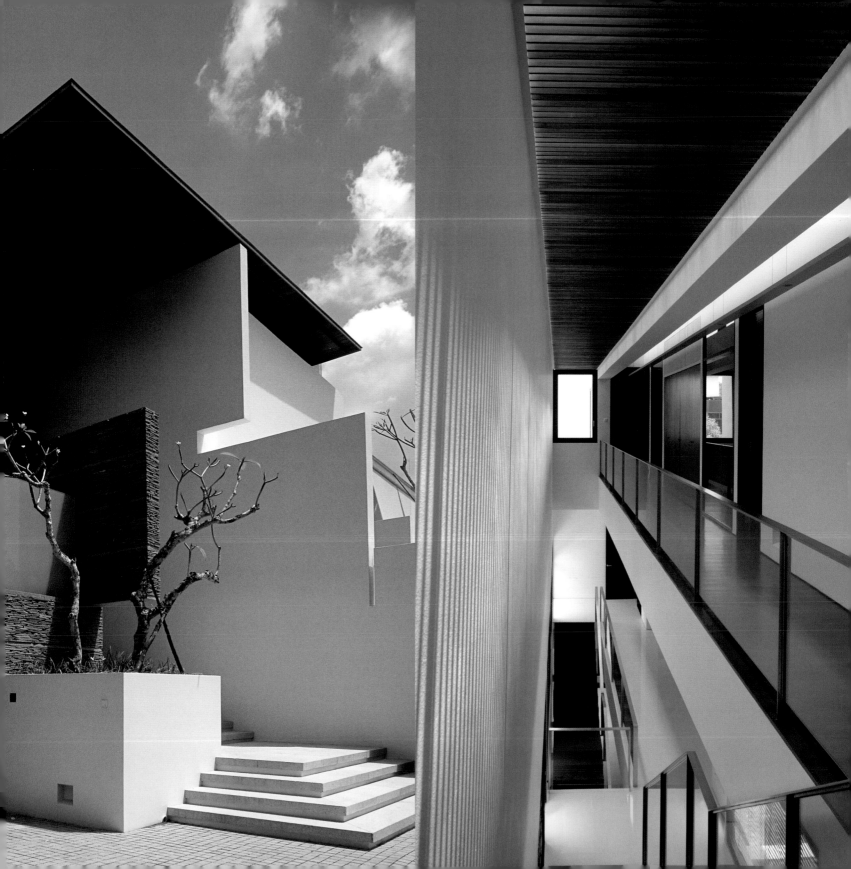

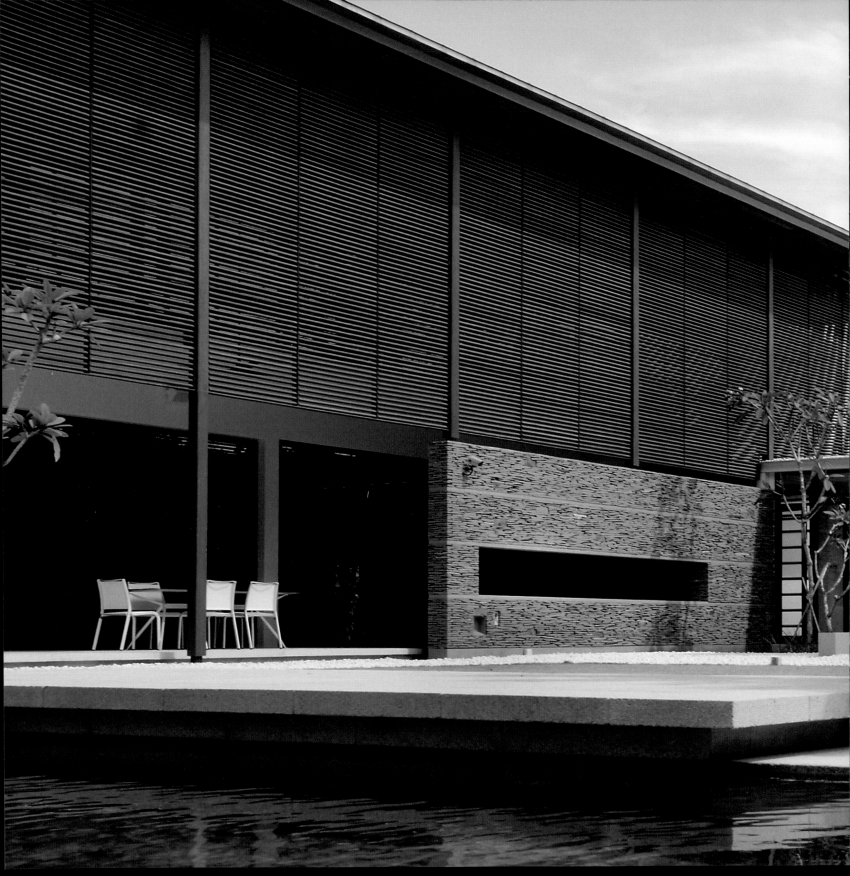

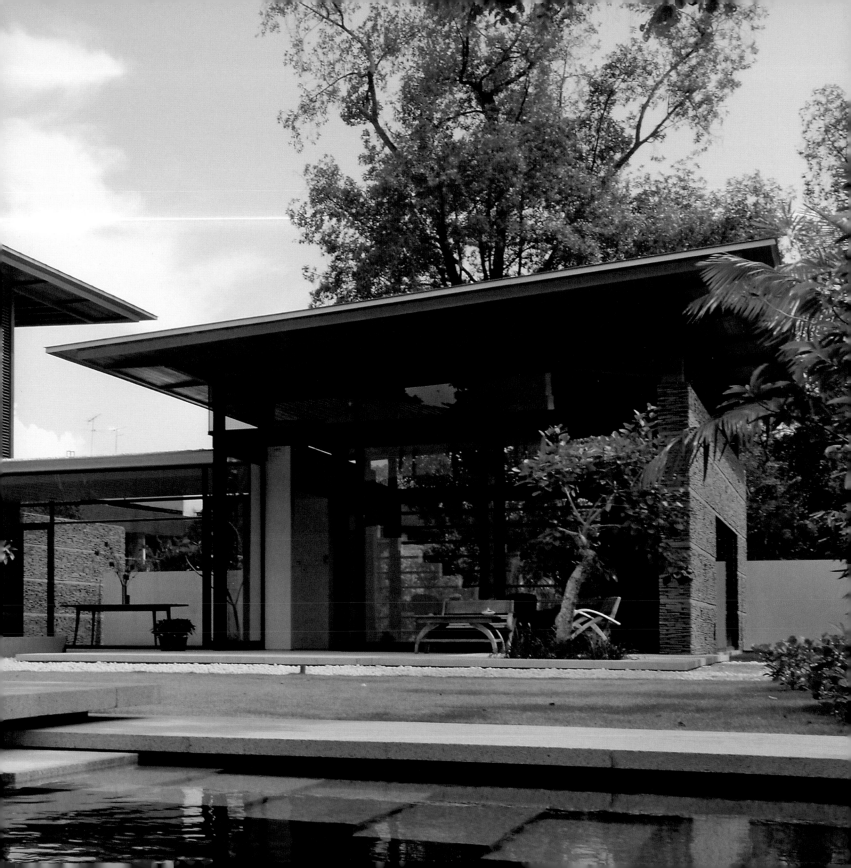

Glade House, McMasters Beach, Australia

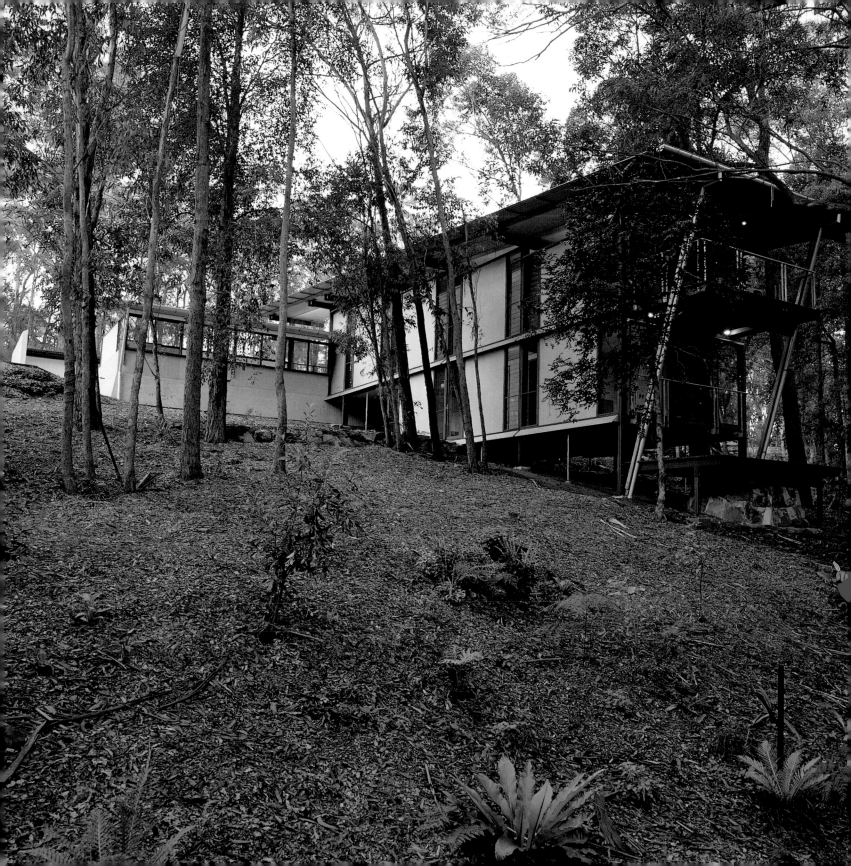

Peter Stutchbury and Phoebe Pape of their eponymous firm outside Sydney are the architects behind some of Australia's most inventive modern houses. Stutchbury & Pape's designs put a dramatic modern twist—soaring rooflines and sweeping expanses of glass—on traditional typologies, especially rustic sheds and the breezy verandahs that are a staple of Australian vernacular architecture. The house they designed in McMasters Beach, on the central coast of New South Wales, about two hours north of Sydney, is no exception.

The crisp modern structure, set on a grassy clearing on a wooded slope, creates its own internalized world. A pair of single-story service wings bermed into the hillside south of the house frame one side of a long, paved courtyard; the main house defines the other flank of the courtyard, which has a framed patch of lawn on one side. The service wings contain storage rooms, a laundry room, and other back-of-house functions behind solid concrete walls sheltered by deep overhanging roofs. The main house could not be more different: a delicate timber structure with soaring pitched roofs above long expanses of clerestory windows above walls of sliding glass doors. In fact, the transparent facade overlooking the internal courtyard feels immaterial.

The lofty double-height kitchen commands the center of the airy public wing. To one side is the dining room; to the other is the living room. The roofs slope down away from the courtyard to define cozier bedroom areas. The five bedrooms are contained within a two-story wing, perpendicular to the living areas. (The slope of the hillside allowed for another story below the level of the living wing.) The top floor contains two bedrooms and the master bedroom, with a private deck at the end overlooking the woods beyond. The master suite is separated from the other bedrooms by a bathroom and a stair leading down to another pair of bedrooms, one with a private deck directly beneath the master bedroom.

Stutchbury & Pape's architecture has some dramatic moments: the large clerestories weaving their way among the sloping planes of the ceilings above the living spaces, the clean sweep of razor-sharp metal roofs soaring beyond the glass walls. But it is not an aggressively sculptural house. And it is a modest one, too. The inspiration came not from grand works of architecture but from the ad hoc sheds of the Australian countryside and the easygoing spaces of traditional houses, especially the shady verandah. Instead of adding on a large porch Stutchbury & Pape treated the entire living wing as a giant verandah, shaded by the deep overhang of thin metal roofs above.

Paradoxically, the "barely there" quality of the Glade House gives it a strong architectural presence. To sit beneath the towering ceilings of the living room and feel as though one were in a giant picnic shelter in the woods is one of the house's strongest traits. Of course, the surroundings are polished and pristine, an elegant interpretation of the best of the region's history.

previous page
The two-story bedroom wing of the T-shaped house juts out from its wooded hillside perch.
following spread
A soaring double-height kitchen (left) occupies the central bay of the glass-fronted living wing (right), which overlooks a grassy courtyard.
pages 130–31
The bedroom wing steps down along with the hillside terrain (left page, bottom right). Bedrooms at the end of the structure look out into the wooded site (bottom left). A pair of service structures containing laundry and storage frames a courtyard separating the main house from the service wings (right and left page, top left). The overall compound reveals the inspiration the architects found in the rustic sheds of rural Australia.

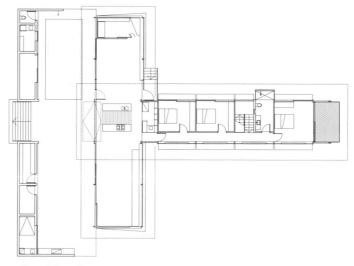

Ground-floor plan

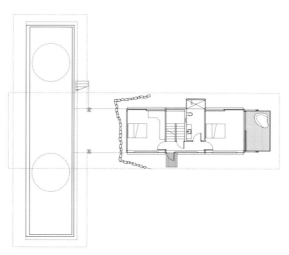

Lower-level plan

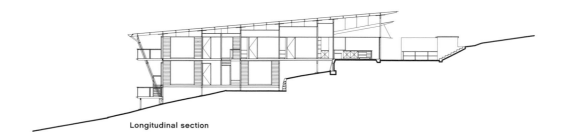

Longitudinal section

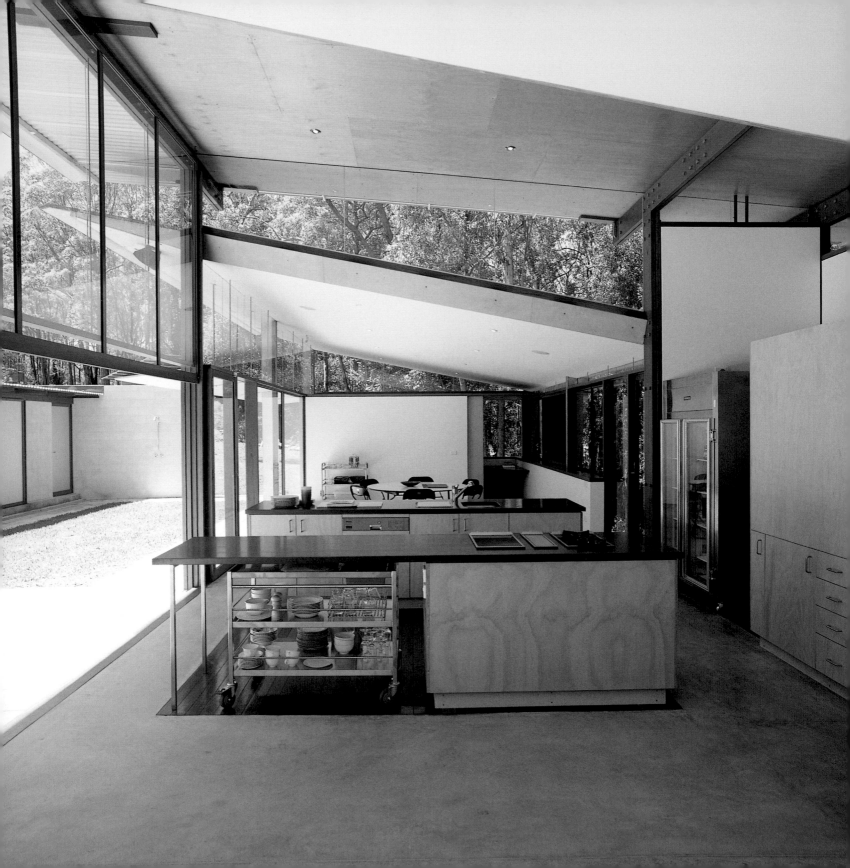

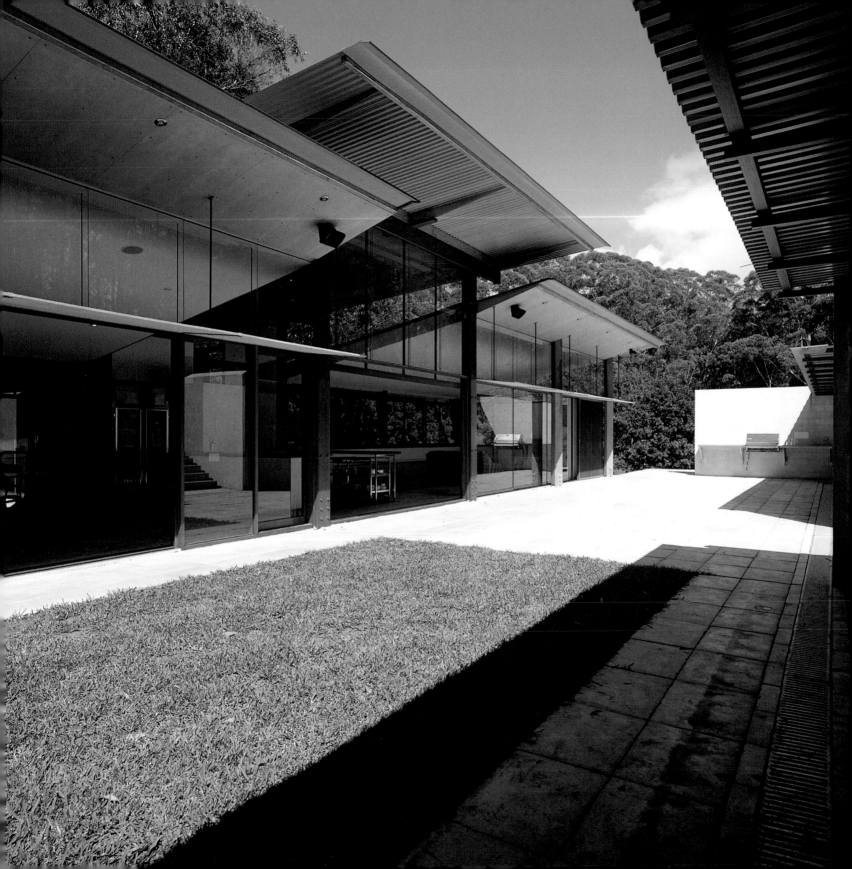

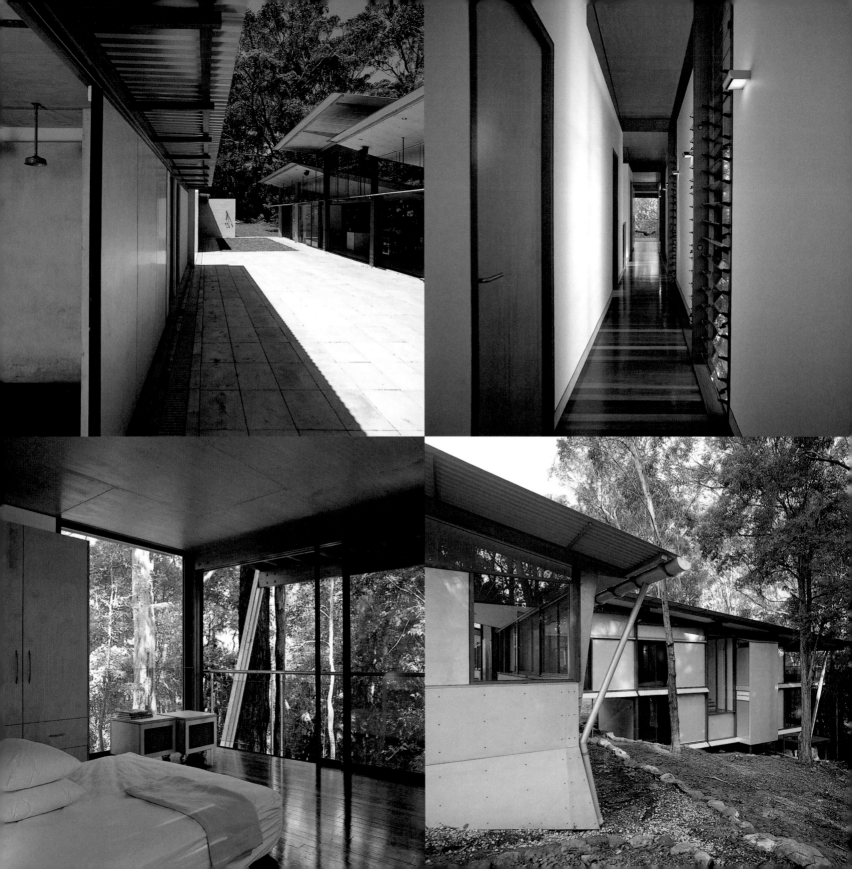

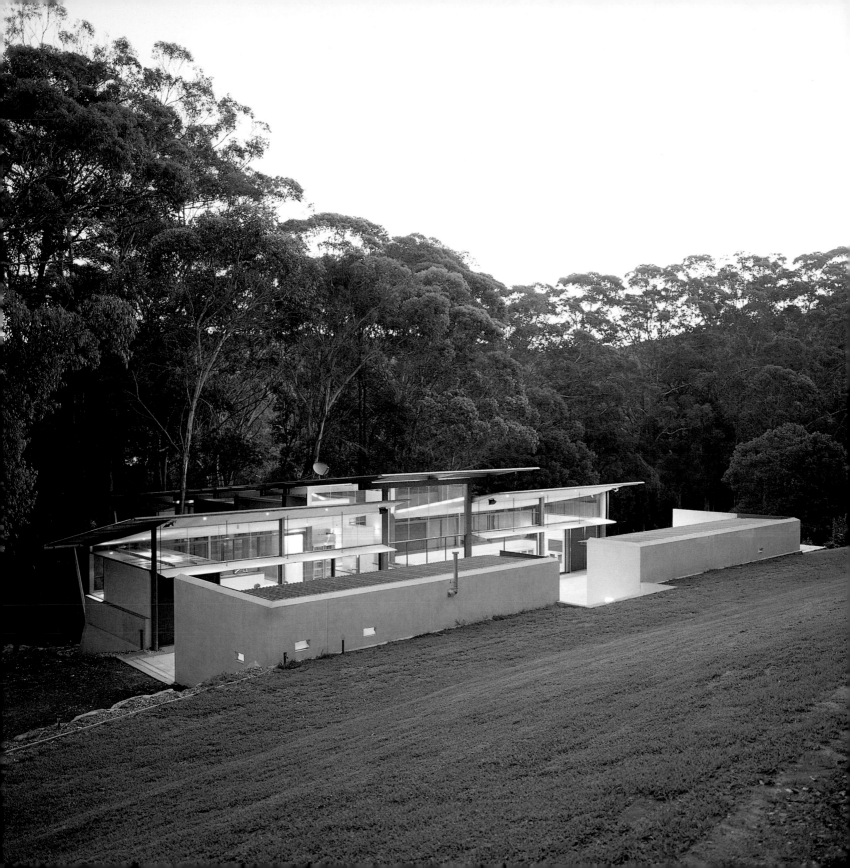

Shark Alley House, Great Barrier Island, New Zealand

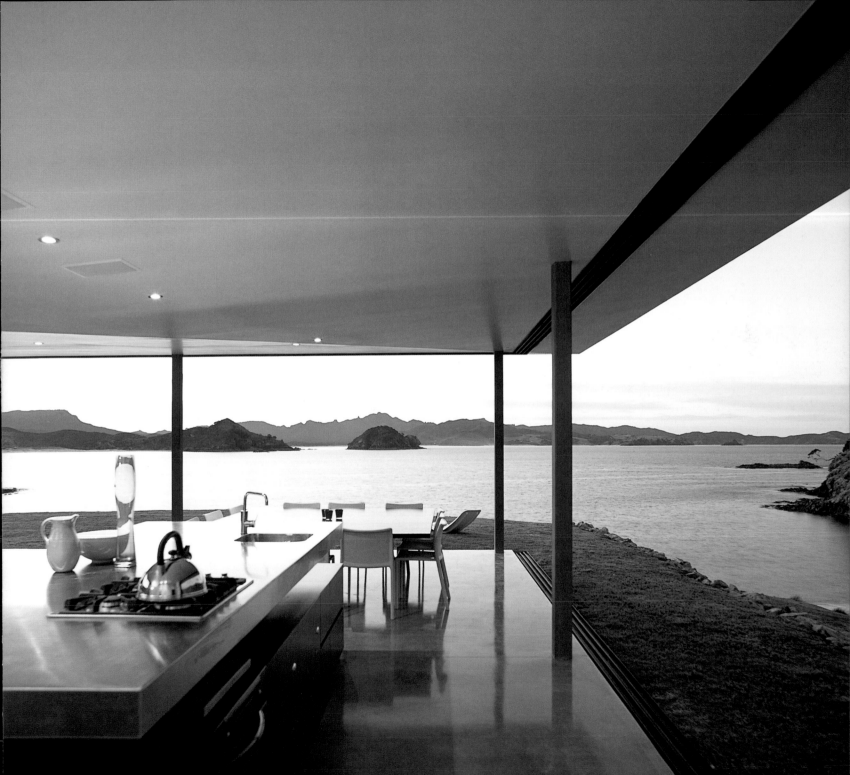

Auckland architects Jeff Fearon and Tim Hay designed a holiday getaway for a family that provides the creature comforts of four bedrooms, three bathrooms, and a spacious open living-dining room ganged around a courtyard with an outdoor fireplace. But despite its polished, Miesian architecture of concrete, glass, and metal, the house is almost immaterial. In good weather, huge glass doors slide to completely open the interior to the elements; only the thin concrete slabs of floor and ceiling and steel columns along the perimeter stand between the occupants and the great outdoors.

The house sits on 16 acres on the southern end of Medlands Bay, on the east coast of Great Barrier Island, a mountainous patch of land about 55 miles from downtown Auckland. Despite its proximity to the city, it's relatively difficult to reach. It's accessible only by small prop plane or by boat; once on the island, there are few roads and no electrical grid or public water lines. The rambling property follows the curve of a small cove named after the surf break on the island's eastern tip: Shark Alley. Fearon and Hay sited the single-story house on a north-facing slope near the water, surrounded by open pastures and hillsides studded with native manuka, or tea trees.

They anchored the L-shaped structure into the hillside and organized its floor plan around an open-air dining courtyard at the back of the house, partly buried in the hill. The main living spaces wrap the courtyard, protecting it from stiff winds off the ocean but still letting in the view through walls of sliding glass doors. At one corner of the L shape wrapping the courtyard is the master suite; at the other is the kitchen. In between are a guest room and the free-flowing, loftlike living-dining area. Another freestanding volume, backing up to the hillside, contains a pair of bunkrooms and a shared bath for overnight guests.

When all the sliding glass doors are retracted, it's as if the house has no walls. The whole structure turns into a giant verandah, open to the breeze and to views of the ocean, with the rugged silhouette of New Zealand's North Island and smaller mountainous islets dotting the blue horizon. On the opposite side the verdant hillsides specked with tea trees and grazing animals become a backdrop to leisurely living. With the courtyard open above, the sky becomes part of the house.

Despite its delicate, streamlined appearance, the house is designed to endure any type of weather. Its structure is robust: poured concrete floors and roof, concrete block walls, and steel columns. Because the strongest winds and storms come off the ocean, the aluminum-framed sliding glass doors along this side of the house can be protected with finely detailed aluminum shutters. (The sliding shutters also adjust for shade, privacy, ventilation, and views.) If the wind is too strong on the waterfront side, it's still possible to enjoy the outdoors from the protected environs of the courtyard. Rain or shine, this sleek, sophisticated getaway distills relaxed weekend living to its barest essentials.

previous page
Retractable glass doors along the perimeter of the living spaces open the house completely to panoramic views.
right
The L-shaped single-story house is perched on a north-facing slope, surrounded by open pastures.

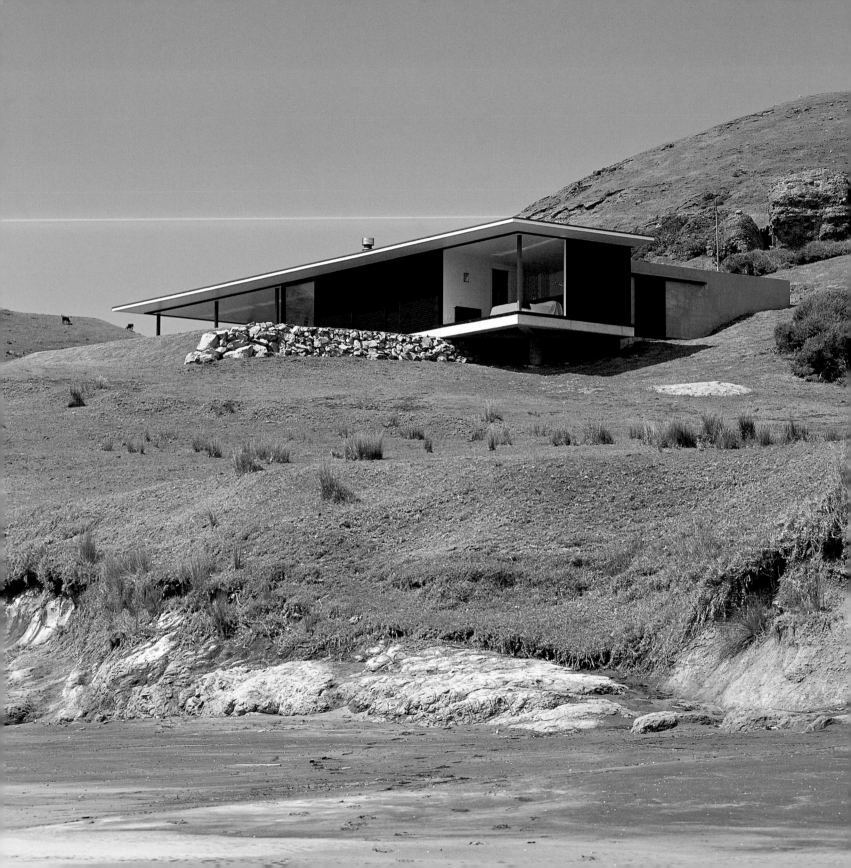

Floor plan

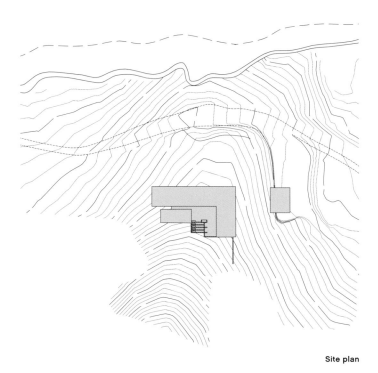

The two legs of the
L-shaped plan enclose
a paved courtyard (right,
top and bottom left)
that creates a more
sheltered outdoor
dining area. Located at
opposite ends of the
loftlike house, the dining
area (top right) and
bedroom (bottom right)
open onto remarkable
views with sliding
glass doors.
following spread
When the doors in the
living area retract, the
panoramic views are
reflected in the polished
concrete floors.

Site plan

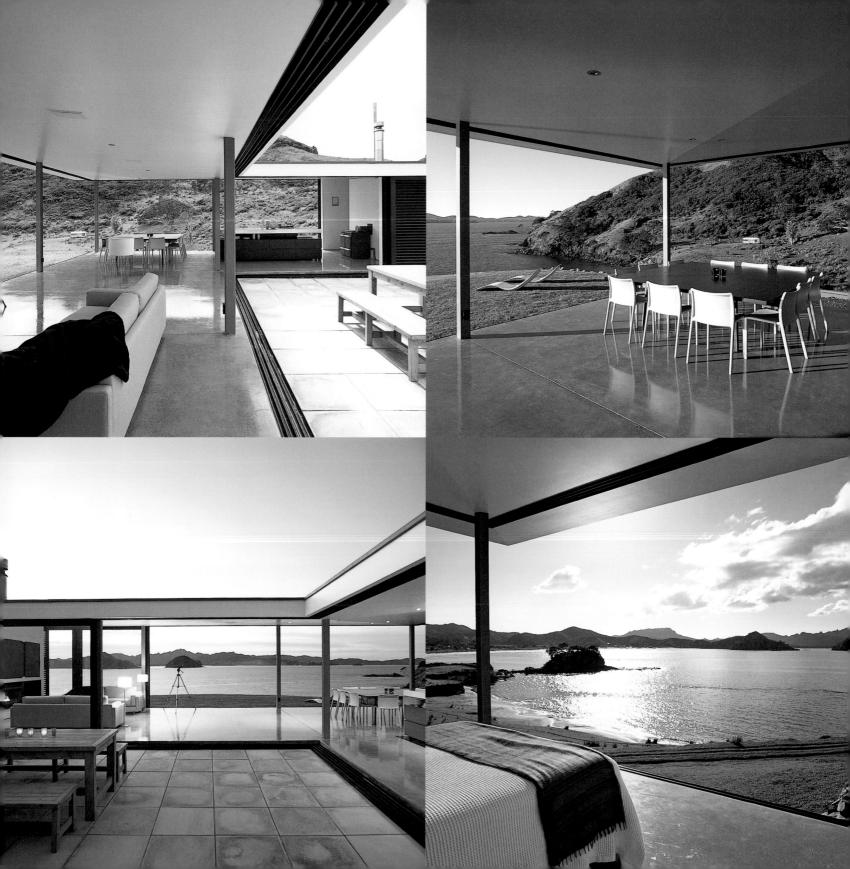

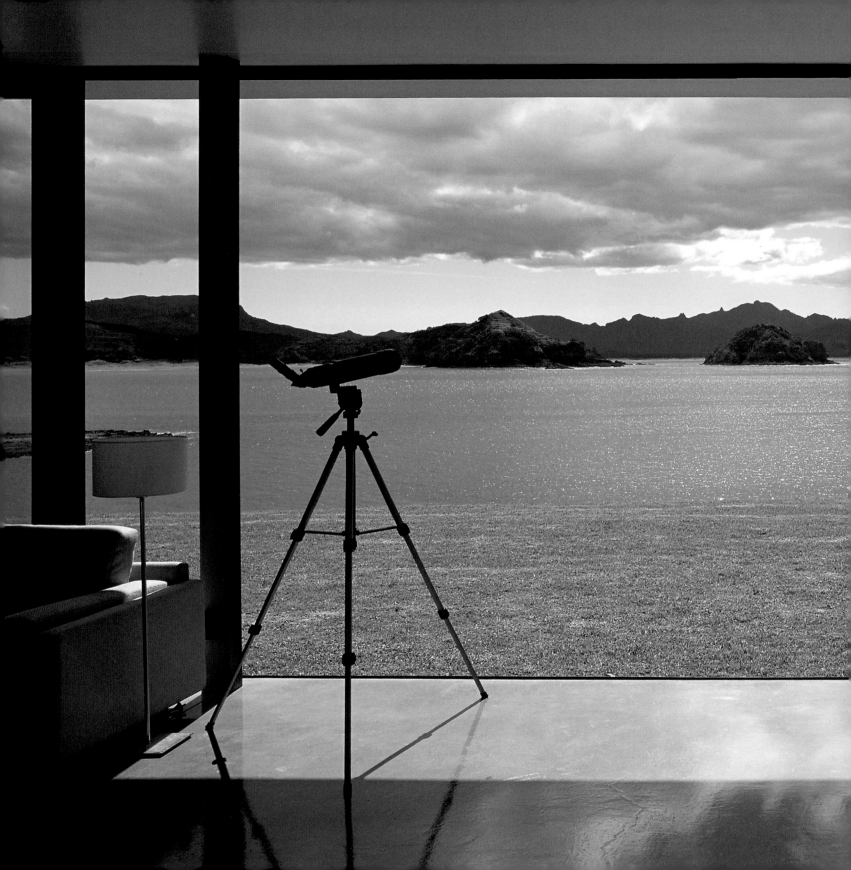

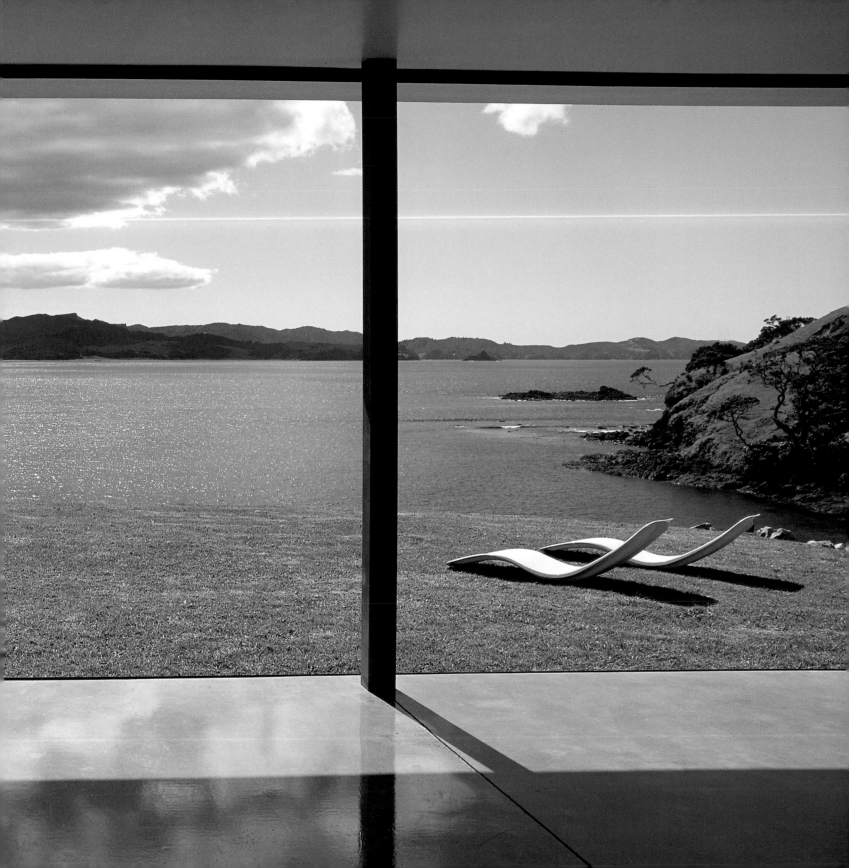

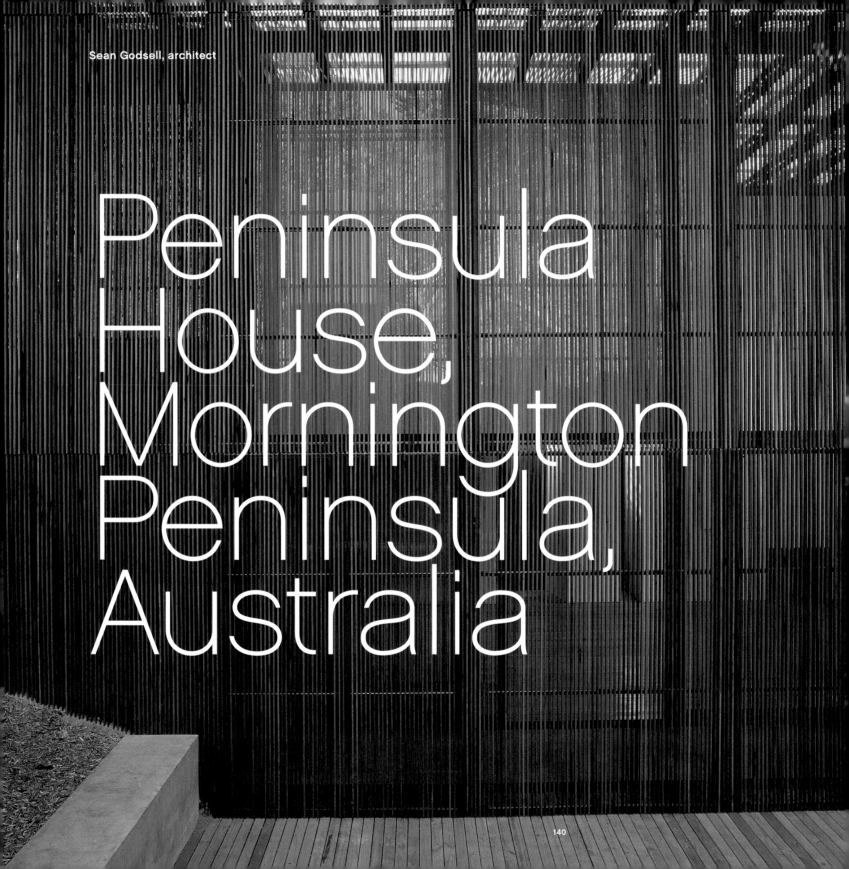

Sean Godsell, architect

Peninsula House, Mornington Peninsula, Australia

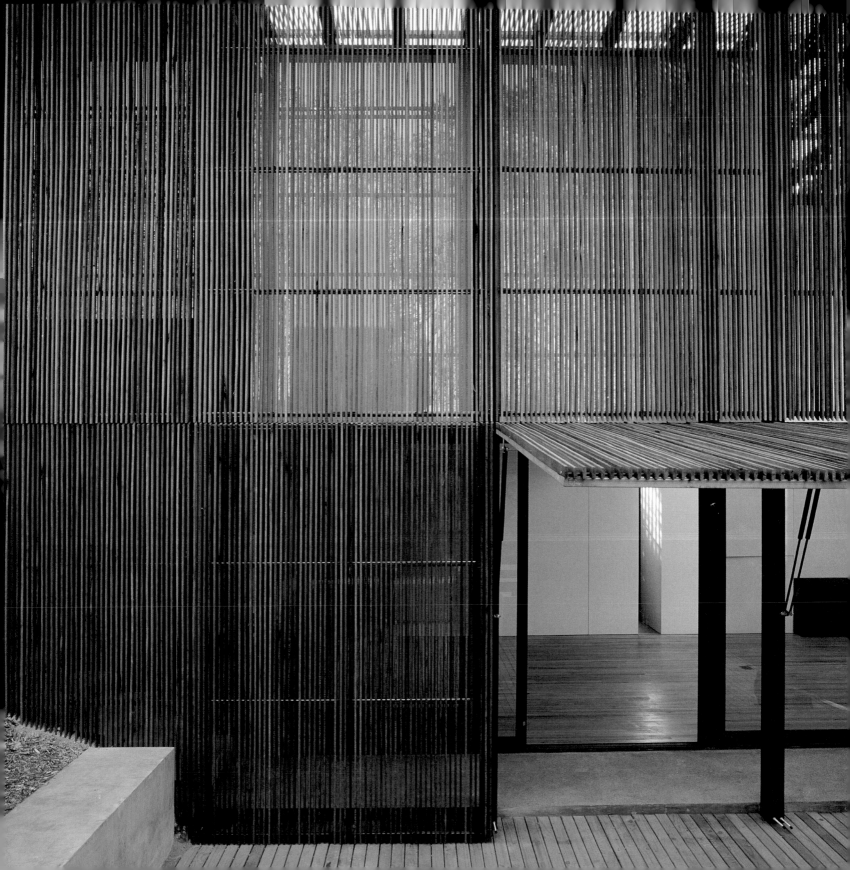

The Mornington Peninsula, a sweeping arc of land cradled between Port Philip Bay and the Bass Strait, just an hour's drive south of Melbourne, is an idyllic, not yet overdeveloped enclave of working wineries, protected beach reserves, and, of course, communities of vacation houses and weekend getaways. The Peninsula House by Melbourne architect Sean Godsell is not the typical Mornington retreat, but in many ways it captures—and enhances—the region's pristine natural beauty. It's a deceptively simple rectangular box that creates quiet, shady corners as well as bright, sunny outdoor rooms in which its owners can escape the bustle of Melbourne and enjoy the laid-back peninsula lifestyle.

The house sits on a scrub-covered cliff rising above the Bass Strait and nestles into densely covered dunes along a coastal reserve. One approaches the house along a dirt road that winds through seaside dunes. Godsell partially bermed the 2,300-square-foot box into the hillside, placing a carport, bedroom suite, and private courtyard on the upper level and a library and open living-dining-kitchen area on the lower level. As the bedroom suite above cantilevers into the double-height living area it creates a lower ceiling and gives a cozier scale to the open kitchen and the library behind it. Adjoining the lofty living space is a wooden deck and barbecue patio where the owners can dine alfresco.

The house is really a box within a box. The outermost layer is a delicate screen of timber battens; the inner container is wrapped in large panes of glass and Cor-ten steel panels. To reach the living spaces, one descends a walkway between the rusty enclosure of the carport and bedrooms, following the site's natural contours toward the loftlike public areas on the lower level. While the storage areas and sleeping quarters above are solid and private, the double-height living area on the lower level boasts walls of floor-to-ceiling glass. Operable panels in the eastern wall, facing the barbecue patio, tilt up on hydraulic hinges. When opened, the panels create overhead canopies that shelter an outdoor room.

Godsell left the north face of the lofty living room completely exposed, opening the room to the sun (in the Southern Hemisphere, north-facing rooms are the sunniest) and to the outdoors with a pivoting expanse of glass that dissolves an entire wall. In a similar move, an entire glass wall of the bathroom tilts up to open the space to a quiet rock garden in a courtyard shaded by wooden battens overhead.

All of the timber-batten screens are made of recycled jarrah wood, a eucalyptus species from southern Australia with a deep reddish-brown hue. The jarrah approaches the color of rusty steel, especially as it takes on the orangey glow of afternoon light. Depending on the sunlight and one's viewpoint, the screens appear solid or gauzy, massive or delicate. The wooden screens are the key to making a tough but laid-back house that fits discreetly into its desirable setting, with free-flowing divisions between inside and out. It's exactly what a beach house on the Australian coast should be.

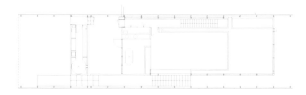

Upper-level plan

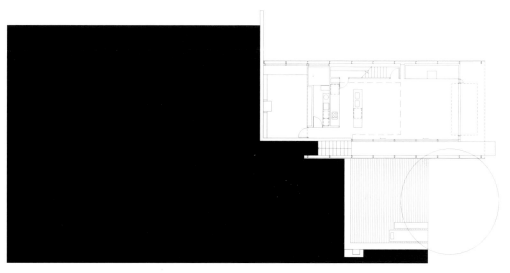

Lower-level plan

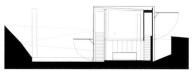

Cross-section

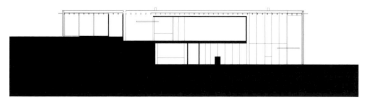

Longitudinal section

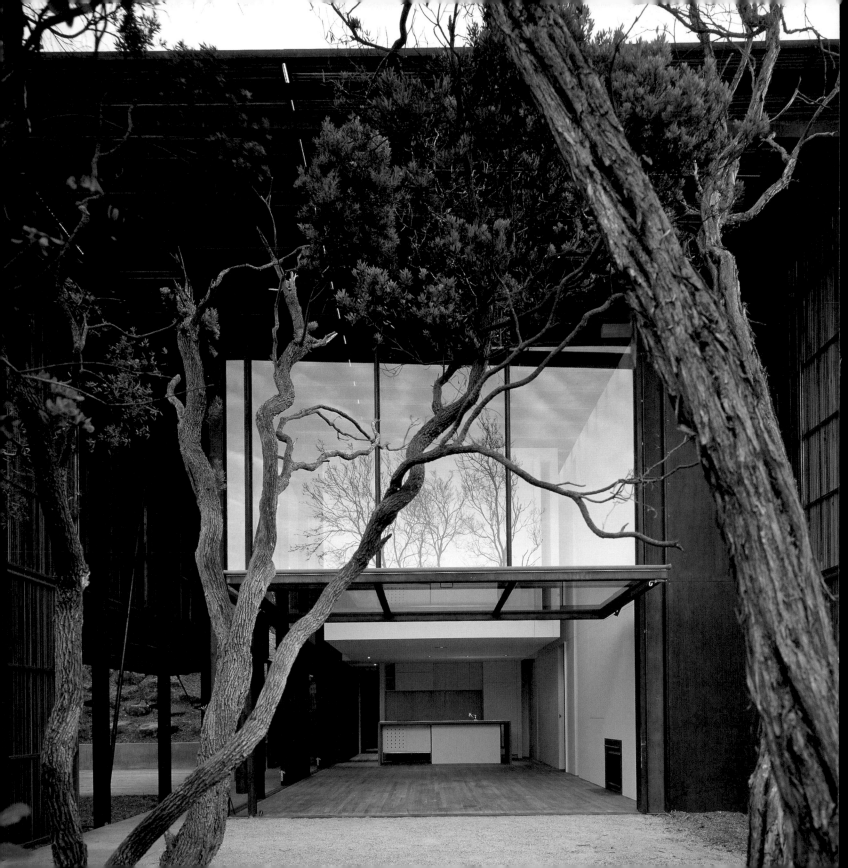

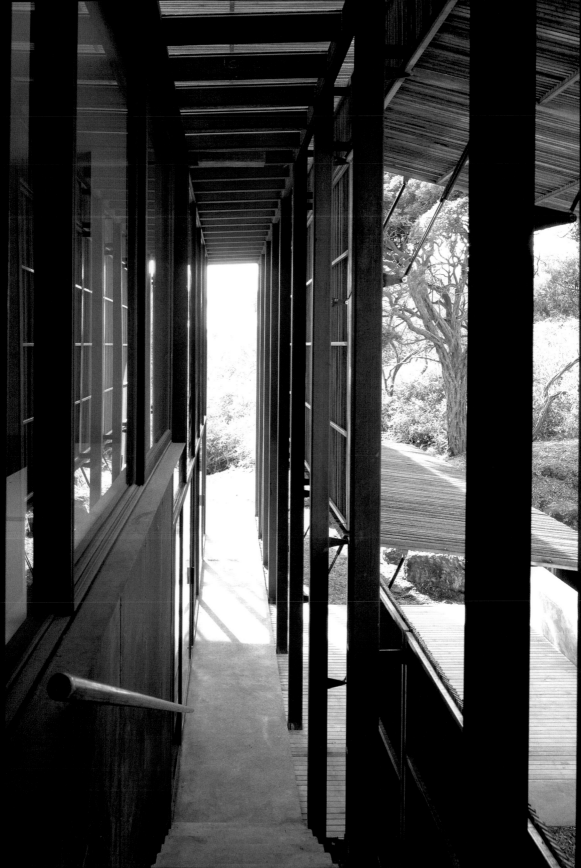

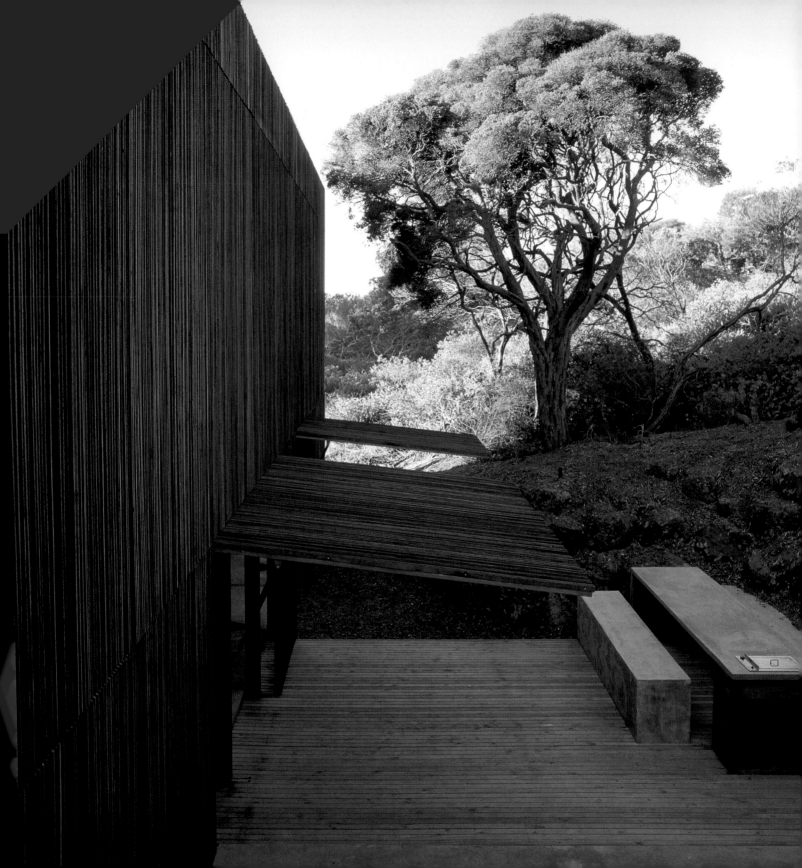

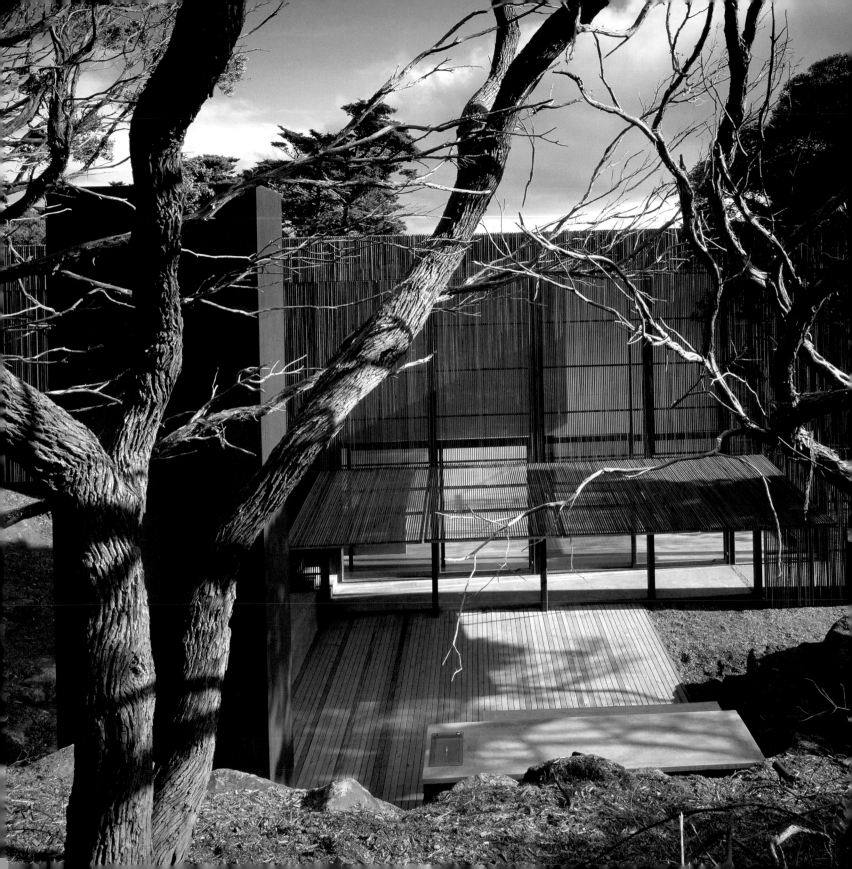

Paihia Retreat, Paihia, New Zealand

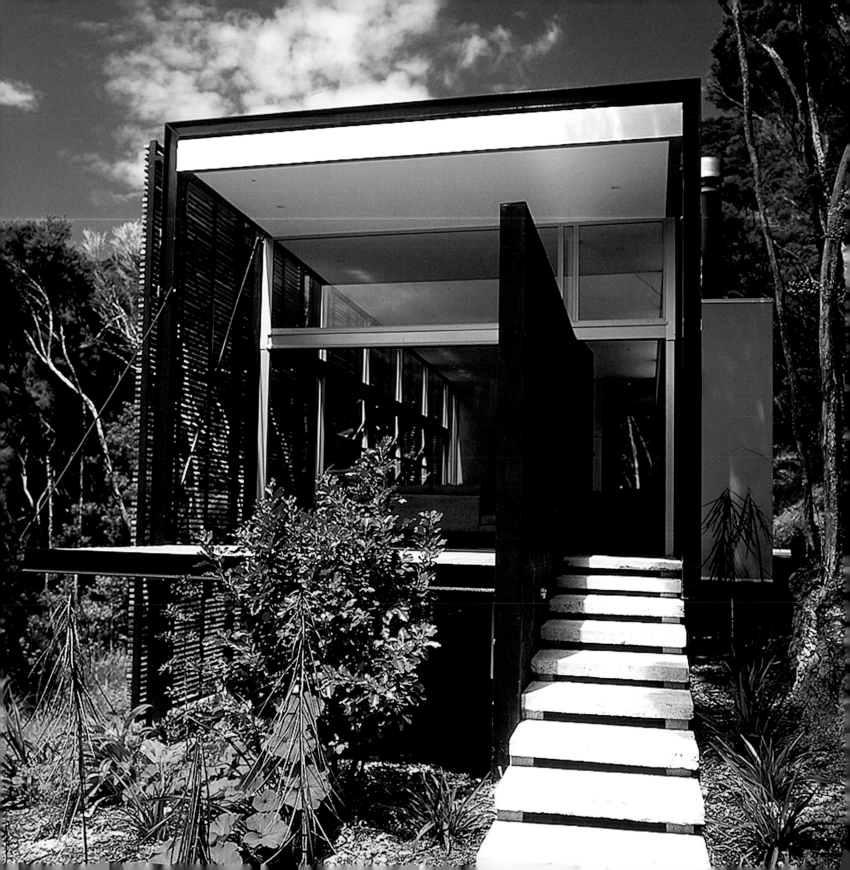

The Bay of Islands, a few hours' drive from Auckland on New Zealand's North Island, is just one of the countless spectacular landscapes that endow every corner of this lush South Pacific nation. True to its name, the bay's clear turquoise waters are dotted with tiny islands and surrounded by curving inlets and coves with white-sand beaches. In the town of Paihia, population 2,000, Auckland architect André Hodgskin built a colorful retreat for a single man on 10 acres of unspoiled bush overlooking the Bay of Islands' postcard-perfect waters. The owner wanted a simple and low-maintenance but well-detailed house that he could lock up and leave behind without worries.

The South African-born Hodgskin is no stranger to building beach houses in spectacular New Zealand settings, having designed many in places such as Waiheke Island, the laid-back island getaway a short ferry ride from downtown Auckland that's now a booming bedroom community and wine lover's hotspot. At Paihia the architect cleared a patch of the thick bush covering the pristine hillside site to open up views of the bay through the dense landscape of thin ti trees. The ti trees' distinctive black trunks inspired parts of Hodgskin's design, a simple rectangular structure with blackened steel portals and timber screens.

The house is, in essence, a long box capped by a flat roof and open to the outdoors at its short ends. From the entrance it appears welcoming, with a gently stepped walkway leading up to a front door separated from a wooden deck by a solid wall. Inside it's a light and airy double-height loft, a single open volume with living and dining areas and an open kitchen. Wooden decks on every side extend out toward the wooded landscape, breaking the confines of the box and extending interior living spaces to the outdoors.

On the more private south-facing side of the house, a deck follows the rugged contours of the rock formations surrounding it. Bright green walls inspired by the color of springtime foliage mark the boundary between indoors and out. On the sunny north side of the house, blackened horizontal timber lattices shade three industrial garage doors that open up the lofty living spaces to the outdoors.

At the back of the house, the floor splits in two, creating a pair of identical bedroom suites stacked atop each other. The uppermost bedroom gets the added bonus of a small balcony extending out into the bush like the squared-off prow of a tiny ship. A freestanding closet floating within the larger volume of each of the bedrooms creates a logical backdrop for the beds—architectural headboards of a sort—that enjoy views of the dense, hilly bushland. Hodgskin's house, which the New Zealand Institute of Architects honored as one of that country's best works of architecture in 2004, harmonizes easily with the native landscape. The bold black and green palette might seem like a graphic choice, but it cleverly distills the colors and textures of its surroundings into a clean, modernist language. The client got his wish for a simple, low-maintenance getaway; he also got a sophisticated work of South Pacific modernism.

previous page
The simple boxlike house opens to the surrounding tree-covered hills with large expanses of glass shaded by deep roof overhangs and slatted timber screens.
following spread
Wooden louvers shade the operable glass walls of the open living-dining area (left) that occupies most of the square footage. The color scheme of the crisply detailed box echoes the blackened trunks of native ti trees and the hues of fresh springtime foliage (right).

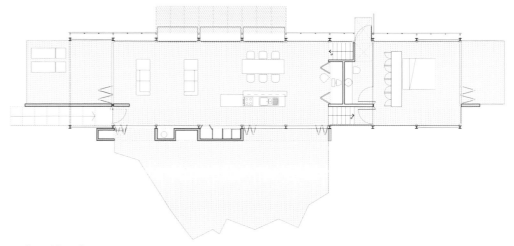

Ground-floor plan

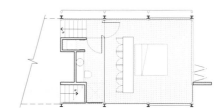

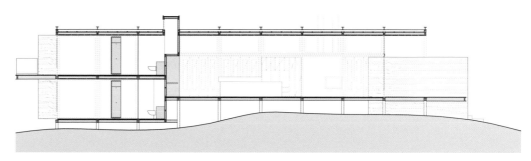

Lower-level plan

Longitudinal section

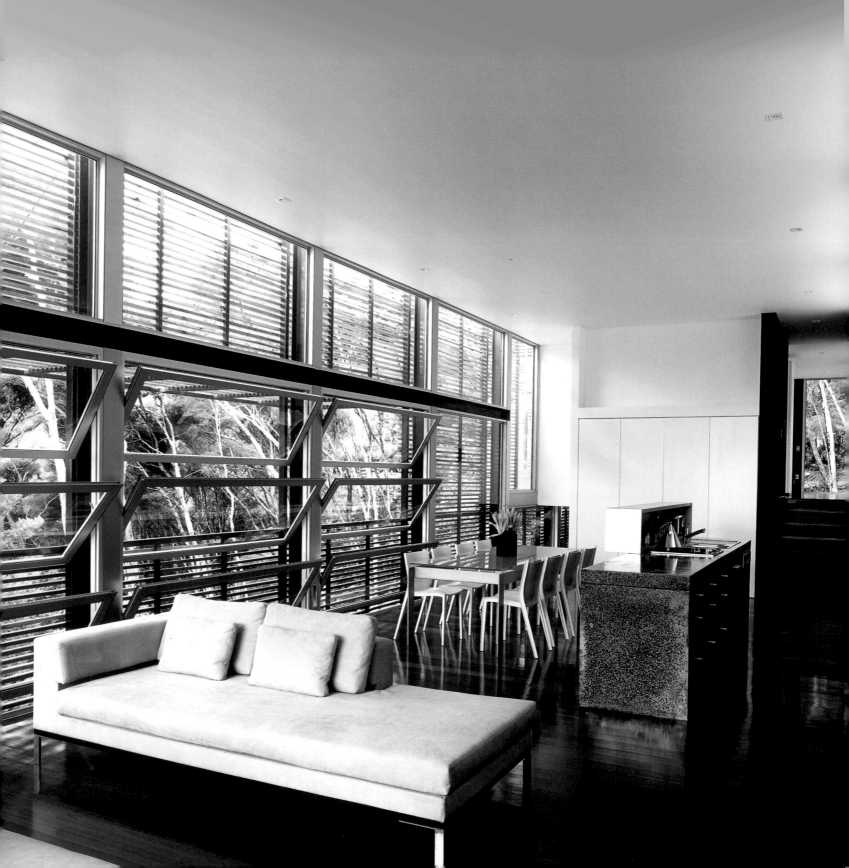

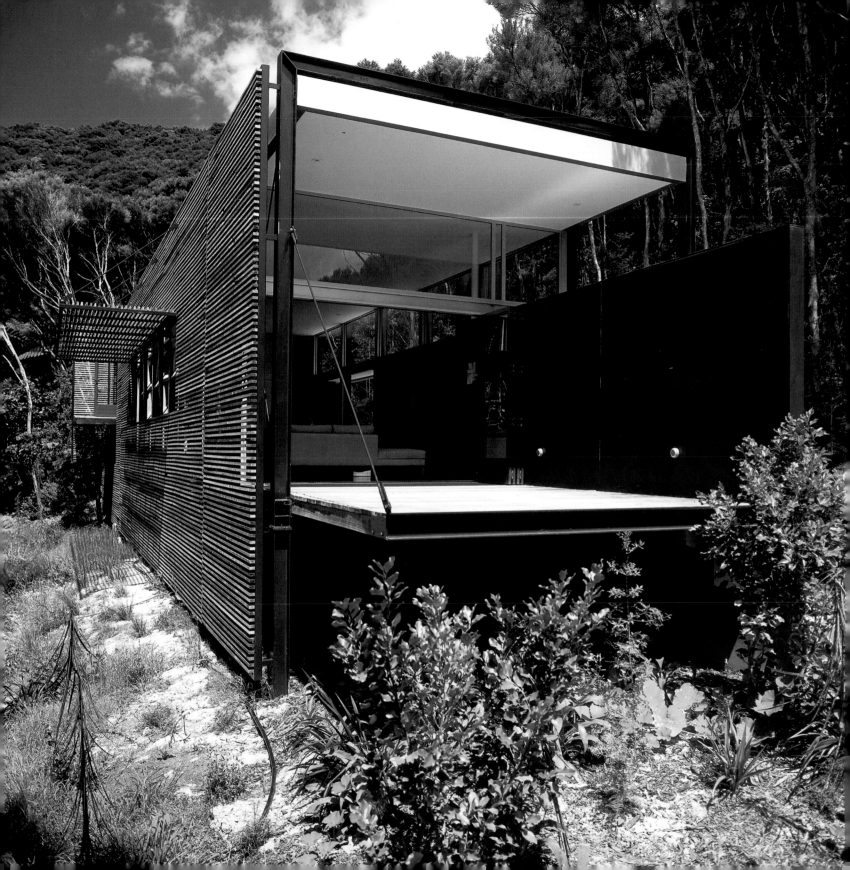

V42 House, Bangkok, Thailand

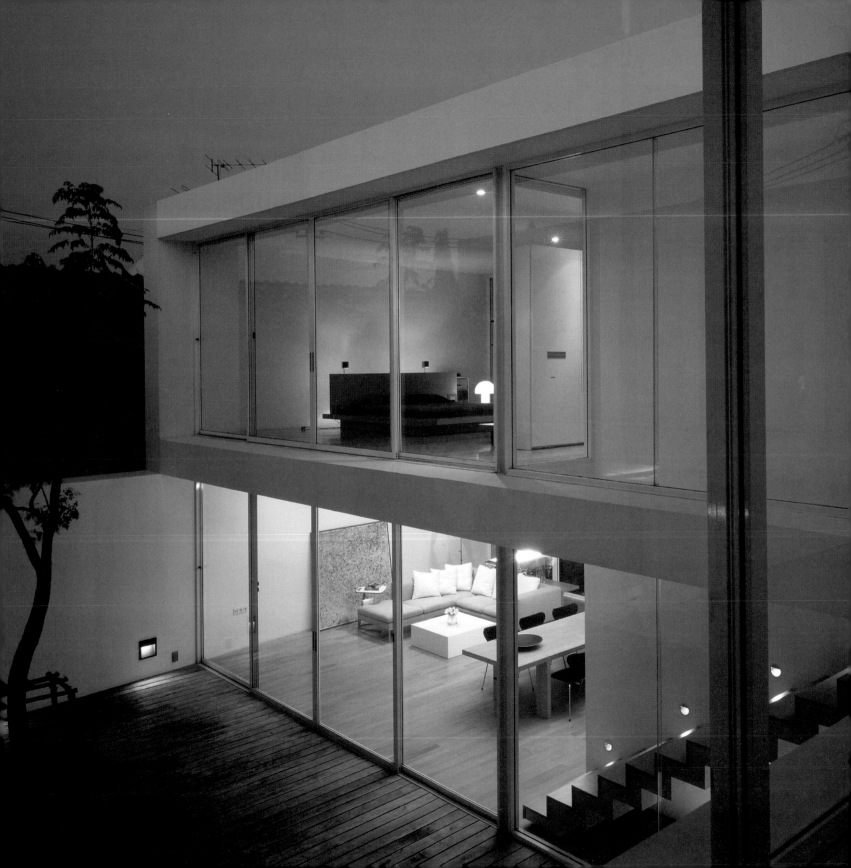

With its messy sprawl, constant gridlock, and choking smog, Bangkok is not the most picturesque of Southeast Asian cities, at least on the surface. It's a bustling city with great energy and allure, but a place where making a home shielded from the urban chaos but still open to the warm tropical weather can be a challenge. The young Bangkok architect Duangrit Bunnag faced that very conundrum when he designed a house in Bangkok. Bunnag, who studied architecture in his native Bangkok and at London's Architectural Association, solved the problem by creating a house that turns a closed, quiet face to the neighborhood and then opens up inside with a large courtyard open to the sky.

From the street the house appears simple, almost modest, with a wooden gate enclosing a driveway and a small entry door in a whitewashed wall. The second story, a plain white box enclosed in floor-to-ceiling glass, peers above the wall. Once inside, the driveway behind the gate opens onto a long rectangular courtyard covered in wooden decking. A pair of two-story rectangular white volumes covered in bands of floor-to-ceiling glass walls and sliding doors define the long sides of the courtyard. With its curving trunk and branches, a lone tree emerging from the decking offers a break from the relentlessly straight lines of the architecture around it.

The two pavilions are almost exactly the same size, making for a neat and tidy division of functions. The ground floor of the street-side volume contains a studio and playroom next to the carport and a pair of bedrooms upstairs, with a shared bathroom between them. The other block holds an open living-dining room and kitchen on the ground floor and a master suite above it, which fills the full length of the structure. A freestanding closet separates the sleeping area from the luxurious bathroom, a cool, luminous space enclosed by translucent glass. On the second floor a long glass-walled corridor connects the two bedroom wings; downstairs the wings remain separate.

All of the ground-floor spaces open to the outdoors with tall sliding glass doors that stretch from floor to ceiling. When the doors slide open, inside and out connect almost seamlessly. (The wooden planks of the courtyard floor have weathered to a pale gray, while the floorboards inside still have their warm honey-colored glow.) One side of the living-dining room opens onto a tiny open-air garden filled with tropical foliage that really lets the outdoors feel like part of the interior when the glass doors slide open.

The house uses space and light, rather than a variety of different materials, to give it character. In fact, with white walls, glass doors, and plain hardwood floors, there isn't much of a palette to talk about. But the overall effect of the house is quite rich, with tropical sunlight and glimpses back and forth across the courtyard making the rooms feel much larger than they actually are. Bunnag succeeded in making a sheltered, inwardly focused house feel open to the outdoors but protected from the urban congestion of Bangkok.

previous page
Walls of sliding glass doors overlook the internal courtyard between the two volumes of the U-shaped house.
following spread
The wood-slatted courtyard on one side of the lofty living-dining room (left) and a walled-in tropical garden on the other allow the owners to open walls of sliding glass doors without compromising privacy. The second-floor master bath (right) is a light-filled, whitewashed retreat enclosed by walls and doors of translucent glass.
pages 160–161
A glass-enclosed bridge above the entry to the central courtyard (left and right, at center) connects the two wings of the house at the bedroom level.

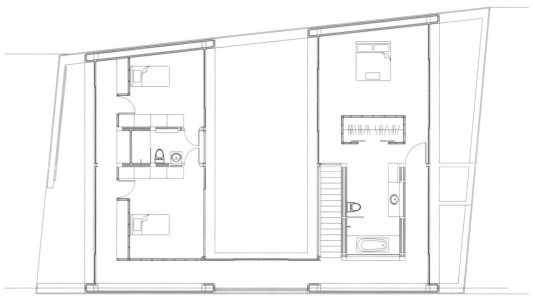

Upper-floor plan

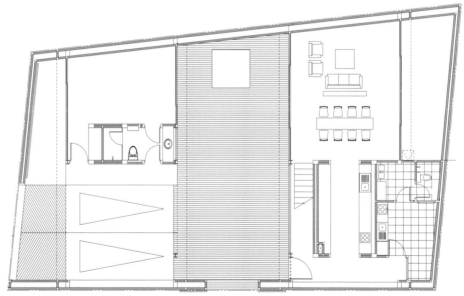

Ground-floor plan

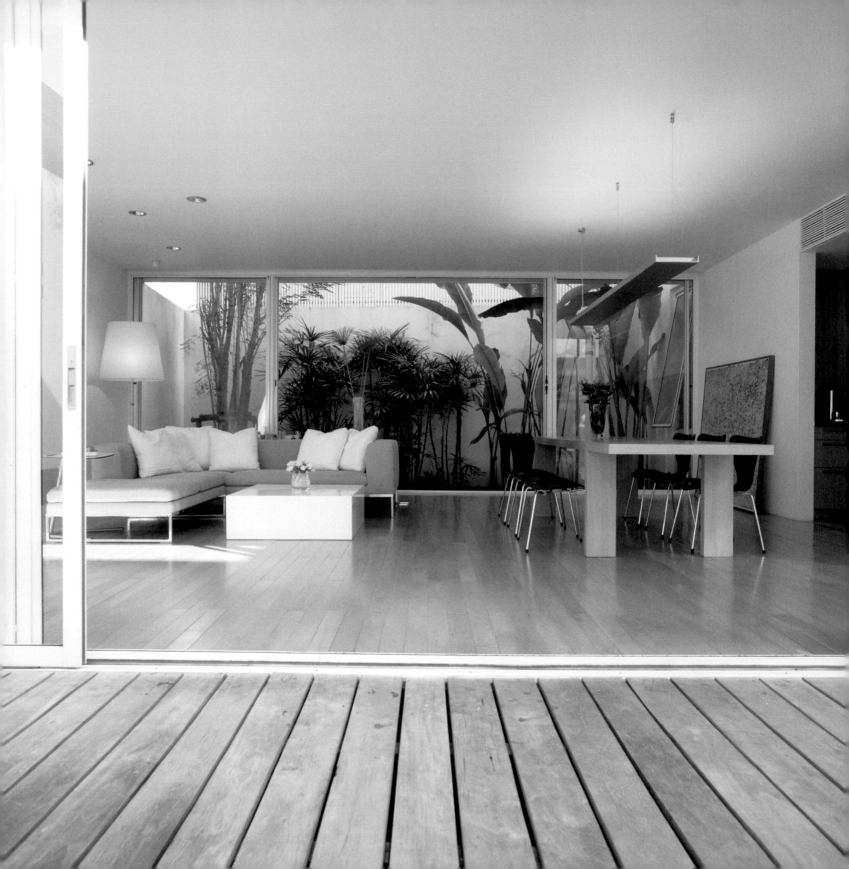

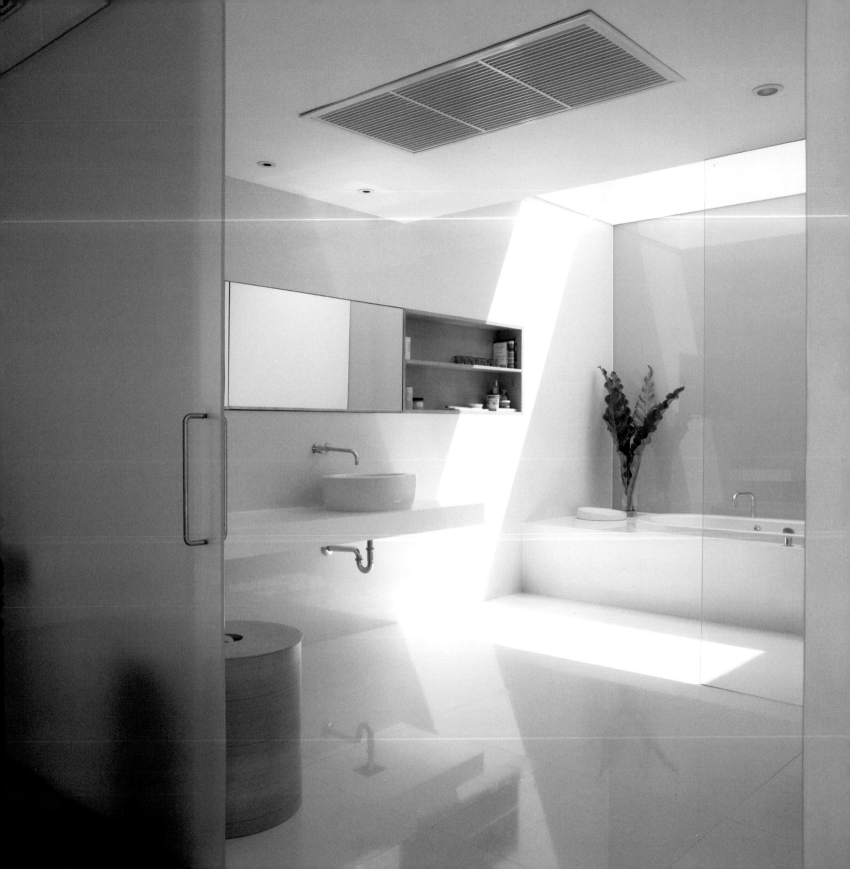

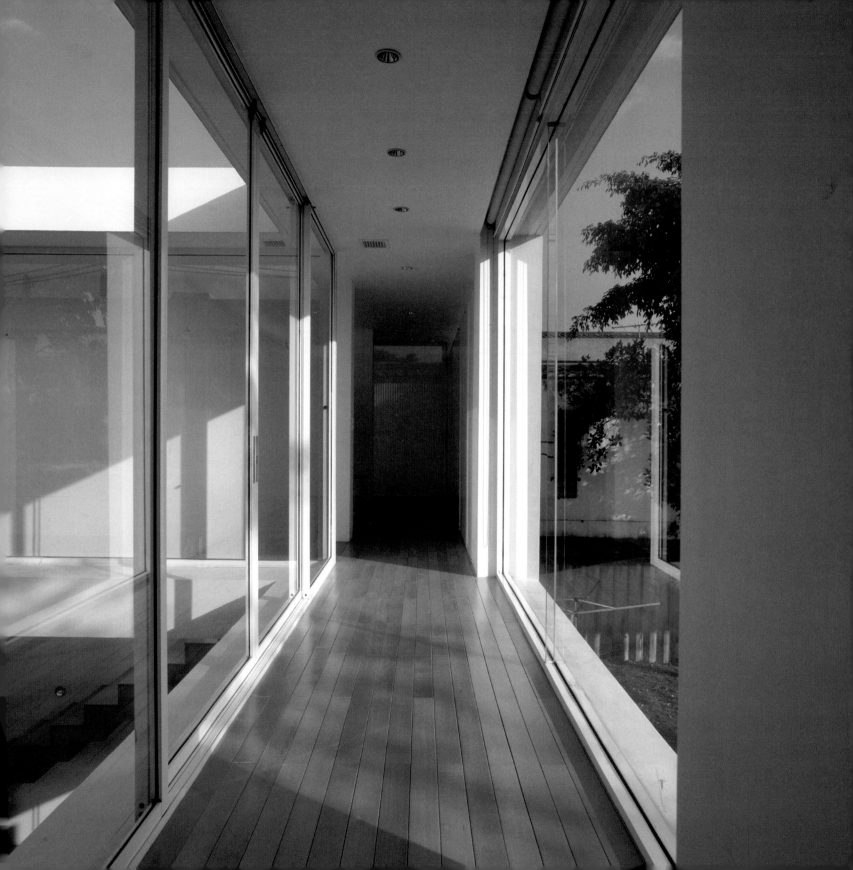

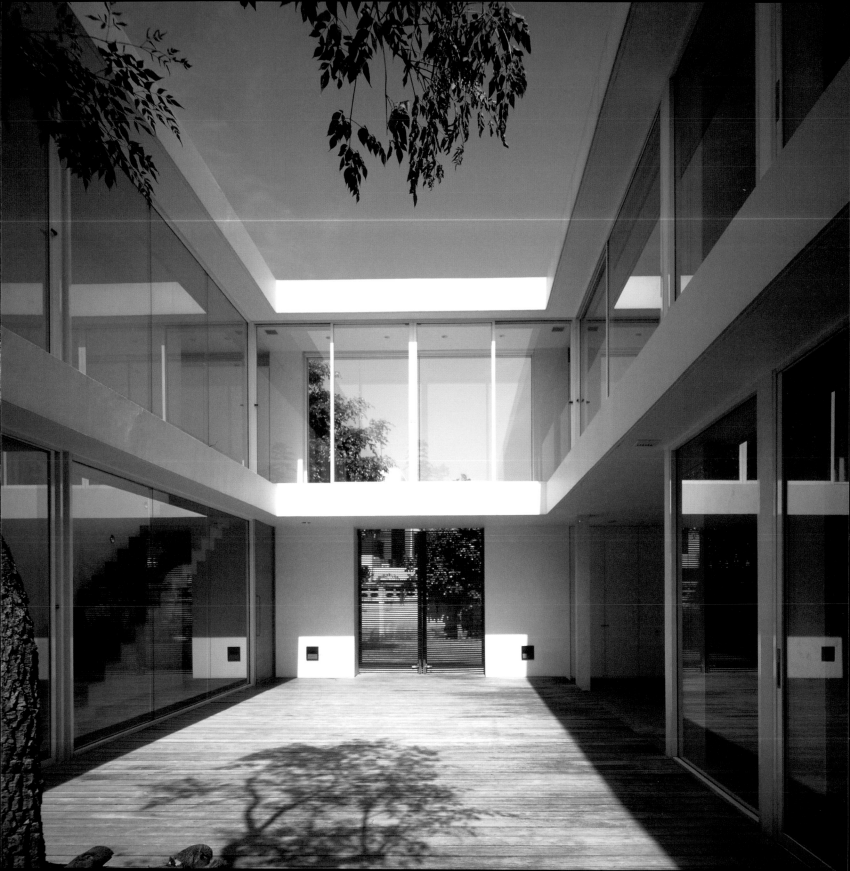

Andrew Road House, Singapore

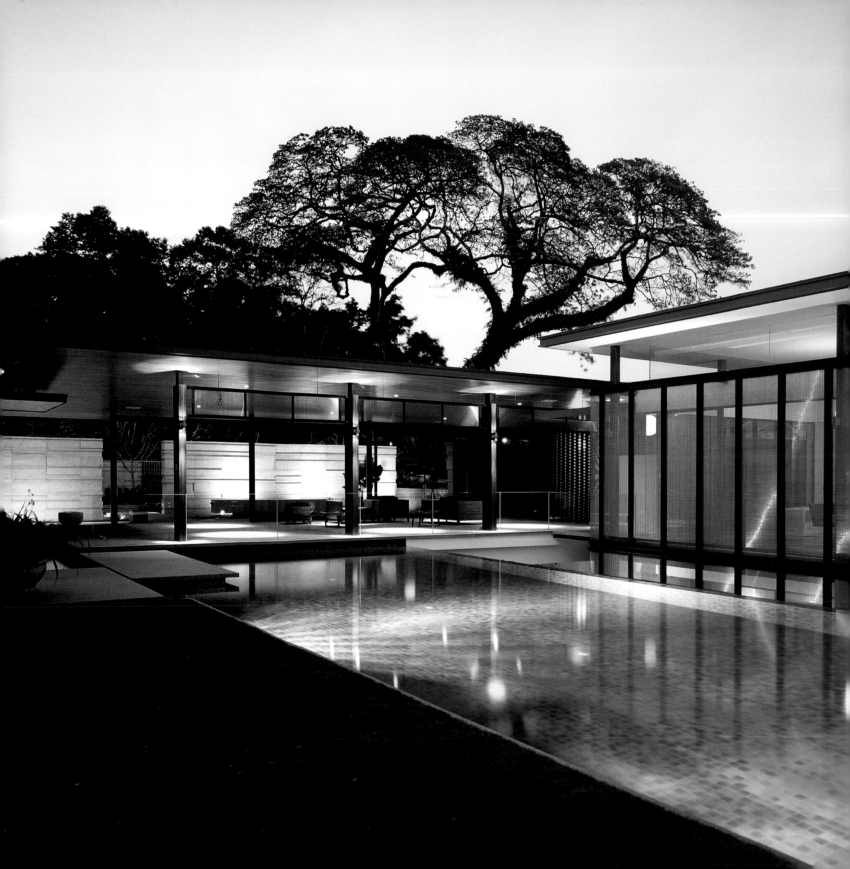

Singapore's SCDA Architects' signature style captures the sophisticated culture of this industrious Southeast Asian city-state: sleek, stylish houses that embrace the region's sultry climate and intense tropical sunlight. The house they designed on suburban Andrew Road is no exception. With three distinct volumes covering 14,523 square feet (1,350 square meters) of space, the sprawling house is a compound of structures carefully arranged atop a slightly sloping site. But the house's physical and visual openness keeps it from feeling shut off from its surroundings. The architects describe their design more lyrically, as a series of carefully choreographed movements following a staccato rhythm.

One enters the house through an opening in a textured stone wall that frames an axial view of the swimming pool beyond and then moves into the first of three flat-roofed rectangular volumes. The architects call this the reception pavilion: It's a dramatic 10½-foot-tall towering room without walls, just slender columns supporting a flat teak wood–lined ceiling. At one end of the space is a 10-foot-tall lantern built of timber and lined with a woven-steel fabric. Lit from within at night, the latticed wood lantern creates a soft, welcoming glow.

Beyond this grand public foyer, a lap pool separates the two other wings of the compound. To one side, reached along a footbridge separating the swimming pool from a reflecting pool, is a long box clad in stone and timber screens, which contains the main living and dining area, a master suite, and additional bedrooms on two above-ground stories and one below-ground level. Long, narrow windows set into the higher reaches of the stone enclosure create privacy along the bedroom wing.

On the other side of the lap pool is a more public two-story pavilion, veiled in a delicate screen of Chengal wood battens that create a gauzy enclosure that glows at night like a long, boxy lantern. This wing contains an entertainment area at the garden level and a guest suite below, reached via a spiral staircase. The lower level of the two-story wing is set back from a narrow courtyard framed by a patterned stone-covered retaining wall. Although it's below the level of the pool and garden, it doesn't feel like a basement. In fact, sliding glass doors open onto a reflecting pool along the length of the stone wall. Also on this lower level, beneath the entry pavilion, is a parking court for four cars, reached by an access stair surrounded by woven-steel mesh.

With its play of open-air living spaces, shady retreats, and the sensory appeal of water and landscape, SCDA's design gets to the best of living in the tropics. Singapore's intense overhead sun and equally intense monsoon rains require more protection than one might think. The architects used broad overhanging roofs and sensuous wood screens to temper both of these perils of the tropics without detracting from the house's sense of openness and relaxation. At times, there is hardly any architecture at all; but it's enough to make this a bold piece of tropical modern architecture.

previous spread
A long, boxy volume clad in a delicate screen of wood battens (left) contains a room for entertaining at garden level and a guest suite below. Flanking the short end of the pool is a dramatic, open-air reception pavilion (right).
following spread
The living room of the main house overlooks a walled-in reflecting pool.
pages 168–69
A change in topography allows the guest suite beneath the entertaining pavilion (left) to overlook a reflecting pool one level beneath the pool and garden. The wood-encased second-floor bedroom wing of the main house (right) telescopes beyond the stone-clad walls separating the main structure from the reception pavilion and guest wing.

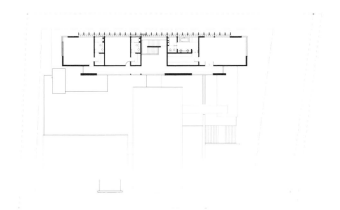

Upper-level plan

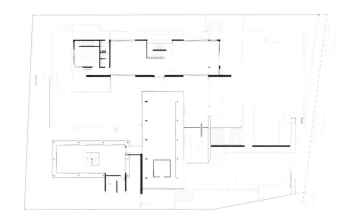

Entry-level plan

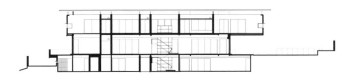

Longitudinal section

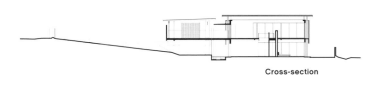

Cross-section

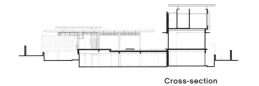

Cross-section

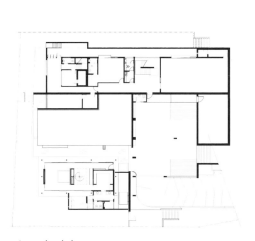

Lower-level plan

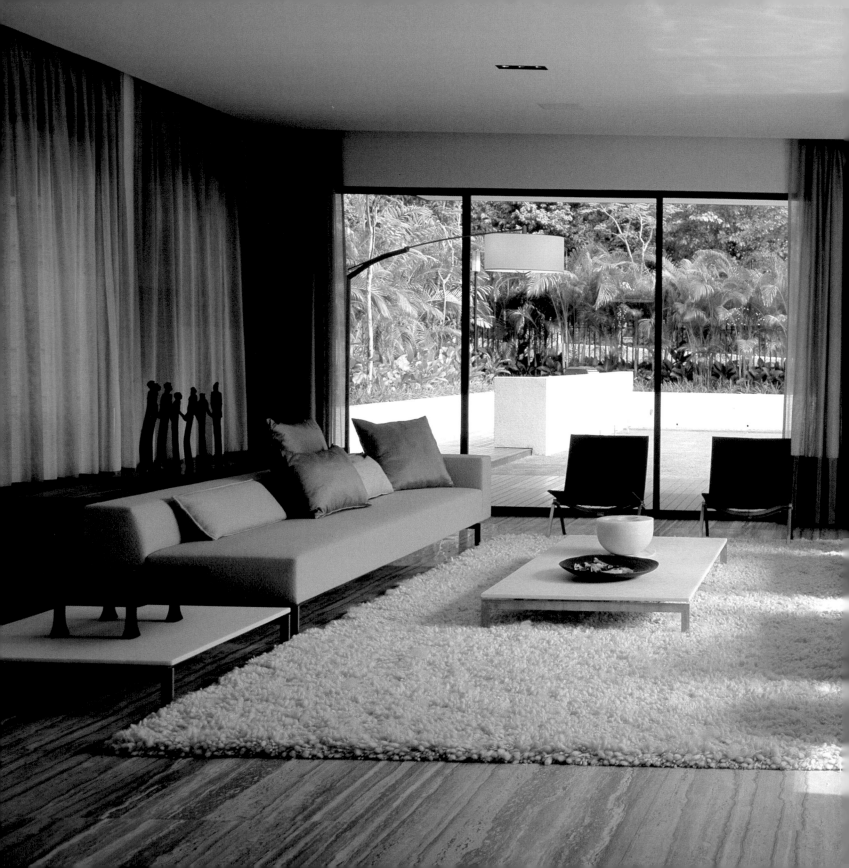

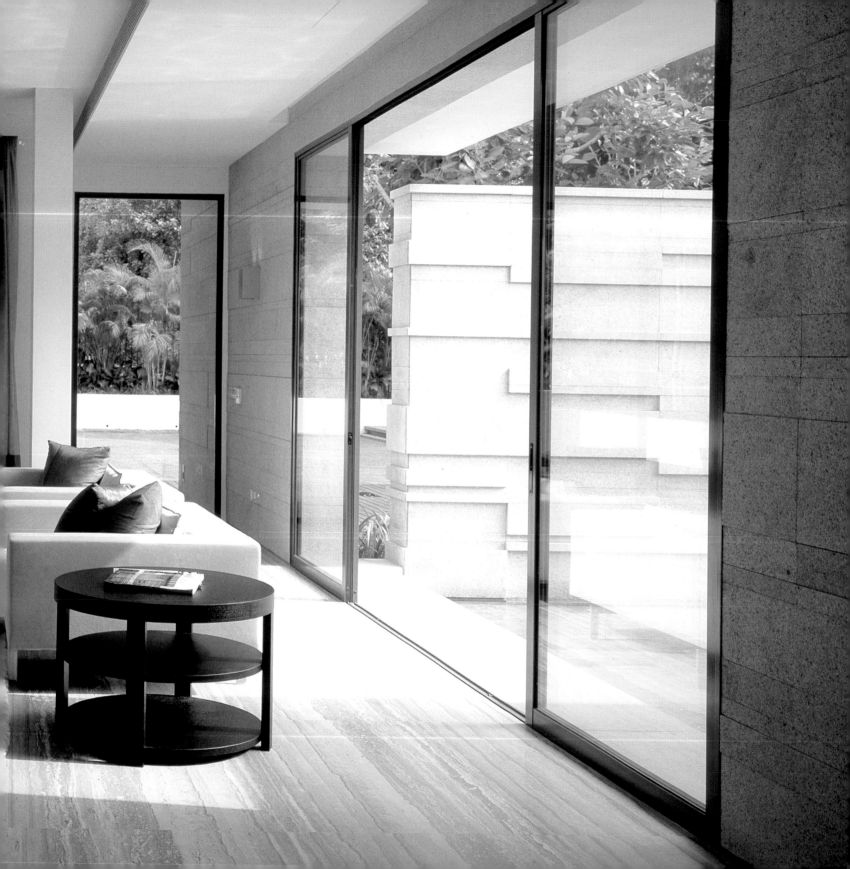

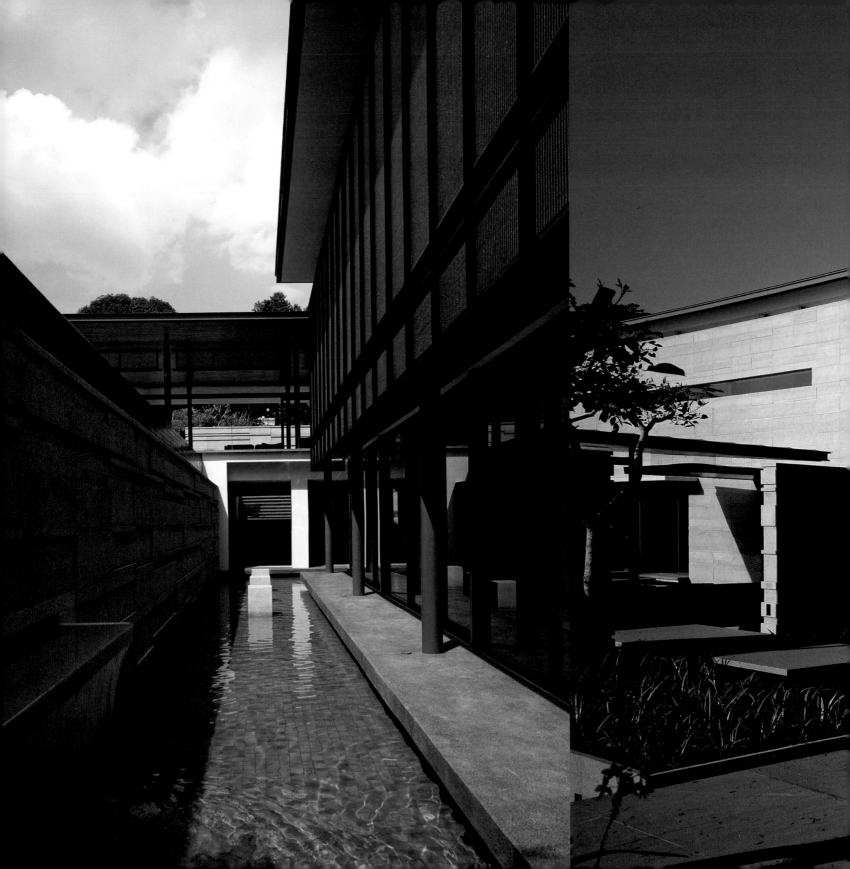

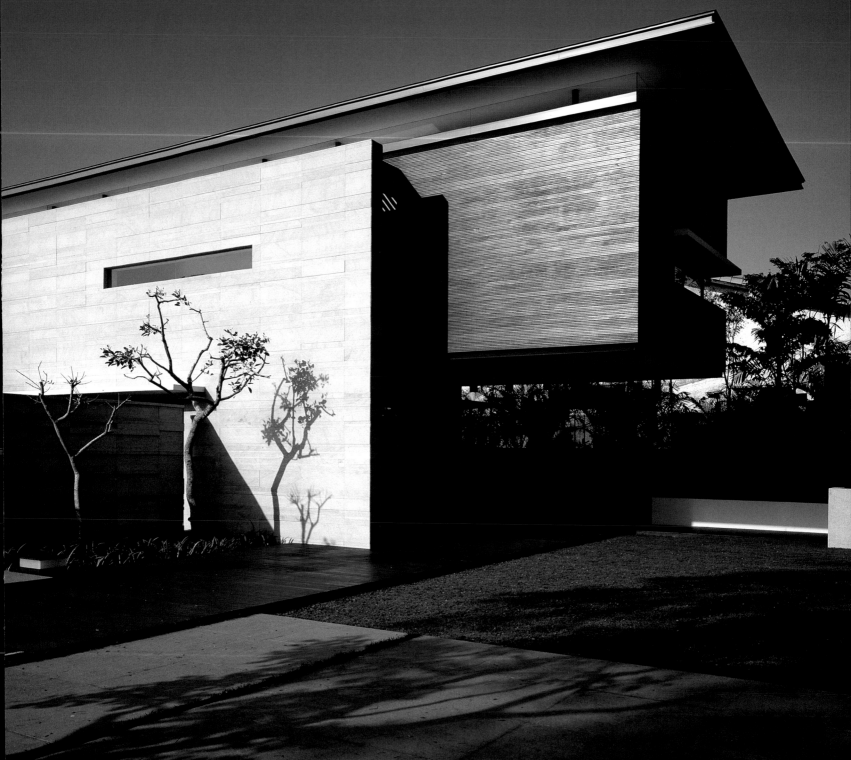

Glenn Murcutt, Architect

Fletcher-Page House, Kangaroo Valley, Australia

Like many of Pritzker Prize-winning architect Glenn Murcutt's houses, the Fletcher-Page House in Australia's pastoral Kangaroo Valley, 100 miles south of Sydney, draws on Aboriginal and early Australian colonial structures as well as rigorous high modernism. The point of Murcutt's synthesis is to root buildings in their cultural and especially their physical setting. The Fletcher-Page House's simple, straightforward profile, a long, narrow bar topped by a sloping metal roof with deep overhangs, frames broad horizontal vistas of the surrounding landscape, the quintessential Australian bush.

The house, a simple, slender rectangular volume 109 feet long and 14 feet wide, sits confidently in a clearing in the woods. A bedroom, bathroom, studio, and garage sit to one side of the small entry hall; to the other is the lofty open living-dining room and kitchen. Beyond is the master bedroom and the typically Australian verandah, or covered porch, overlooking the view. Partitions dividing spaces within the box don't quite reach the sloping metal roof. Clerestory windows above the partition walls let daylight flow through the entire house while creating some acoustic separation between rooms. The partitions make the box feel less like a loft while maintaining the easy flow of space and light throughout the house.

Murcutt kept the house visually open to the outdoors. On the northern exposure (the sunny side in the Southern Hemisphere), the architect extended a deep roof overhang to shade the ribbon of clerestory windows extending the length of the entire elevation. Louvers and retractable wood shutters protect north-facing windows that cross-ventilate the narrow house. Luckily, the choice views of the green Kangaroo Valley hillsides were on the shadier south side, so Murcutt could open up this side of the house as much as he liked. Along the lofty living and dining area, sliding glass doors open up the indoors to the outdoors. Screens keep the bugs at bay; rolling wood shutters add privacy.

Since the south elevation is given over to so much glass, Murcutt placed fixed functions on the northern side of the house, where he wanted to minimize the number of openings to keep out the direct sun. Plumbing and wiring is contained in the north wall of each room. The northern side also accommodates the laundry room (part of the garage), the sink and rows of cabinets in the kitchen, the fireplace in the living-dining room, and the guest room's built-in desk.

Keeping the south side as open to the view as possible had a transformative effect: When these glass doors are open, the house gains more than a panoramic valley view and intimate contact with nature; the whole house becomes a verandah. Australians rightly describe their treasured verandahs as outdoor rooms, rather than porches added on to the side of a house. In the Fletcher-Page House, Murcutt takes the idea one step further. With economical means, he exponentially expanded the scale of the verandah to become an entire house. Once again, Murcutt took the lessons of Australia's architectural past and turned them into a simple, stylish modern house very much in touch with its surroundings.

previous spread
Large corrugated-metal tanks flanking the south-facing entrance catch rainwater directed by gutters along the sloping roof.
following page, clockwise from top left
A wall of sliding glass doors opens the narrow bar-shaped house to the outdoors. An open loftlike kitchen/living/dining room occupies the center of the house. A band of north-facing clerestory windows extending the length of the low-slung house bring sunlight into the house. Panes of glass above doorways and partition walls that stop short of the angled ceiling create the impression of a continuous flow of space through the house.

page 175
Deep roof overhangs shade an outdoor verandah; sliding wood louvers draw across a west-facing window.
pages 176–77
When floor-to-ceiling glass doors are drawn open, the entire house opens to the outdoors like a giant verandah.

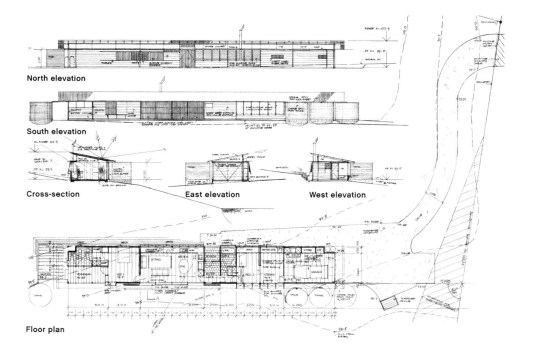

North elevation

South elevation

Cross-section East elevation West elevation

Floor plan

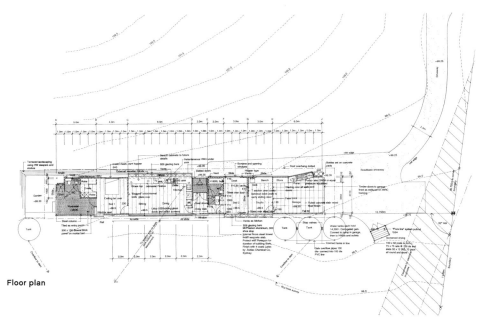

Floor plan

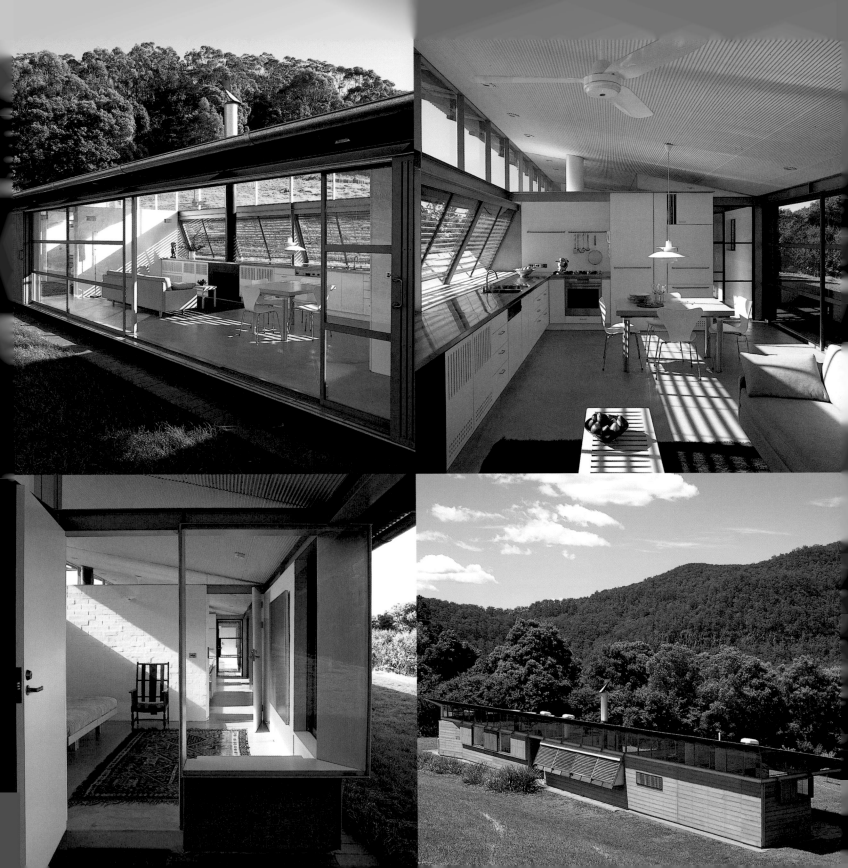

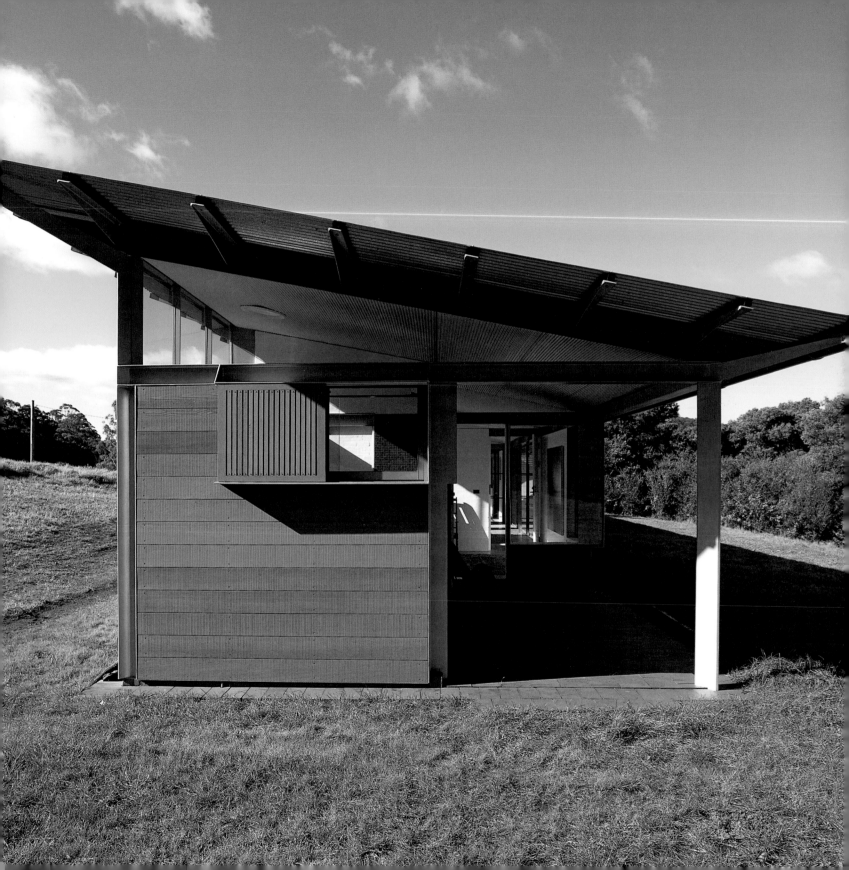

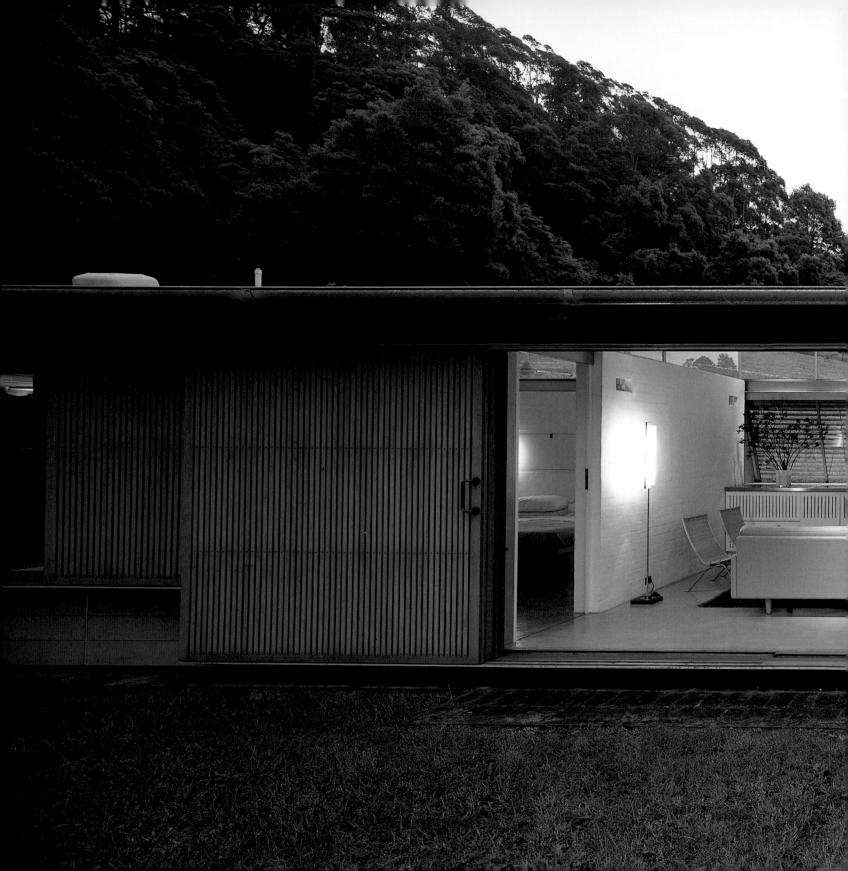

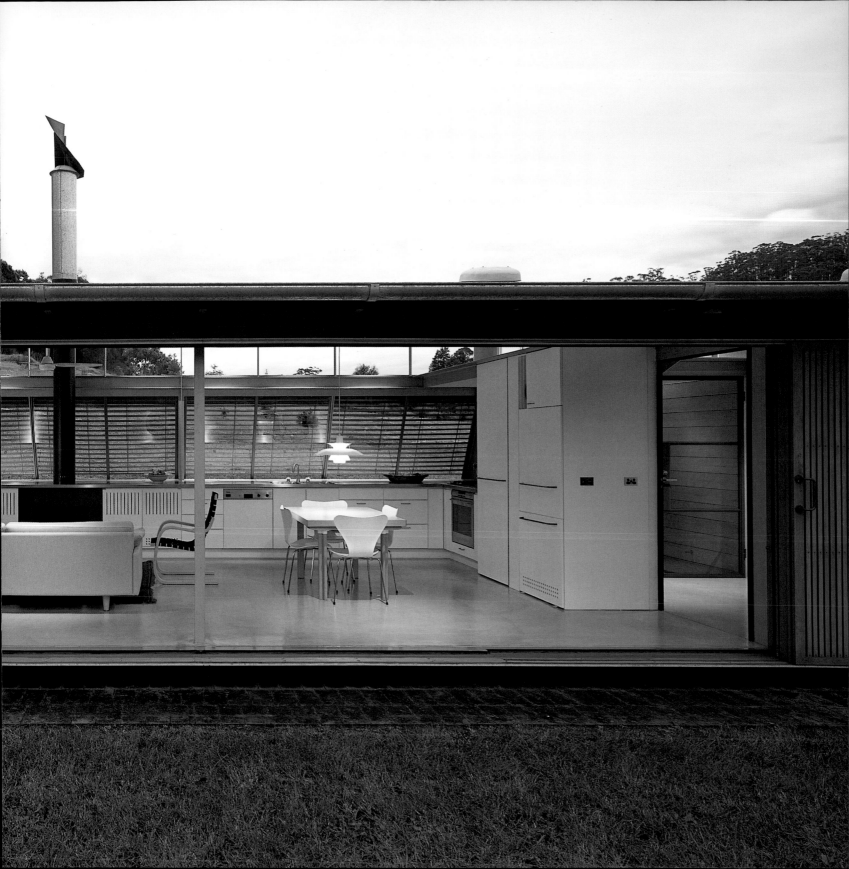

Mackerel Beach House, Mackerel Beach, Australia

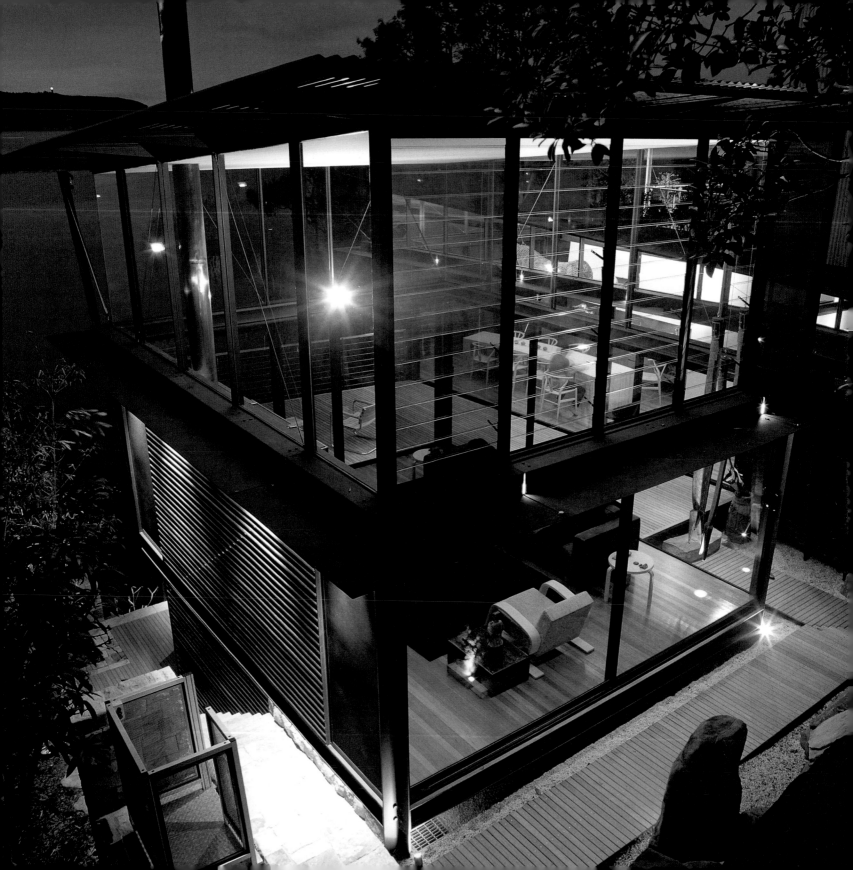

For a close weekend escape from the city, fashionable Sydneysiders head an hour or so north to Palm Beach. This narrow, winding peninsula cradled between Pittwater bay and the wide-open South Pacific draws movie stars and other glamorous types to its lush hillsides overlooking powdery beaches and brilliant blue seas. The other side of the bay, however, boasts a completely different character, infinitely more casual. In the town of Mackerel Beach, sandy "streets" and a discernable laid-back vibe greet you the second you arrive onshore by ferry or water taxi. High up on a hillside overlooking Mackerel Beach, Sydney architect Robert Brown built a spectacular hideaway that embodies the hamlet's casual spirit, but with polished, elegant modern materials.

The clients, an affable middle-aged couple, told the architect they wanted a tent. Brown delivered a refined, sophisticated structure—but a simple one, in a sense not too far off from the owners' initial request. The house is really a series of separate and interconnected glass and steel pavilions perched on a plinth of reddish orange sandstone. The volumes climb up the steep hillside to capture sweeping 180-degree views across Pittwater to the rocky Barrenjoey Head and its telltale lighthouse, and to the unspoiled green of the Ku-ring-gai Chase National Park off to one side.

The house conveys a vaguely Asian feeling as you enter along a slatted-wood walkway surrounded by gravel, squeezed between the house to one side and boulders and the hillside to the other. The first level contains two lofty open structures: one with the kitchen, walk-in pantry, and dining room, the other with the living areas. Although the pavilions are separate, their corrugated red copper roofs overhang each other to create a continuous flow of covered space, with no hard distinctions between indoor and outdoor rooms. The only real distinction is the floor: weathered outdoor decking or polished interior flooring. A large Aboriginal fish trap hangs above the dining table as an organic sculptural piece that plays off the hard-nosed modern style of Hans Wegner chairs and the gently curved silver ash dining table. Brown's wife, the furniture designer Caroline Casey, created the custom table (she calls it a brushstroke to draw your eye out to the view, as if one needed further prodding) and most of the house's furnishings, including a curving daybed, a Tibetan wool rug, and a woven wall unit for storage.

The bedroom pavilion is the most adventurous space in the house. To reach it, one must glide up the steep hillside in a motorized mini-funicular for two. Once atop this private perch, the views become even more spectacular. From here you can look down on the living quarters and appreciate the delicate enclosures of clear and frosted glass, wooden screens, operable louvers that keep the house so open to its surroundings, as well as the palette of black steel and red copper that lets the house pop subtly from the olive-green bush and the ocher rock outcroppings. The house has subtle Asian qualities, but it's really an innately Australian house in its informal, laid-back elegance and openness between indoors and out.

previous page
The entry path to the hillside compound winds past the crisp glass and steel pavilion containing a lofty double-height living room.
following spread
The entry path continues toward a walk-in pantry screened by louvered doors (left), beneath the overhanging corrugated roofs of the living and kitchen/dining pavilions (center), and to an outdoor terrace beyond the living room (right).
pages 184–85
On the lowest level of the living and dining pavilions, louvers and sliding translucent glass walls create plays of light and shadow behind a paved terrace.

pages 186–87
The lofty kitchen and dining pavilion opens onto the terrace outside the living room and a spectacular view of Pittwater bay. Above the Caroline Casey dining table, designed to direct one's view out to sea, is an Aboriginal fish trap.

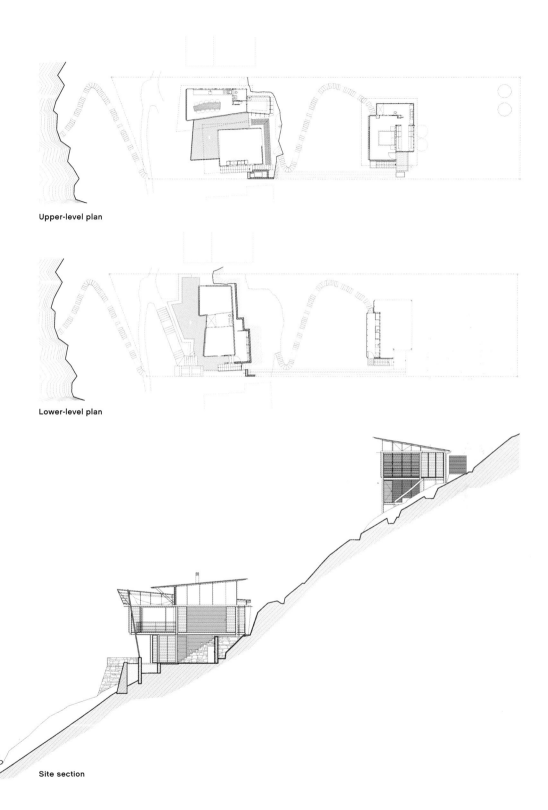

Upper-level plan

Lower-level plan

Site section

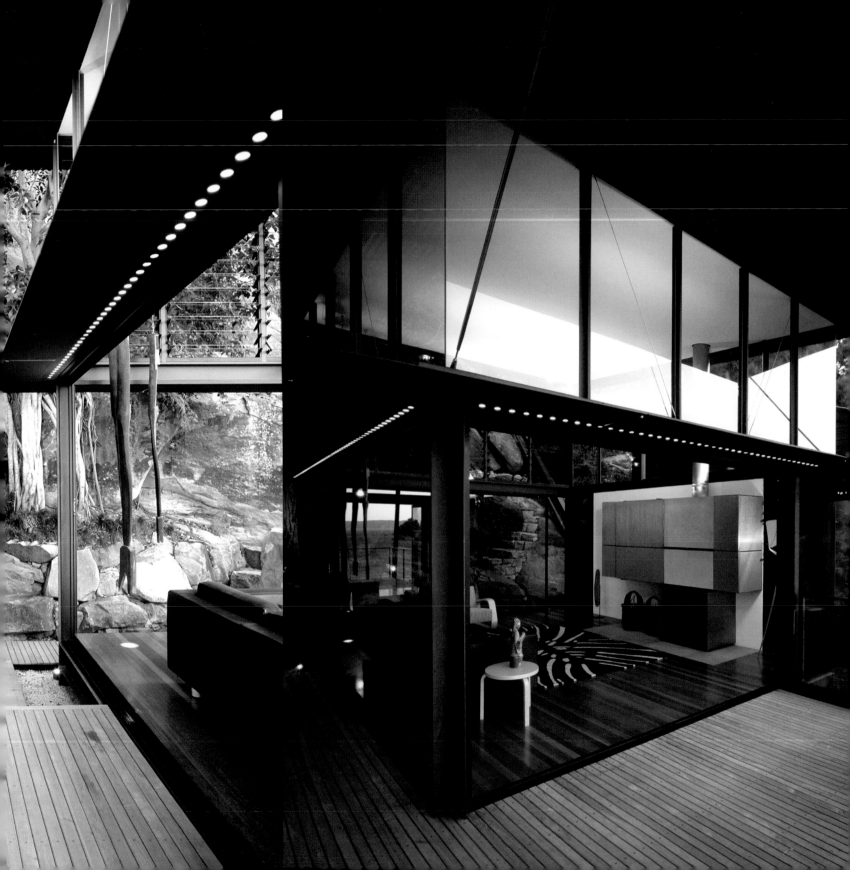

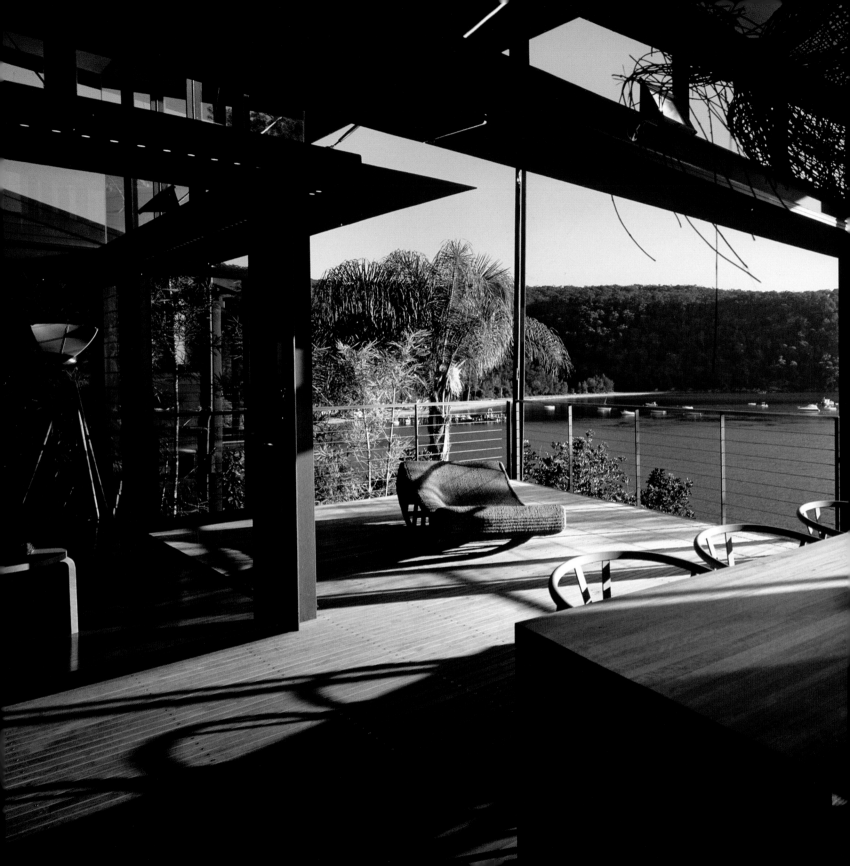

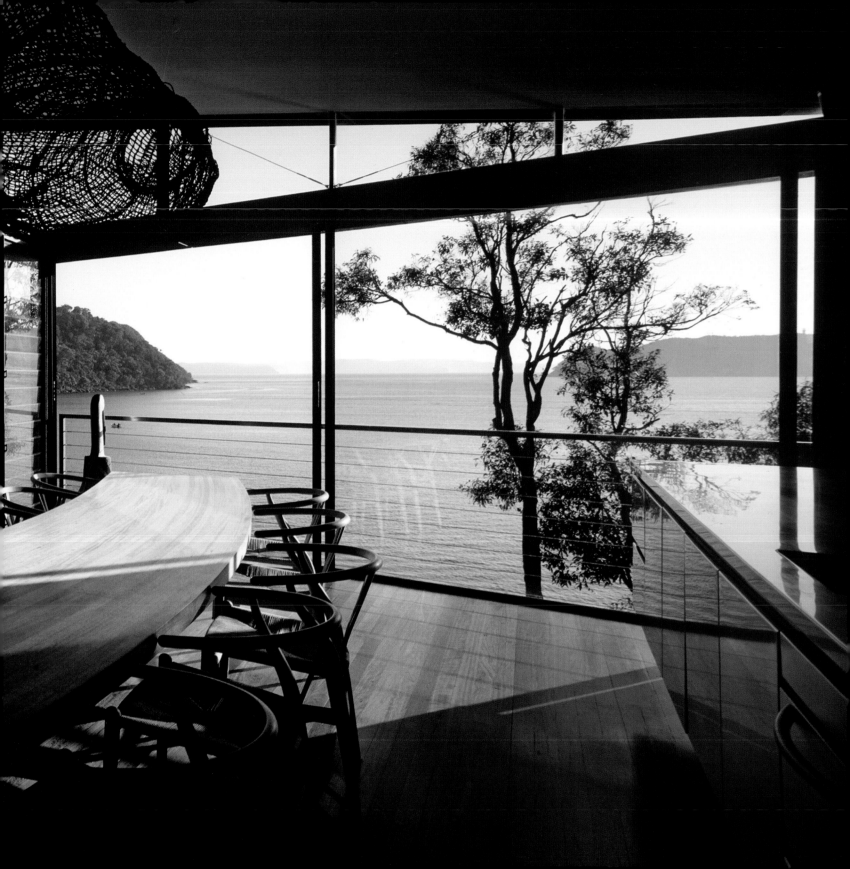

North Shore House, Auckland, New Zealand

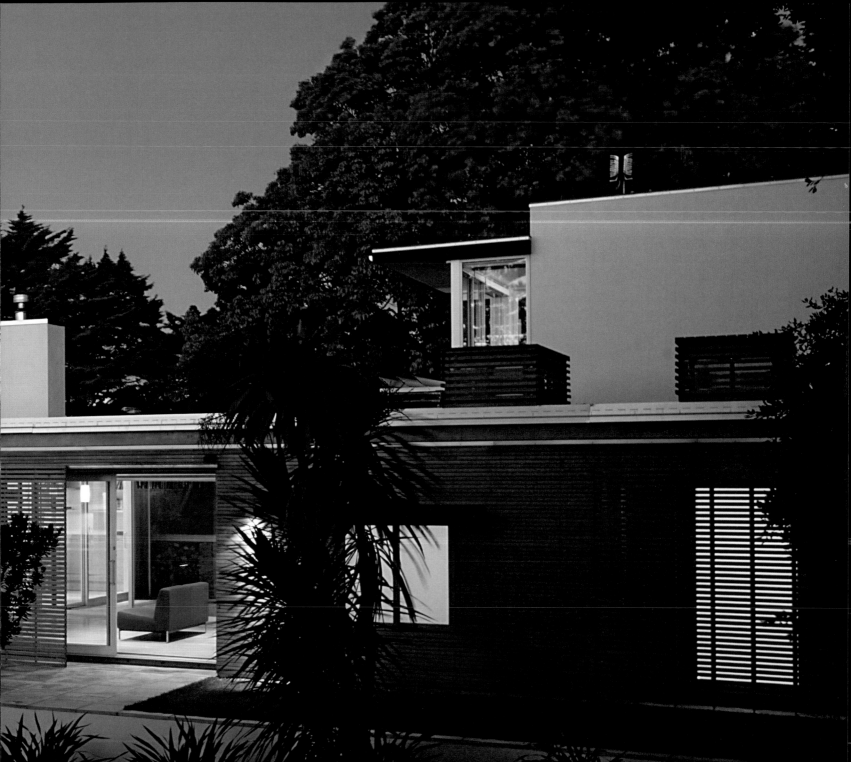

The clients of this rambling house, sited on a densely landscaped hillside overlooking post-card views of Waitemata Harbor and downtown Auckland, asked for a comfortable family house that reflected the way they lived and tied itself to its environment. They wanted a clean, unadorned but refined house, a house that exuded warmth through unfussy materials and details while demonstrating its economy of means. The designers, the Auckland office of the international cooperative Architectus, responded with a long, lean design that follows the site's sloping contours and embraces its privileged perch on a lush peninsula with gregarious outdoor courtyards and terraces. The architects describe it as both a sculptural object and an earthwork integrated into the landscape.

The property, located at the end of a quiet dead-end street, abuts a reserve on one side and an unbuilt lot on the other. One enters on the third of four levels, down a short flight of steps and past a small reflecting pool. The house unfolds along a narrow spine extending toward the water. On this main level a long hallway leads past a pair of bedrooms with a shared bath and an outdoor courtyard covered by a translucent canopy, to a proper living room and a slender, more informal space that efficiently combines family room, kitchen, and dining room. The family room opens onto a small terrace through sliding glass doors, shaded by a slatted wood screen that rolls along an overhead track, like a barn door. At the far end of the multifunction space, a simple wooden dining table—continuing the palette of wooden cabinets and ceiling—extends beyond the kitchen island, both of which are crowned by a long, narrow light monitor shaded by wooden louvers along its perimeter. A wall of sliding glass doors beyond the built-in table opens up to a large outdoor deck with views of the bay and the Auckland skyline beyond.

One level up is a study; one level down is the master suite, which shares an outdoor terrace with another bedroom, as well as a storage area and laundry room. Beneath that, on the bottommost level, is a very private guest suite with its own small terrace overlooking the water. The walls in the long direction are generally solid, finished in no-nonsense painted concrete block and screens of slatted wood; the short walls are almost entirely glazed. The long walls, which project beyond the glass line to shade the interiors and provide more surface area for cabinets and storage, are incised with narrow windows. The strategically placed slots, shaded by built-in sunscreens, frame edited views of the surroundings, in contrast with the broad panoramas created by the sliding glass walls on the short facades.

The house has a smooth, logical flow down the hillside, toward the water and the view. But it's not entirely focused on the light at the end of the tunnel. The architects wove comfortable terraces, courtyards, and decks into the long path to perfect views of city and bay, creating multiple ways to enjoy the tranquil surroundings.

previous spread
The long, rambling house covers four levels that march down the hillside site. The family room on the main level opens onto a terrace through sliding glass doors shaded by retractable louvered screens.

following spread
A louvered skylight caps the informal kitchen-dining room (left and center), which opens onto a terrace overlooking the water. The driveway and entrance (top right) are on the third of four levels; the lowest level, at the bottom of the hill, contains a guest suite with a private terrace (bottom right).

pages 194–95
With its long, lean forms and natural materials, the house nestles comfortably into the lushly landscaped hillside overlooking Auckland's harbor.

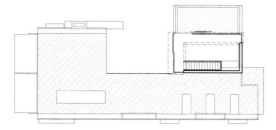

Upper-level plan

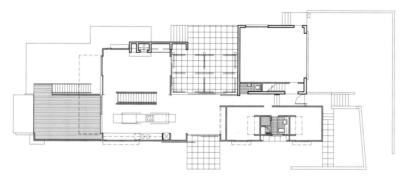

Entry-level plan

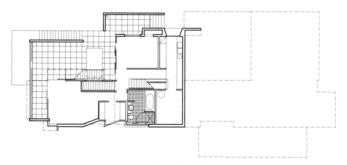

Lower-level plan

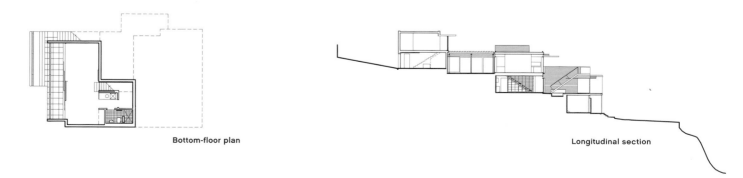

Bottom-floor plan

Longitudinal section

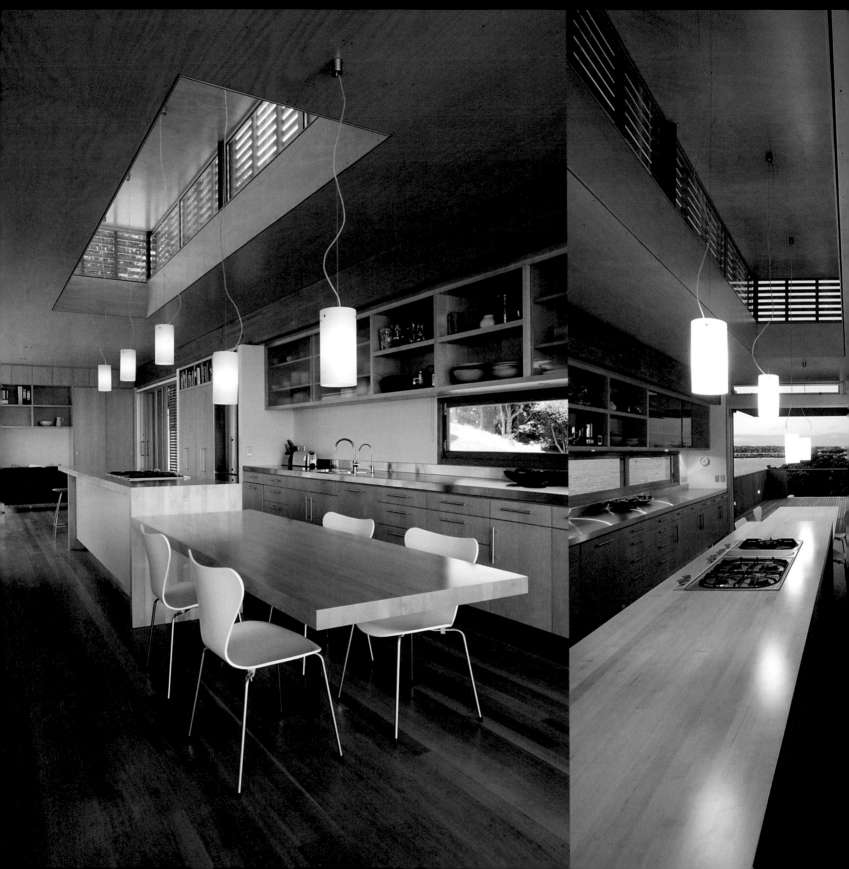

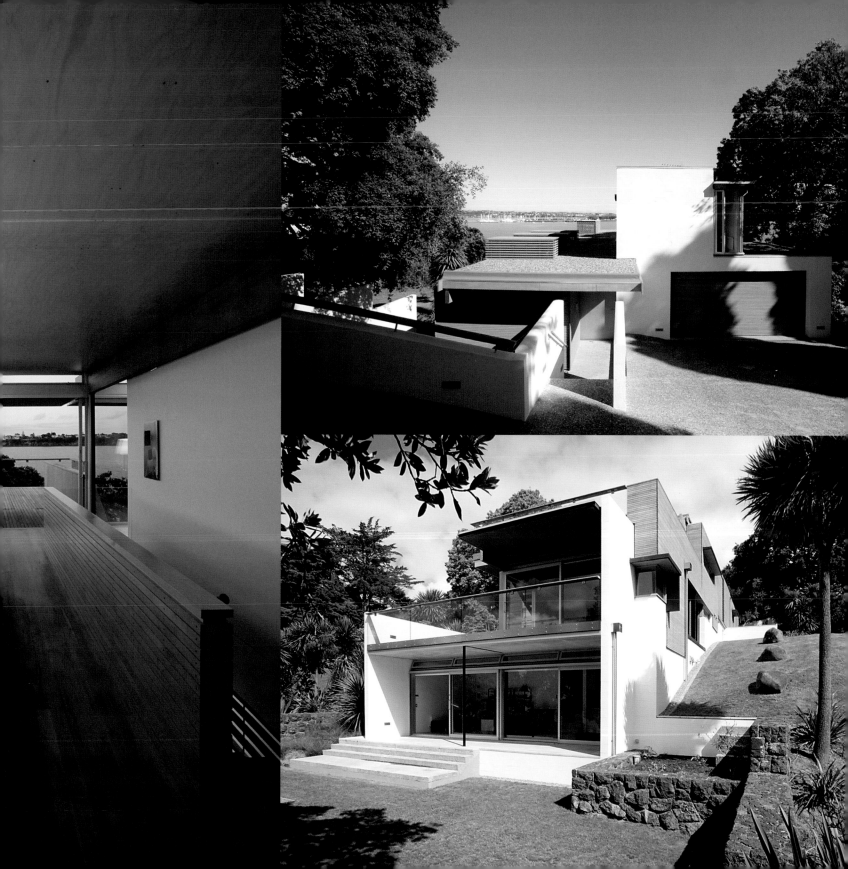

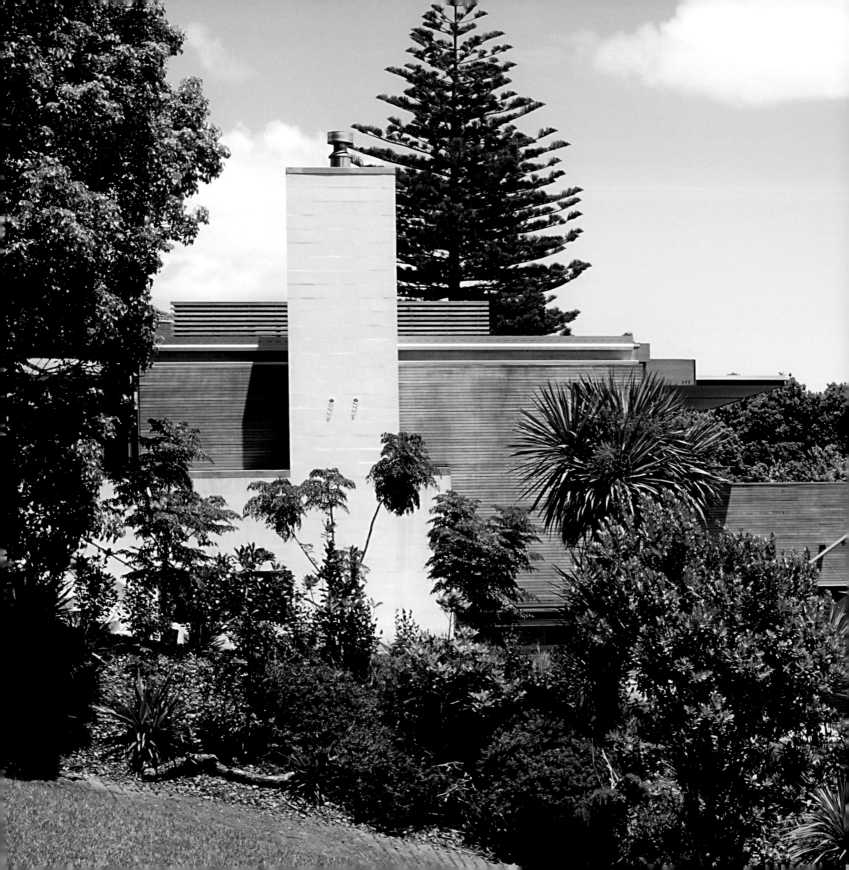

House in Kangaroo Valley, Kangaroo Valley, Australia

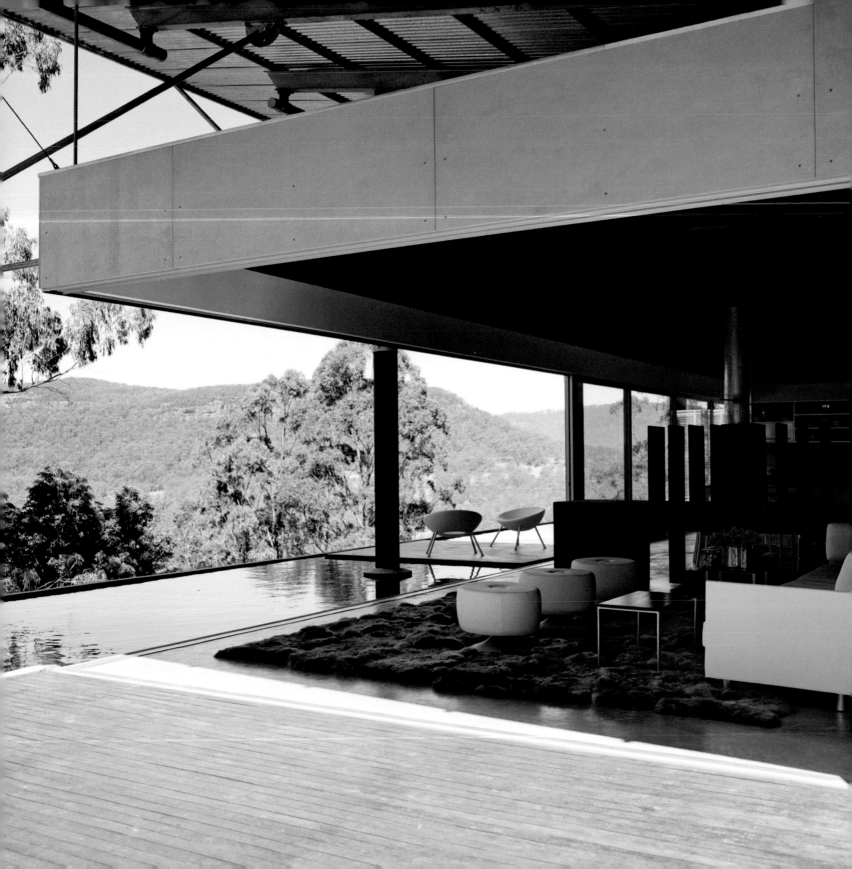

Sydney designer Alexander Michael and his partner started their search for a modest beach house far from the Australian bush—on the Tuscan coast. When they couldn't find an affordable retreat in Italy, they looked closer to home, eventually buying a secluded 100-acre property with pristine panoramic views of rain forest and dense green hills in Kangaroo Valley, 100 miles south of Sydney.

Michael designed the house of his—though perhaps not everyone else's—dreams, a rough-and-tumble structure that draws on his love of hardware stores and industrial materials. Perhaps atypically for an interior designer, Michael, who designed and documented the entire project, wanted to expose the structure and avoid covering up tough materials such as concrete, galvanized steel, glass, and heavy timber. Poetry aside, there is a practical benefit to keeping materials simple and low maintenance in such a remote location.

The house comprises two distinct wings: an open living area containing a sitting room, dining area, kitchen, and media room, and a bedroom wing connected to the main house by an open-air walkway beneath a towering corrugated metal roof. Michael wanted to imbue his weekend retreat with the feeling of a resort—hence, the open-air walk to the bedroom. Separating the bedroom also boosts privacy.

With its polished concrete floors and mostly transparent enclosure of sliding glass doors, the living area has a strong lofty feeling. The space, roughly 65 feet long by 23 feet wide, has no internal columns. The ceiling of exposed beams hangs on four steel rods from a robust superstructure of twelve massive timber columns with a corrugated-steel butterfly roof. Four of the hefty wooden posts rise from an almost 90-foot-long reflecting pool that creates a tranquil watery horizon for the valley vistas on the back side of the house. The daring structure allowed Michael to open up three sides of the living area to the outdoors without so much as a column interrupting the wide expanses of glass.

Inside the dramatic volume there are no proper rooms. A rusty steel fireplace divides the living and dining areas; a freestanding service "pod" housing a utility room and bathroom behind a bright orange door separates the kitchen from the media room, which contains a television, sound system, and telescope. As he did with the solid entry facade, Michael covered the service pod in cement fiberboard panels held together by exposed galvanized-steel braces.

The bedrooms are contained within a pair of freestanding cubes, each with its own tiny bathroom. These private boxes, covered in floor-to-ceiling wood louvers and doors, project out beyond the hillsides like telescoping timber tubes with balconies overlooking the lush valley.

The house is smart as well as stylish: It scoops up the sun with twenty photovoltaic panels and stores the solar power in a dozen large batteries, which Michael displayed behind glass along one wall of the living room. And rainwater collects in corrugated metal drums that frame the entrance like a pair of oversized rustic columns. Michael may be an accidental resident of Kangaroo Valley, but his house is perfectly suited to its setting.

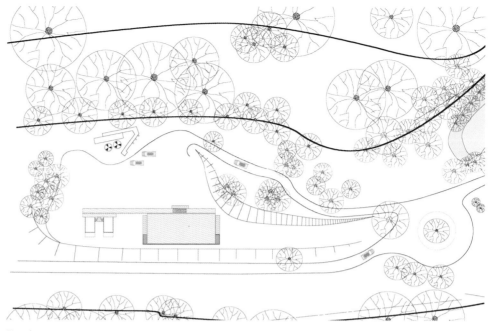

Site plan

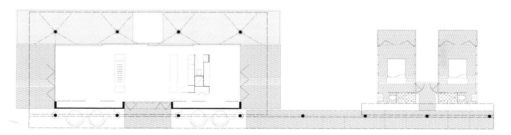

Floor plan

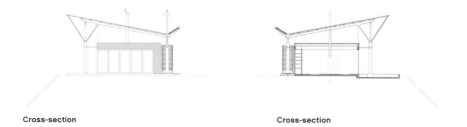

Cross-section Cross-section

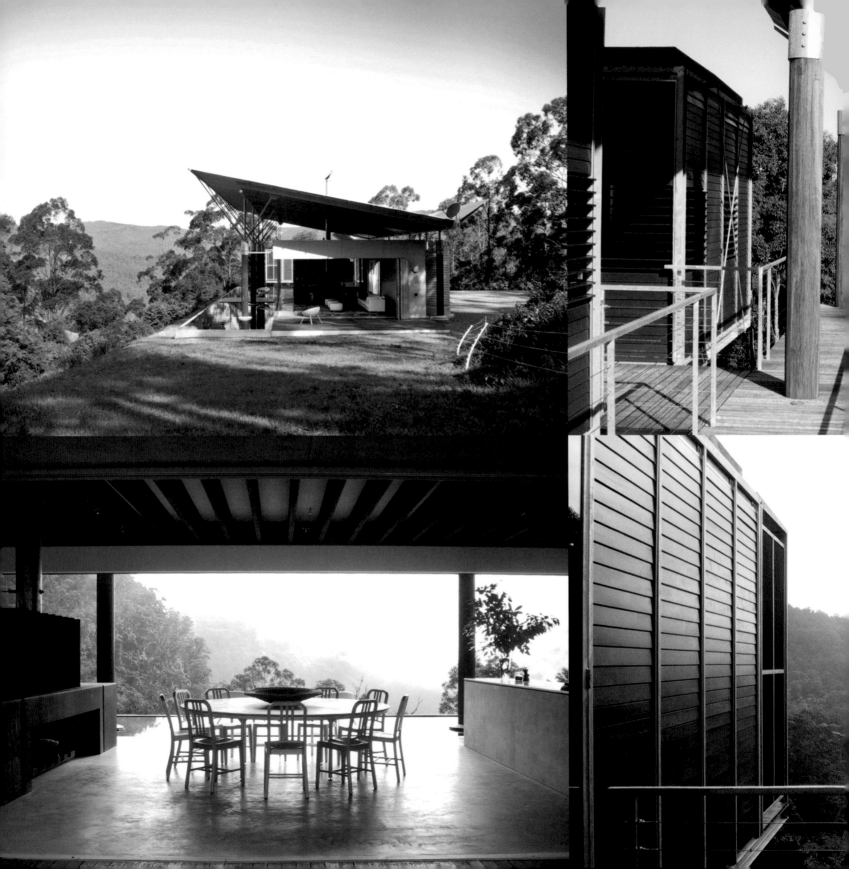

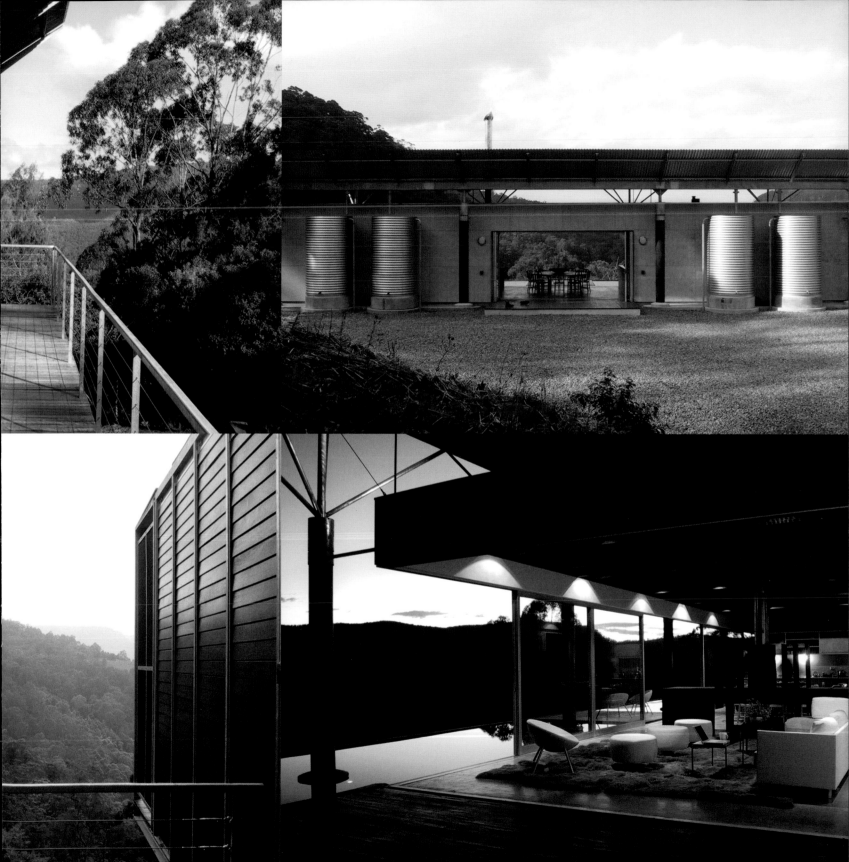

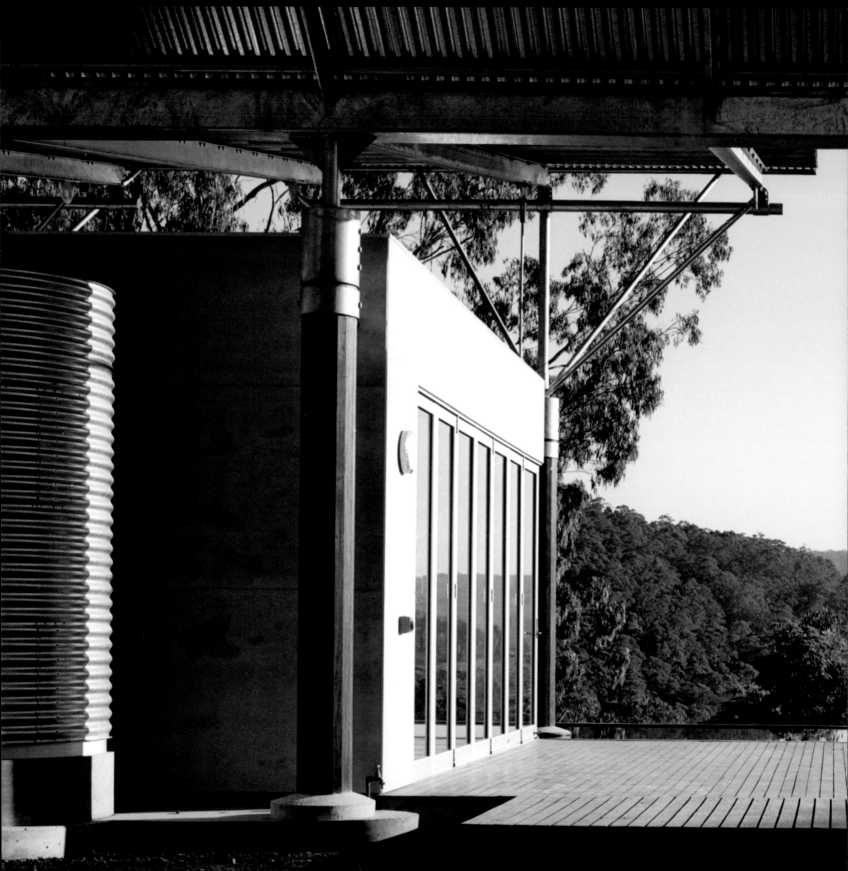

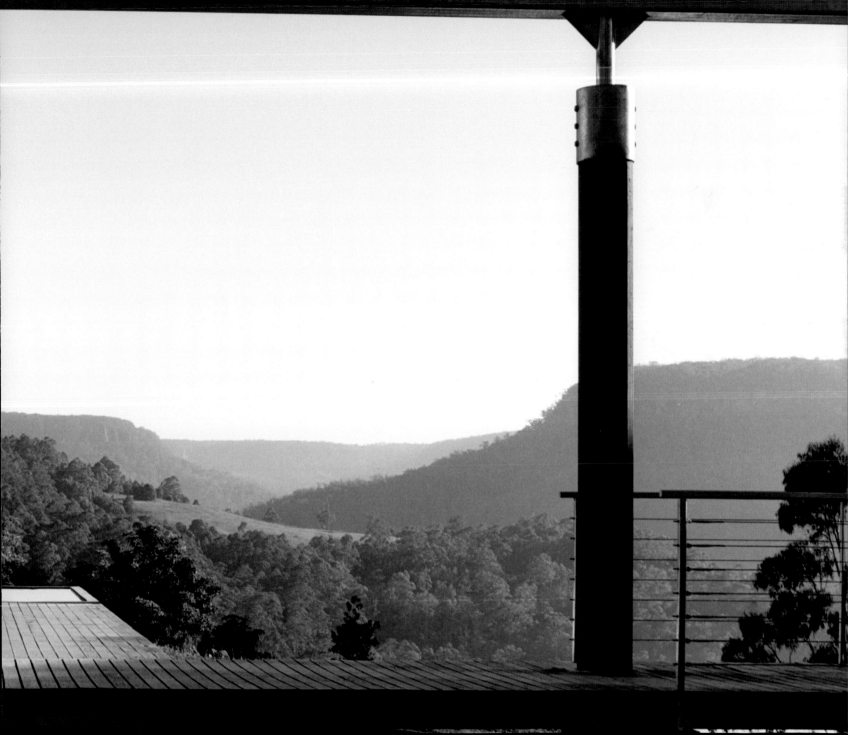

Sharek House, Auckland, New Zealand

Auckland architect Andrew Lister designed a house and working studio for British-born glass artist Liz Sharek in the city's Westmere district. In her art, Sharek pushes the boundaries of glass, breaking, so to speak, with traditional techniques of the medium. Her cast-glass objects, although made of a delicate material, have a strong, abstract graphic quality. Yet they also have a definite organic look, resembling crystalline slices of tree trunks or hunks of bright blue ice. Sharek's house similarly eschews typical architectural style. With its complex plays of texture, color, light, and reflection, the house reflects, quite literally, the owner's artistic work—a house that, in the architect's eyes, is more sculpture than pure dwelling.

From the outside the house appears to be composed of three compact volumes, each clad in a different material palette and each offering a different degree of enclosure according to the functions contained within: working, sleeping, and living. In reality, the two-level house is composed of a single long rectangle with cladding that varies around its perimeter. The entrance is on the lower level, where a small car park opens onto a foyer with a staircase leading up to the living areas and sliding doors that access Sharek's studio. Upstairs, the foyer opens into a loftlike open living area, with a kitchen that overlooks spaces for dining and entertaining. A large skylight brings in natural light from above. Sliding doors along the living area open onto a sunny outdoor deck. At the rear of the house, behind a large fireplace, are two bedrooms, each with its own ensuite bathroom.

Lister clad different parts of the house in no-nonsense materials, creating visual variety and making a small structure look bigger than it really is. According to Lister, all of the cladding is a nod to the quintessential New Zealand bach, or rustic beach shack, and the ideals of relaxed Kiwi living that appeal to the British-born Sharek. Lister enclosed Sharek's north-facing studio, which has an enclosed kiln room and a tiny outdoor courtyard at the back, in a lattice of wooden slats that let natural light in but offer some degree of shade and privacy. He covered the living-dining wing in a skin of matte metal panels. Combined with the black-framed sliding glass doors, the metal skin gives this wing a tough, industrial loft look. Finally, the bedroom wing is clad in sheets of corrugated metal typically used as roofing. With just one large square window that faces west, the bedroom offers a sense of privacy and security.

Throughout the house, Lister used sliding doors that let rooms change size and function at will. For instance, the large glass doors lining the living-dining room roll open to extend the indoor space onto the outdoor terrace. And a wall of sliding doors between the living-dining room and the second bedroom can be left open to combine those two spaces, or closed to make a private bedroom. Like its owner's artistic output, this small house is complex and nuanced, and engaged with its New Zealand setting.

previous page
The boxy bedroom wing is wrapped in a skin of corrugated metal typically used as roofing.
following spread
A long clerestory skylight crowns the lofty living-dining room, surrounded by walls of glass and sliding doors that open onto an adjoining terrace.

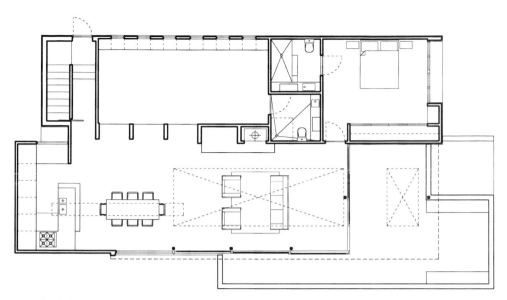

Upper-level plan

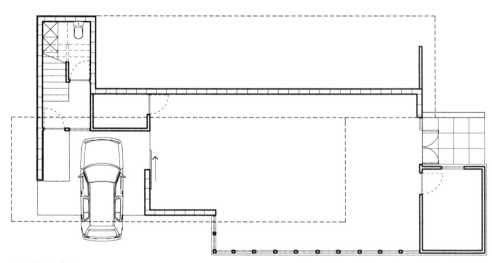

Lower-level plan

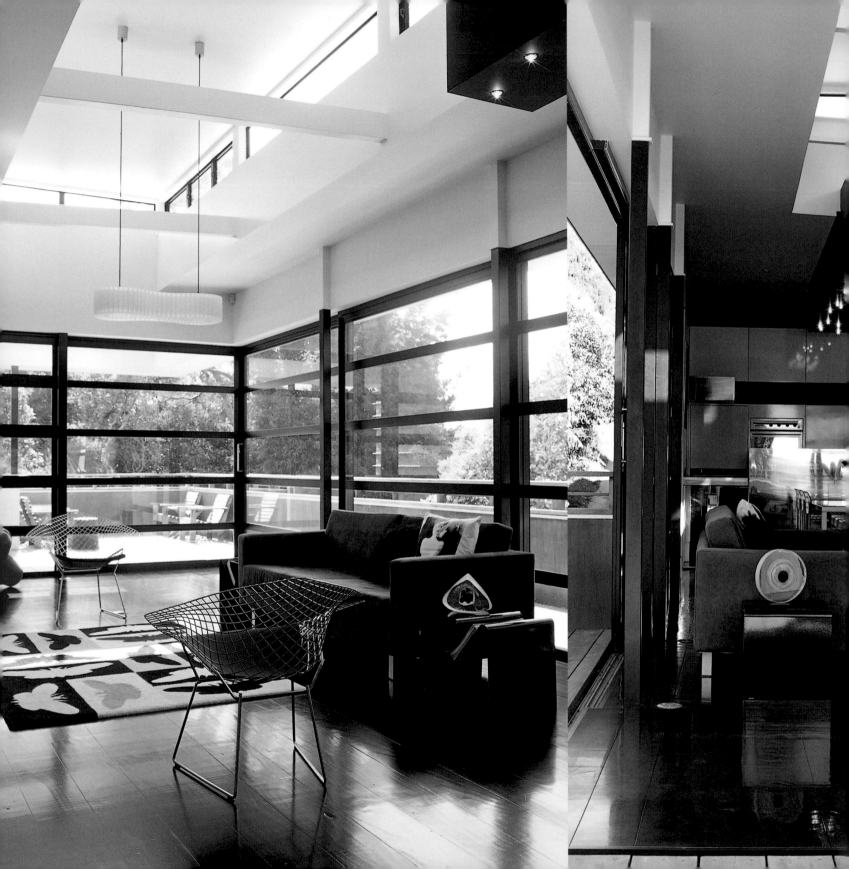

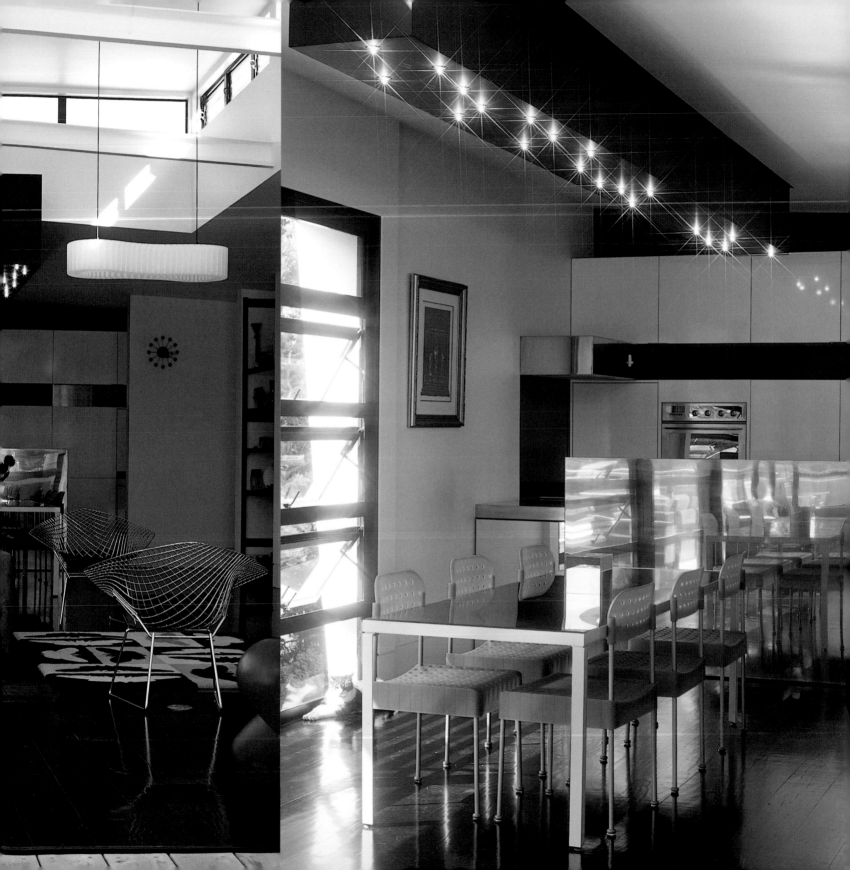

Holman House, Dover Heights, Australia

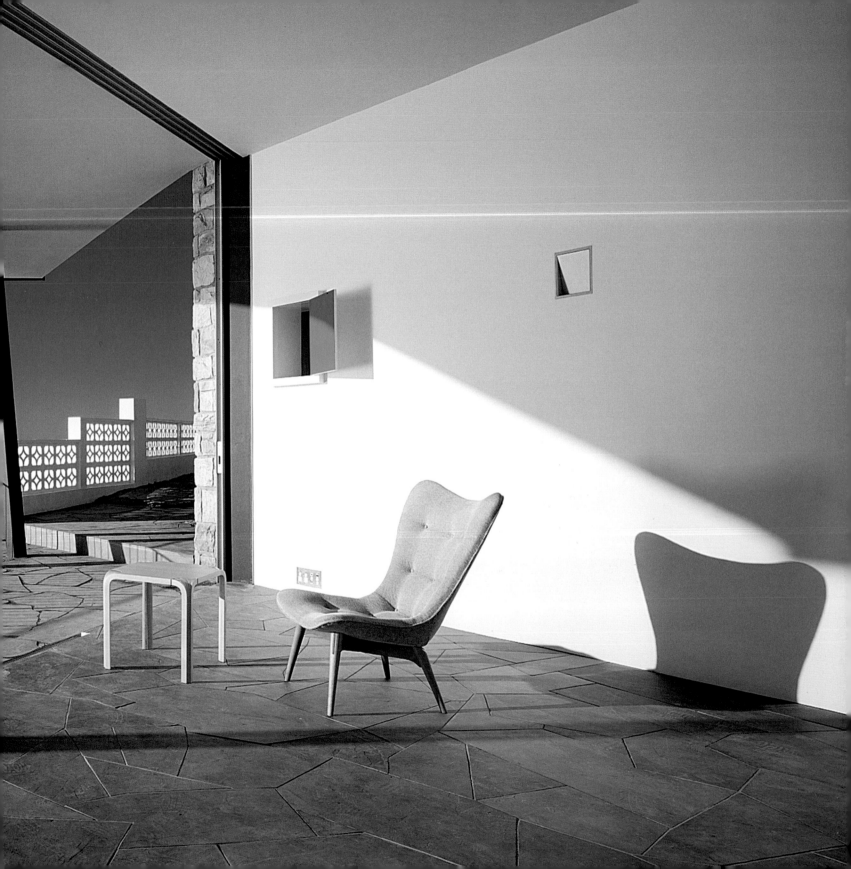

Like its namesake on the southeastern tip of England, Dover Heights in Sydney's eastern suburbs sits high atop the sea on craggy cliffs. The dramatic sandstone cliffs, less than a mile north of the famous crescent of Bondi Beach, look out at the sprawling blue horizon of the Tasman Sea. As dramatic as the views are, the suburban subdivision of mediocre houses built atop the cliffs is anything but. Sydney architects Neil Durbach and Camilla Block challenged the suburban status quo and captured Dover Heights' best assets with the sculptural Holman House, a structurally daring house perched high above—and seemingly precariously floating beyond—the vertiginous topography.

An obvious design might have been to put a glassed-in box parallel to the cliff to open the house up to views of the sea. Instead, Durbach and Block created a two-story house that hugs the cliffside 230 feet above the ocean, on its lower level, but opens up on its upper level with a curving ribbon of space with cinematic flair. The curved plan allowed the architects to open up three sides of the house to the broad blue expanse of ocean—effectively tripling the views.

The entrance on the house's upper level is conventional enough: The front door opens into a funnel-shaped foyer, with a window facing a solid wall, so as not to give away the surprising views to come. From there, the house opens up in two directions with two dramatic curves. The lofty living and dining areas share a curving wall with a ribbon of windows above chair height, which frames a sliver of blue sea. At opposite ends of the space, the arching surface opens up to even more dramatic framed views, through walls of floor-to-ceiling glass. It's as if the architects lopped off the ends of a gently snaking box to reveal full-frontal vistas of sea and sky. A curving open kitchen at the back of the open space continues the sinuous geometry.

A second curve, a horseshoe-shaped courtyard cradled by the living room, study, and master bedroom, opens the house to views in another direction. An unconventional curved sliding glass door follows the arcing contours of the courtyard. The court opens onto a flight of angled stairs, a nod to the famous stepped rooftop of Villa Malaparte on Capri, immortalized by Brigitte Bardot in the 1963 Godard film *Contempt*.

The cinematic staircase leads to a lower-level terrace and pool. The lower level contains a pair of bedrooms on either side of another curving space, this one slightly shallower than the horseshoe-shaped court one level up. This curve defines an indoor space, a family room beneath the twisting living-dining room, which cantilevers beyond the family room and over a terrace that extends along the clifftop. The overhang creates a giant sheltered deck, open to the family room through a wall of sliding doors.

For all its structural daring, the house feels remarkably safe on its hillside perch. The best part of the airy interiors and fluid outdoor spaces is the remarkable relationship they strike with the site. Like the best works of architecture, the house truly improves on its spectacular setting.

previous spread
A wall of sliding doors opens up the lower-level family room to a stone-paved deck sheltered by a cantilevered wing of the house above.
pages 214–15
The top-floor living areas are squeezed in and around two curves: a horseshoe-shaped courtyard with angled steps leading down to the lower-level terrace and pool, and the twisted, cantilevered living-dining area.
pages 216–17
Glass walls at either end of the boomerang-shaped living-dining wing open the space up to stark panoramas of the Pacific.

pages 218–19
The horseshoe-shaped courtyard outside the kitchen (top left) required custom curved glass sliding doors. A band of windows midway up the curving exterior of the living-dining room (bottom left) creates a long, narrow view of the ocean. At night the cantilevered dining room's glass wall creates a dramatic beacon on the seaside cliff top.

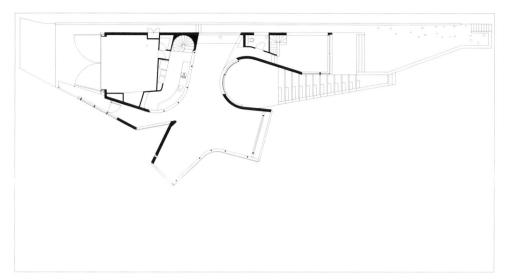

Upper-level plan

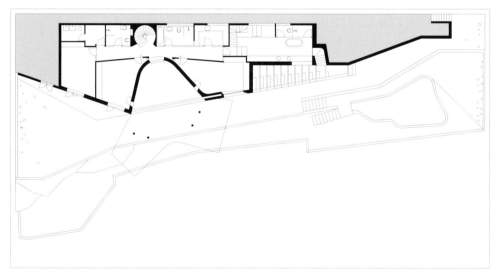

Lower-level plan

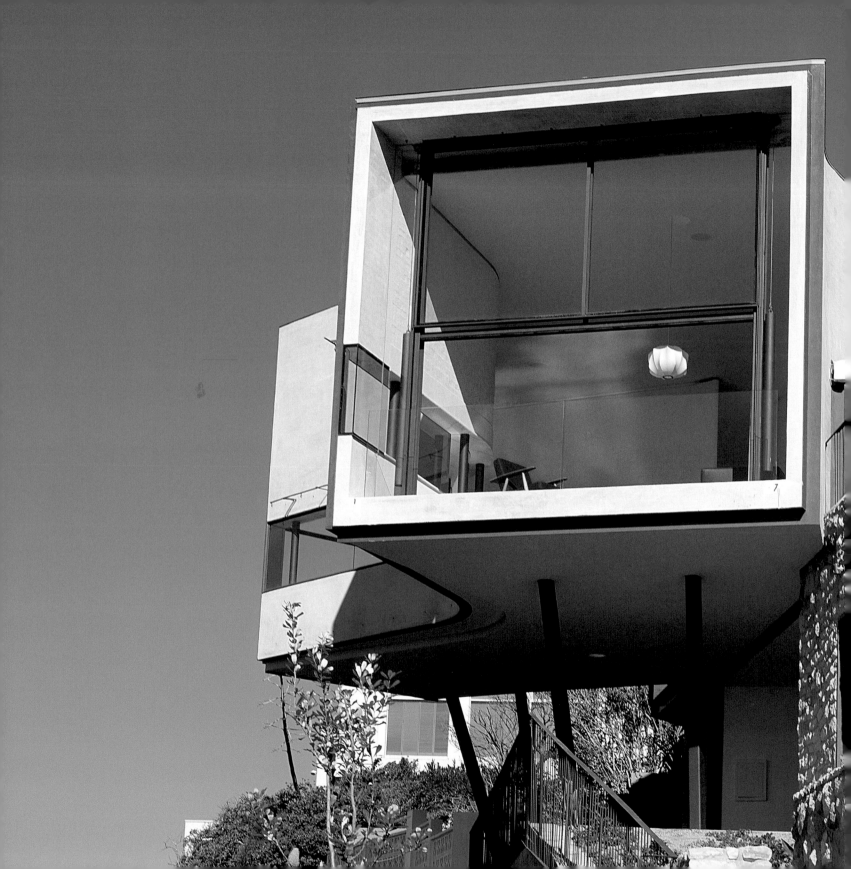

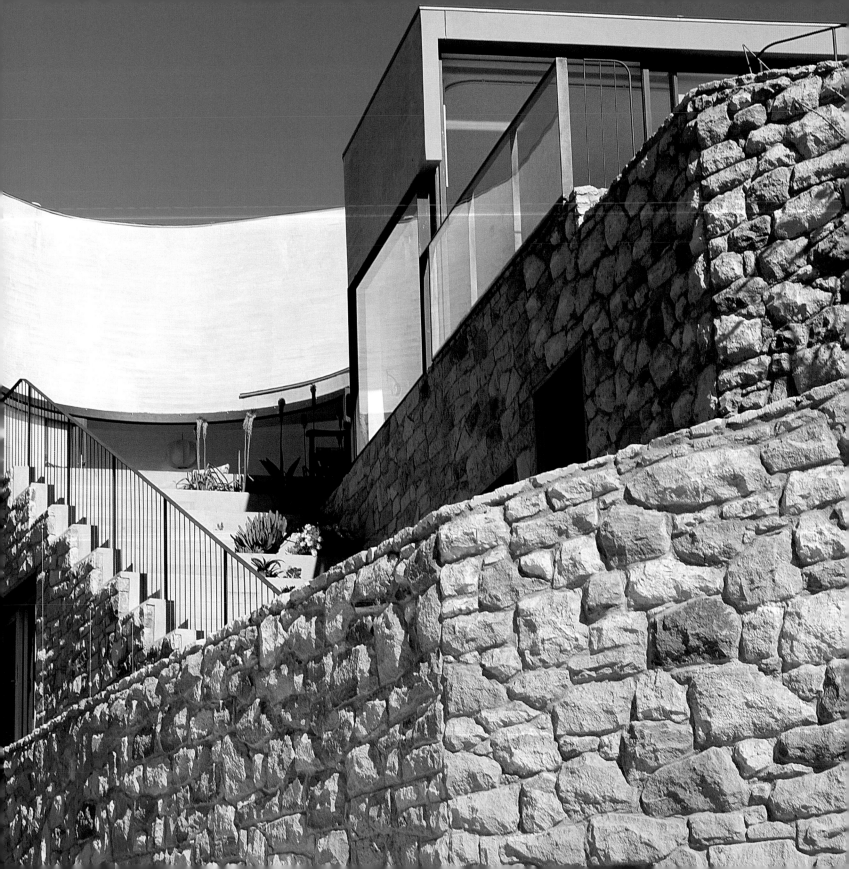

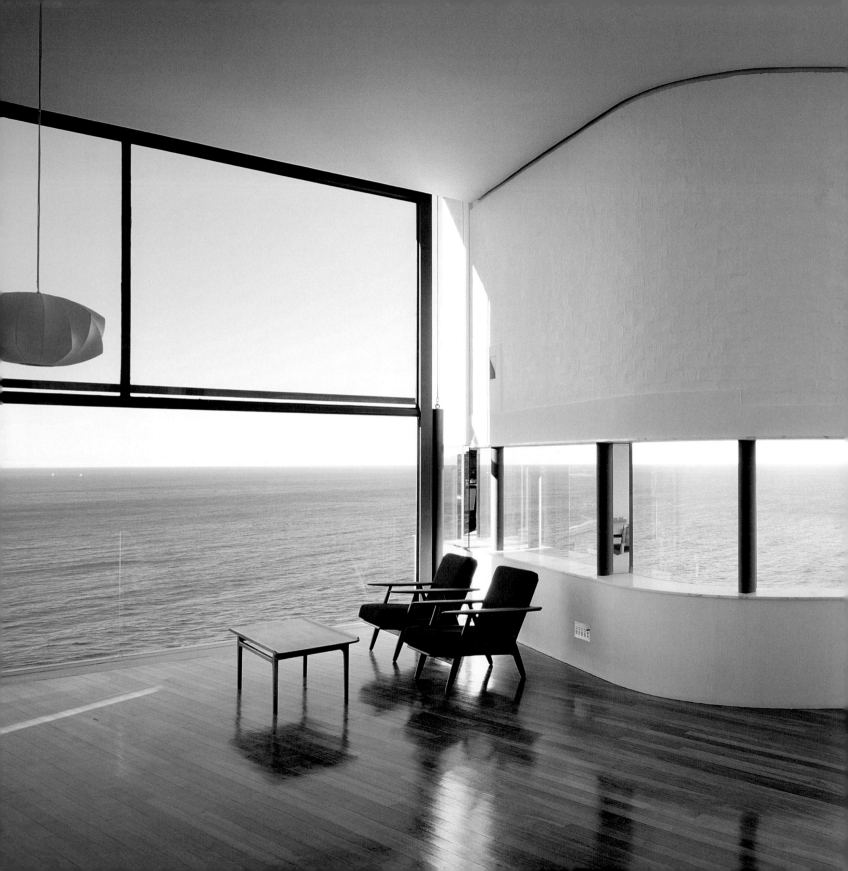

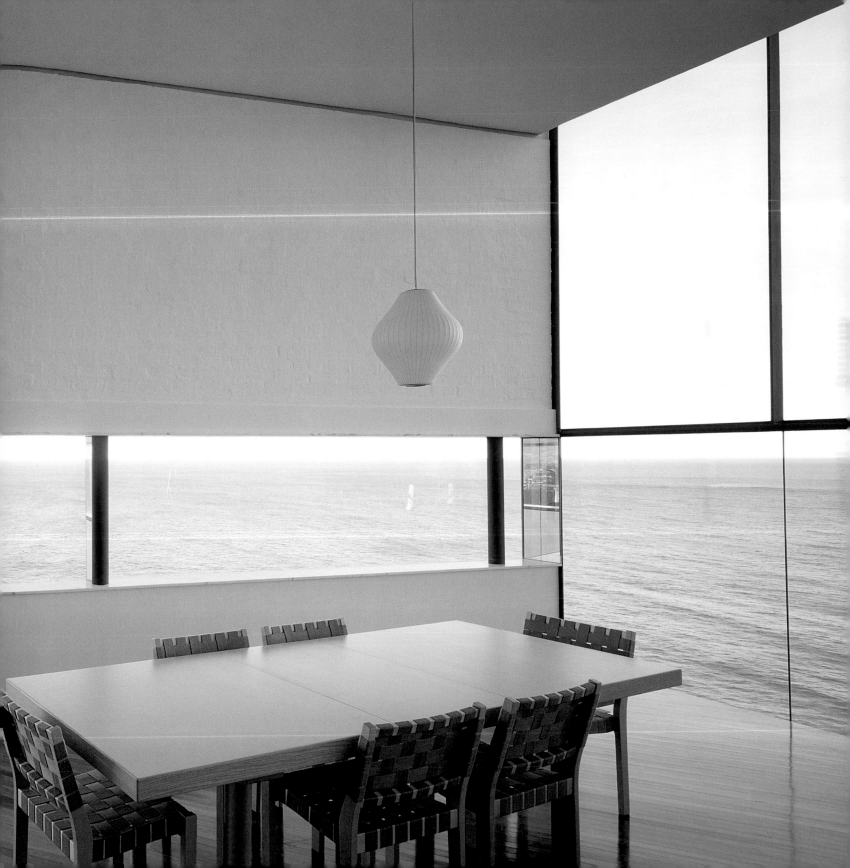

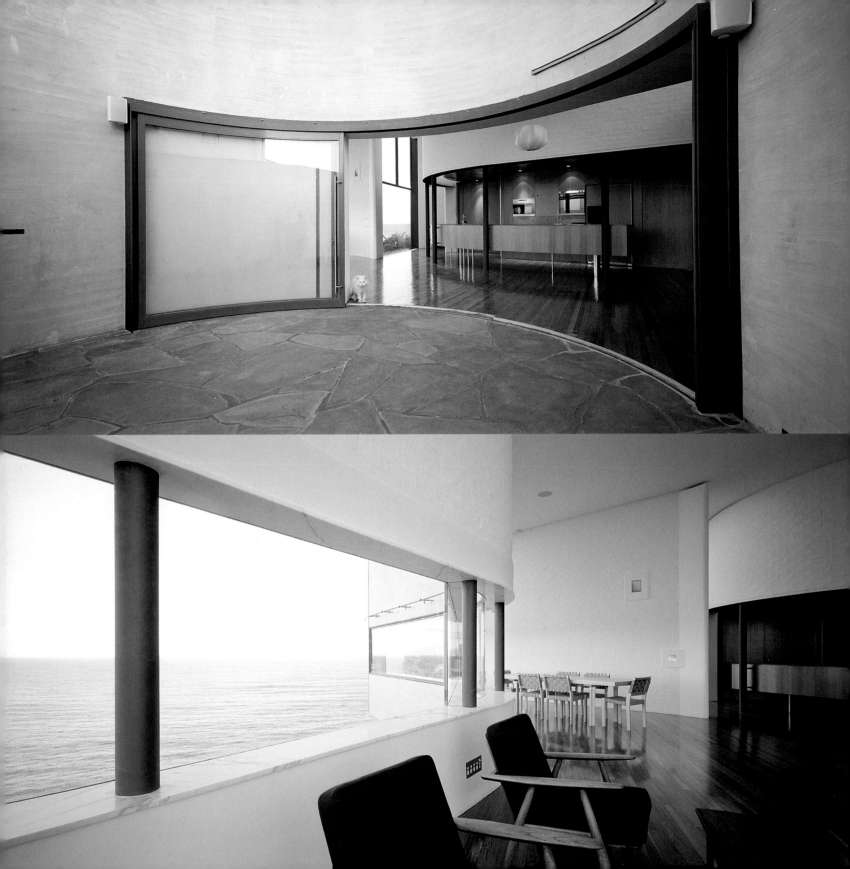

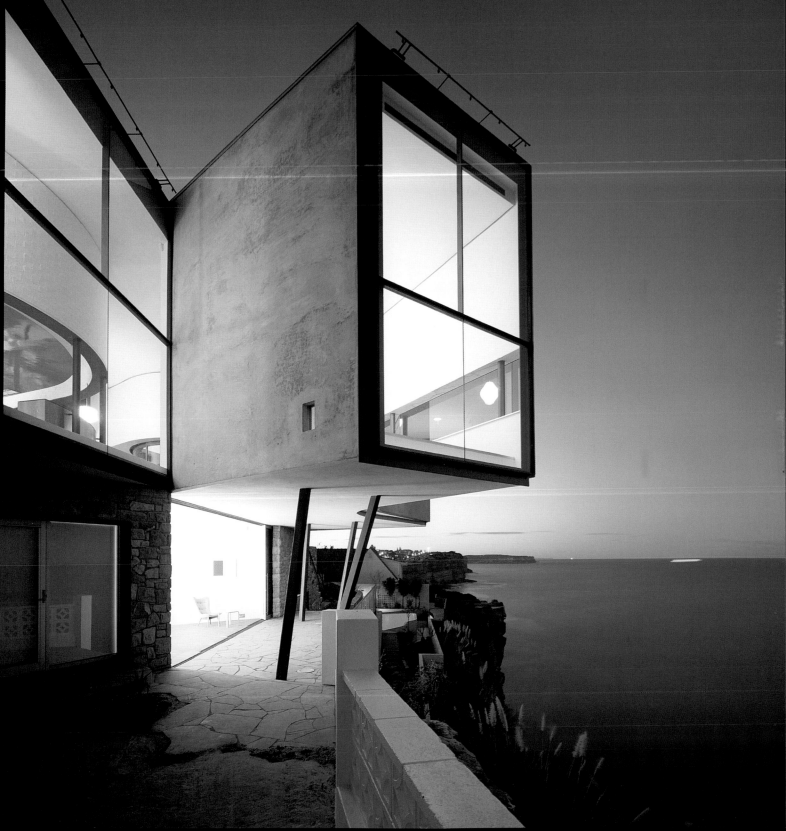

Acknowledgments

Thank you to all the architects, photographers, and clients who allowed their homes to be included in these pages. Thanks also to Rob Dawson Brown, Caroline Casey, Hernan Alvarez, Harry and Penelope Seidler, John Wardle, and Jarrod Haberfield for their hospitality in Australia and New Zealand; and to the following people around the world for their insights, suggestions, and contacts: David Clark at *Vogue Living Australia*; Richard Benedict and Richard Weinstein; Davina Jackson; Annabelle Lahz; Cameron Pollock; Antonio Eraso; Peter Webster; Calvin Tsao.

Thank you to Claudia Brandenburg, who made this book look even more beautiful than the last.

And thank you to the late Stephen Case, a patient and supportive editor who got this book off the ground, and to Ron Broadhurst, Ellen Nidy, Julie Di Filippo, and Charles Miers at Rizzoli for their help in seeing it through to completion.

Credits

Cover
Mackerel Beach House, Mackerel Beach, Australia, Casey Brown Architects
Front cover photographed by Anthony Browell, Back cover photographed by Patrick Bingham Hall

Introduction
pp. 9; 10–11: Penelope Seidler House, Killara, Australia
Harry Seidler & Associates Architects & Planners, 2 Glen Street, Milsons Point, NSW 2061, Australia
t: +61.2.9922.1388; f: +61.2.9957.2947; www.seidler.net.au
p. 12: Rose Seidler House, Wahroonga, Australia
Harry Seidler & Associates Architects & Planners, photographs by Raul A. Barreneche
p. 15: Herbst Bach, Great Barrier Island, New Zealand
Lance Herbst Architects: Lance and Nicola Herbst, principals
www.herbstarchitects.co.nz
Photographer: Jackie Meiring
p. 16: P-Cube House, Naresuan Beach, Thailand
Spacetime Architects
Photographer: Skyline Studio
pp. 18–19: Bach Kit, Waiheke Island, New Zealand
André Hodgskin Architects
Photographer: Mark Smith
pp. 4, 6, 20, 220: photographs by Raul A. Barreneche

Bowral House, Kangaloon, Australia
Glenn Murcutt, Architect, 176a Raglan Street, Mosman, 2088 Australia
Landscape architect: Sue Barnsley
Structural engineer: James Taylor & Associates
Builder: C&C Symonds

Bay of Islands House, Rawhiti, New Zealand
Fearon Hay Architects, Level 2, 20 Beaumont Street, PO Box 90-311, Auckland, New Zealand
t: +64.9.309.0128, e: contact@fearonhay.com, www.fearonhay.com
Design architects: Tim Hay, Jeff Fearon
Engineer: Markplan Consulting
Contractor: John Nicholas
Photographer: Patrick Reynolds

Vineyard House, Mornington Peninsula, Australia
John Wardle Architects, Level 10, 180 Russell Street, Melbourne, VIC 3000, Australia
t: +61.3.9654.8700, f: +61.3.9654.8755, e: johnwardle@johnwardlearchitects.com, www.johnwardle.com
Project team: John Wardle, Andrew Wong, Fiona Dunin, Grant Roberts, Aimee Goodwin, Tarryn Deeble, Zoe Geyer, Fiona Lynch
Structural engineer: Gamble and Consentino
Services engineer: Foster Heating
Quantity surveyors: Prowse Quantity Surveyors
Builder: Melford Constructions
Photographer: Trevor Mein

Coromandel Beach House, Coromandel Peninsula, New Zealand
Crosson Clarke Carnachan Architects, Level 1, 33 Bath Street, PO Box 37521, Parnell, Auckland, New Zealand
t: +64.9.302.0222, f: +64.9.302.0234, e: architects@ccca.co.nz, www.ccca.co.nz
Architect: Ken Crosson
Photographer: Patrick Reynolds

Bartlett/Pennington House, Sydney, Australia
Burley Katon Halliday, architect and interior designer, 6a Liverpool Street, Paddington, NSW 2021, Australia
t: +612 9332 2233, f: +612 9360 2048, e: bkh@bkh.com.au, www.bkh.com.au
Design team: Ian Halliday, David Katon, David Selden, Tim Alison, designers
Engineer: Taylor Thompson Whitting
Hydraulic & Mechanical Engineers: VOS Partnership
Photographer: Sharrin Rees

Hobson Bay House, Auckland, New Zealand
Stevens Lawson Architects, 19/75 Parnell Road, Parnell, Auckland, New Zealand
t/f: +64.9.377.5376, e: gary@stevenslawson.co.nz
Principals: Nicholas Stevens, Gary Lawson
Project team: Andrew Day, Ellen McArthur
Planning consultant: Neil Rasmussen, RMS Ltd.
Engineer: Mark Smith, Markplan Consulting
Builder: Chris Doige
Photographer: Mark Smith

Fulton Road House, Singapore
Forum Architects, 47 Ann Siang Road #06-01, Singapore 069720
t: +65.6224.2778, f: +65.6323.4603, www.forum-architects.com
Architect: Lim Cheng Kooi
Interior designer: Susan Heng Soo Hiang
Structural Engineer: John Lim, MSE Engineering & Management Consultants
Builder: Nelson Tee, CHH Construction System
Photographer: Albert Lim

Spry House, Point Piper, Australia
Durbach Block Architects, Level 5, 71 York Street, Sydney 2000, Australia
t: +61.2.8297.3500, mail@durbachblock.com
Architects: Neil Durbach, Camilla Block, David Jaggers, Lisa Le Van, Joseph Grech
Engineer: Robert Herbertson
Landscape consultant: Terragram
Builder: CBD
Photographers: Anthony Browell; Brett Boardman

Hughes/Kinugawa House, Auckland, New Zealand
Andrew Lister Architect, PO Box 91793, Auckland Mail Centre, Auckland, New Zealand
t: +64.9.307.7050, andrewlister1@mac.com, www.andrewlisterarchitect.com
Designer: Andrew Lister
Builder: Laurie McMurtrie
Structural Engineer: Charles Sue, Law Sue Consultants
Photographer: Richard Powers

Pablito Calma House, Manila, Philippines
Lor Calma Design Associates, GF 186 Salcedo St., Legaspi Village, Makati City, Philippines
t: +632.8178465, f: +632.8167514, e: info@lorcalma.com, www.lorcalma.com
Design principal: Eduardo Calma
Project architect: Asa Almario Montenejo
Project designer: Ramsay Lopez Banos
Contractor: MDCC Pablito Calma
Photographers: Neil Lucente/Claudine Sia

Rose House, Kiama, Australia
Engelen Moore, architect, 44 McLachlan Avenue, Rushcutters Bay, NSW 2011, Australia
t: +61.2.9380.4099, f: +61.2.9380.4302, e: architects@engelenmoore.com.au, www.engelenmoore.com.au
Design team: Ian Moore, Tina Engelen, Dua Cox, Claire Meller, Sterrin O'Shea
Structural engineer: Peter Chan + Partners
Geotechnical engineer: Cottier + Associates
General contractor: Philip C. Young
Photographer: Ross Honeysett

Clifford-Forsyth House, Auckland, New Zealand
Patrick Clifford/Architectus, 1 Centre Street, PO Box 90621,
Auckland, New Zealand, t: +64.9.307.5970, f: +64.9.307.5972, www.architectus.co.nz
Project architect: Patrick Clifford
Project team: Malcolm Bowes, Patrick Clifford, Michael Thomson, Mahendra Daji, James Fenton, Tim Mein, Rod Sellars
Structural Engineer: Gary James, Brown & Thomson
Photographers: Paul McCredie; Patrick Reynolds

Three Houses on Jervois Road, Singapore
Bedmar & Shi, Architects, 12a Keong Saik Road, Singapore 089119
t: +65.62277117, f: +65.62277695, www.bedmar-and-shi.com
Design team: Ernesto Bedmar, Henny Susanti, Himaal Kak Kaul, Tan Ho Kiat
Structural Engineer: Tham & Wong
Mechanical/electrical engineer: Woo & Associates
Landscape design: Bedmar & Shi
Contractor: Sysma Construction
Photographer: Albert Lim K.S.

Glade House, McMasters Beach, Australia
Stutchbury & Pape, 5/364 Barrenjoey Road, Newport, NSW Australia
t: +61.2.9979.5030, f: +61.2.9979.5367, e: admin.sp@ozemail.com.au
Principal: Peter Stutchbury
Project team: Fergus Scott, Richard Smith
Structural engineer: Max Irvine
Landscape architect: Tom Gordon
Contractor: Cochran Construction
Photographer: Reiner Blunck

Shark Alley House, Great Barrier Island, New Zealand
Fearon Hay Architects
Principals: Tim Hay, Jeff Fearon
Engineer: Markplan Engineers
General contractor: Offshore Builders
Photographer: Patrick Reynolds

Peninsula House, Mornington Peninsula, Australia
Sean Godsell Architects, architect and interior designer, 45 Flinders Lane, Melbourne, Victoria 3000, Australia
t: +61.3.9654.2677, f: +61.3.9654.3877, e: godsell@netspace.net.au
Design team: Sean Godsell, Hayley Franklin
Engineer: Felicetti
General contractor: Kane Construction (VIC)
Landscape: Sean Godsell with Sam Cox
Photographer: Earl Carter

Paihia Retreat, Paihia, New Zealand
André Hodgskin Architects, Level One, Victoria House, 23 Victoria Street East, PO Box 5953, Wellesley Street, Auckland 1036, New Zealand
t: +64.9.377.4691, f: +64.9.377.4693, www.andrehodgskinarchitects.com
Architect: Andre Hodsgkin Architects
Engineer: P.K. Engineering
Contractor: John Nicholas Builders
Steel portals: Mark Fell Engineering
Lighting: Absolute Sound/Lighting Direct
Photographer: Kallan MacLeod

V42 House, Bangkok, Thailand
Duangrit Bunnag Architect, 989 Unit A2-B3, Floor 28, Siam Tower, Rama 1 Road, Patumwan, Bangkok 10330, Thailand
t: +66.2.658.0580.1, f: +662.658.0582, e: duangrit@loxinfo.co.th
Architect: Duangrit Bunnag
Photographer: Somkid Piampiyachart

Andrew Road House, Singapore
SCDA Architects, 10 Teck Lim Road, Singapore 088386
t: +65.6324.5458, f: +65.6324.5450, e: sdca@starhub.net.sg, www.scdaarchitects.com
Design team: Chang Soo Khian, Ng Kok Yang
Engineer: Ronnie & Koh Partnership
Surveyor: Davis Langdon & Seah
Landscape design: Tierra Design
Contractor: Huat Builders
Photographer Albert Lim K.S.

Fletcher-Page House, Kangaroo Valley, Australia
Glenn Murcutt, Architect
Design team: Glenn Murcutt and Associates, assisted by Nick Sissons
Engineer: James Taylor
Contractor: Jim Anderson (Boardwalk)
Photographer: Anthony Browell

Mackerel Beach House, Mackerel Beach, Australia
Casey Brown Architects, 47 William Street, Paddington, NSW 2021, Australia
t: +61.2.360.2322
Project team: Aaron Cook, Hernan Alvarez, Robert Brown
Civil consultant: Murtagh Bond Structures Buro
Interior designer: Caroline Casey Design
Quantity consultant: D.R. Lawson
Builder: Bellevarde Constructions
Photographers: Anthony Browell, Patrick Bingham Hall, Elliot Cohen

North Shore House, Auckland, New Zealand
Architectus
Design team: Malcolm Bowes, Patrick Clifford, Michael Thomson, Carsten Auer, Stephen Bird, James Mooney, Lance Adolph, Prue Fea, Sean Kirton, John Lambert, Juliet Pope, Rachael Rush, Raymond Soh
Contractor: Good Brothers Construction
Structural Engineer: Thorne Dwyer Structures
Landscape architect: Rod Barnett
Quantity surveyor: Page Kirkland NZ
Photographer: Patrick Reynolds

House in Kangaroo Valley, Kangaroo Valley, Australia
Alexander Michael & Associates, 12 Mary Place, Paddington, NSW 2021, Australia
t: +61.2.9360.4512, e: siloboy@ozemail.com.au, www.siloboy.com
Building and landscape design: Alexander Michael
Interior design: Alexander Michael
Structural engineer: Seeto Lee
Builder: Bill Hawkins
Photographers: Johnny Valiant; Alexander Michael

Sharek House, Auckland, New Zealand
Andrew Lister Architect
Designer: Andrew Lister
Builder: Warren Adolph
Structural Engineer: Charles Sue, Law Sue Consultants
Cabinetmaker: Steve Leslie, Leslie A.J and Co
Photographer: Richard Powers

Holman House, Dover Heights, Australia
Durbach Block Architects
Architects: Neil Durbach, Camilla Block, David Jaggers, Lisa Le Van, Joseph Grech, Adrian Gressner
Engineer: Baigents
Landscape architect: Jane Irwin Landscape Architect
Builder: LH Building Services
Photographer: Anthony Browell; Brett Boardman; Chris Cole